Rainforest
Endangered

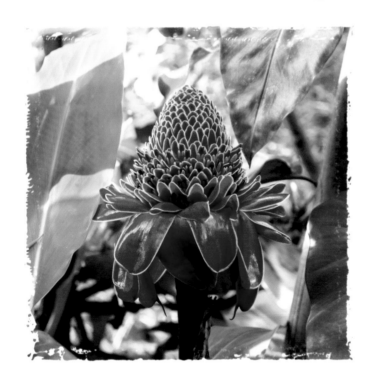

Publisher and Creative Director: Nick Wells
Commissioning Editor: Polly Prior
Picture Research: Taylor Bentley
Digital Design and Production: Chris Herbert
Copy Editor: Catherine Bradley

Special thanks to Dawn Laker and Helen Snaith

FLAME TREE PUBLISHING
6 Melbray Mews
Fulham, London SW6 3NS
United Kingdom

flametreepublishing.com

First published 2020

20 22 24 23 21
1 3 5 7 9 10 8 6 4 2

Image Credits: Courtesy of **Getty Images** and © the following: Michele D'Amico supersky77 6 & 25; Bento Fotography 8 & 72; sergey Mayorov/500px 36-37; guenterguni 39; George Vlad/500px 44; Yann Guichaoua-Photos 62; 35007 81; Desmond Lobo 77; Thanit Weerawan 79; Sylvain Bouzat 89; Robin Moore 95; Javier Fernández Sánchez 113; Kim Schandorff 119; Ricardo Lima 120; Fotografías Jorge León Cabello 161; Tihomir Dimitrov/EyeEm 174. Courtesy of **SuperStock**: 3, 10-11, 20, 65, 110, 144, 158; and © the following: Pete Oxford/Minden Pictures 4, 127, 131; Prisma 9 & 115; Ch'ien Lee/Minden Pictures 12, 21, 91; Matthias Breiter/Minden Pictures 14; Konrad Wothe/Minden Pictures 15; Susan E. Degginger/age fotostock 16; Tier und Naturfotografie 23, 117; Minden Pictures 24; Ben Langdon/robertharding 25; NaturePL 29, 34, 40, 41, 48, 172, 175, 180; Universal Images 30 , 78; Jan Sochor/age fotostock 31; Scubazoo 32; Florian Kopp/imageBROKER 33; Thomas Marent/Minden Pictures 42, 57; Juniors 43; NASA 46; Piotr Naskrecki/Minden Pictures 50; Patricio Robles Gil/Minden Pictures 53; Dave Montreuil/Minden Pictures 54; Mile 91/robertharding 56; Nature Picture Library/Will Burrard-Lucas 58; APATOW PRODUCTIONS/WILSON, GLEN/Album/SuperStock 60; Dave Stamboulis/age fotostock 63; Nature Picture Library/Nick Garbutt 66; Paul Bertner/Minden Pictures 67; Westend61 71, 125; Christian Goupi/age fotostock 73; Thomas Mangelsen/Minden Pictures 75; CORDIER Sylvain/Hemis 76; Suzi Eszterhas/ Minden Pictures 85, 105; Michele Westmorland/SuperStock 88; Erich Schmidt/imageBROKER 93; Tim Graham/robertharding 96; D. Parer & E. Parer-Cook/ Minden Pictures 99, 164; Jon G. Fuller/age fotostock 104, 111; Biosphoto 108, 132, 136, 139, 176; Vision 21/imageBROKER 109; Luis Davilla/age fotostock 112; Nick Garbutt/SuperStock 122; Heeb Christian/Prisma 124; Morales/age fotostock 128; BRUSINI Aurélien/hemis.fr/Hemis 129; Stock Connection 133; Luciano Candisani/Minden Pictures 145; Andreas Werth/Mauritius 149, 159; Milo Burcham/Alaska Stock - Design Pics 151; Jan Holm 153; John E Marriott/All Canada Photos 154; Randall J Hodges/SuperStock 157; John E Marriott/All Canada Photos 146; Tui De Roy/Minden Pictures 165; Cyril Ruoso/Minden Pictures 168; Wolfgang Kaehler 183, 188; Nature Picture Library/Cyril Ruoso 192. Courtesy of **Shutterstock** © and the following: David G Hayes 1; samanthainalaohlsen 7 & 98; Phuong D. Nguyen 19; Al'fred 28; O.Rek 44; Fabian Plock 47; Travel Stock 61; R.M. Nunes 69-69; Mazur Travel 82; Michael Knitl 83; My Good Images 84; Philippe Clement 86; By Anatoliy Alekseev 90; Don Mammoser 94; howamo 97; Kevin Wells Photography 100-101; Galyna Adrushko 103; Damsea 106, 107; Chris CR 116; RPBaiao 123; Ricardo de Paula Ferreira 131; Ondrej Prosicky 134, 173; COULANGES 135; Anton_Ivanov 140; Alexandre Laprise 143; Max Lindenthaler 150; Flystock 152; Roman Khomlyak 156; kridsada kamsombat 160; Dmitry Naumov 162; LP2 Studio 166; Stephane Bidouze 167; Cyrus Wang 169; Maks Ershov 170; Martin Fowler 177; ichefboy 178; Tarcisio Schnaider 182; N. Antoine 184; Daniel Andis 186; Dmitry Burlakov 187.

ISBN: 978-1-83964-159-6

Printed in China

Rainforest
Endangered

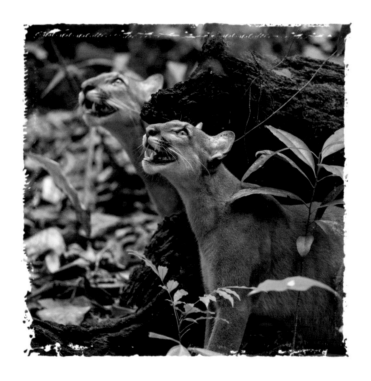

Simon G. Dures

FLAME TREE
PUBLISHING

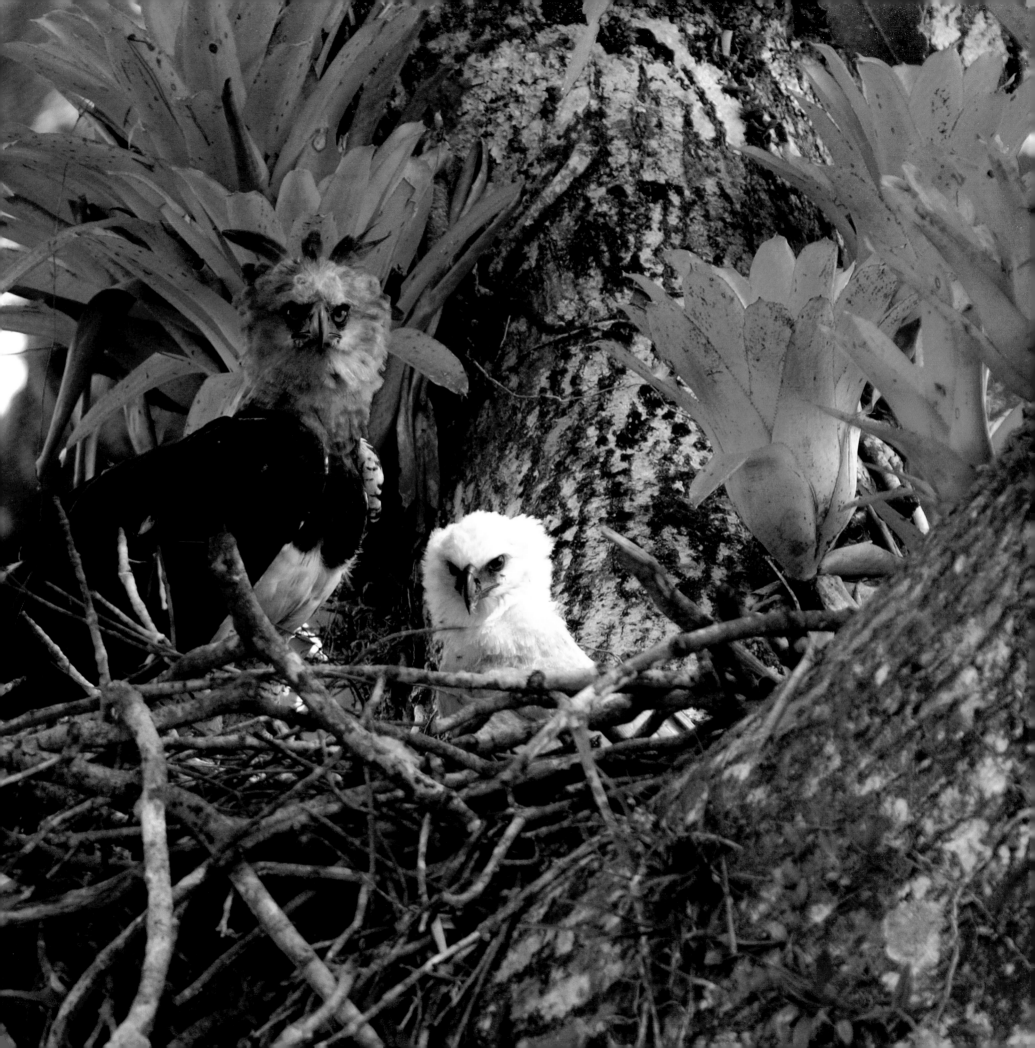

Contents

Introduction

Your shirt sticks to your back and sweat pours down your face in the heat and humidity. You peer through binoculars up into the canopy, wishing you could be up high and close to the teeming life above. As you walk across the open forest floor, stepping over rotting, moss-covered branches and through dark, wet ferns, you approach an enormous, gnarled tree trunk. It looks as though huge wooden snakes have twisted around and are entwined in each others' grasp.

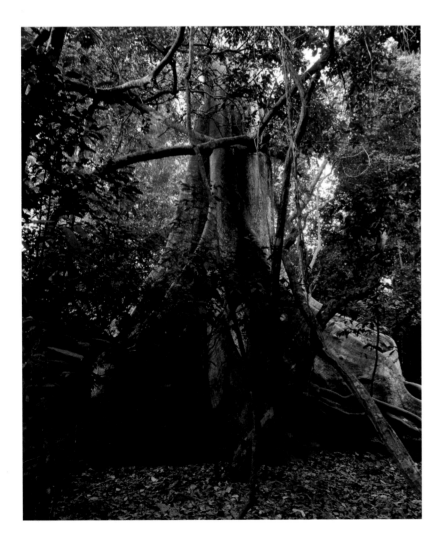

A Vibrant Habitat

A closer look reveals the inside of this massive trunk to be hollow. Perfect natural handholds allow you to climb high up the centre of the tree, emerging through one of the many openings between the entwined wooden snakes some 30 or 40 metres (98 to 131 feet) up in the canopy. This fantastical sounding tree is a strangler fig – perfectly harmless, unless you are another tree. The seeds of the fig have probably been dispersed by birds, perhaps dropped on a bed of lichen high up in the canopy of one of the forest's giant trees. Slowly and patiently the fig used the access its height granted to absorb light and moisture in the high canopy. It slowly grew its many roots downwards, clinging to the trunk of its host tree until they reached the ground.

On reaching the ground, the fig can access the nutrients in the soil. Its roots now begin to grow more rapidly, sending the rich nutrients up into its developing canopy that begins to overshadow the original tree – depriving it of life-giving water, nutrients and sunlight. Eventually the host tree cannot hold on to life and slowly rots away, leaving only its impression in the thick lattice of the strangler fig. Welcome to the wondrous world of the rainforest.

Cathedrals of the natural world, the Earth's rainforests are magnificent, lush and diverse wildernesses. Covering less than six per cent of the Earth's land surface, they are thought to account for over half of the planet's plant and animal species. Life quite literally crawls, scampers, flies, stalks, creeps and grows over every surface. Rainforests contain some of the most unexplored places on the globe – yet together these complex environments form a crucial organ in maintaining the stability of the world's ecosystems.

An Ancient Realm

The world's rainforests have been around for a very long time, although perhaps not in the same form that we know them today. Tropical forests were evolving at a time when the world's land was formed of a single supercontinent, Pangea. This was approximately 200 million years ago, when giant reptiles such as stegosaurus and brachiosaurus roamed the Earth. The predecessors to modern birds, archaeopteryx, glided between the trees, while huge pterodactyls ruled the skies above, their lineage now completely extinct. The world was warm and wet. The forests that thrived in these conditions were dominated by enormous towering conifers, cycads and giant tree ferns, the ancestors of which can still be seen in modern rainforests.

As Pangea began to break apart, forming the more distinct continents we know today, the ancient tropical forest was also fragmented. This enabled novel evolutionary pathways to develop, allowing the eventual divergent speciation onto a multitude of distinct and unique flora and fauna. Fast forward time even further and these continents, with their now distinctive composition of plants and animals, collided once again. The diversity that had evolved over millennia could now mix and evolve into species with ever more unique niches.

Home Sweet Home

The world's rainforests are undoubtedly the most biodiverse regions on Earth, estimated to be home to approximately half of all terrestrial animals and two-thirds of all plant species. This diversity is in part due to their ancient history and in part to the clement conditions; life needs water and sunlight, and the tropical regions have these in abundance. In addition, this water and sunlight is spread evenly and constantly

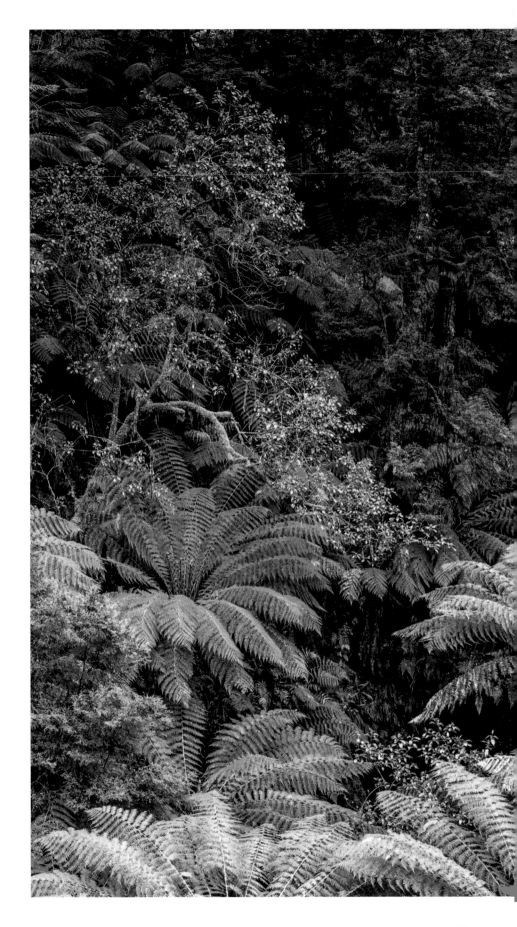

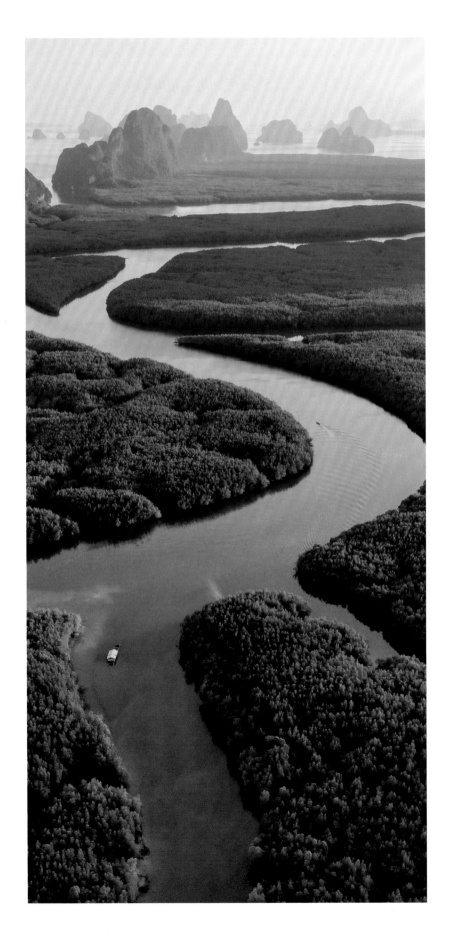

throughout the year, without the seasonal changes that hinder growth in less tropical latitudes.

An amazing statistic illustrates this diversity: while the combined landscape of the United States of America and Canada is home to around 700 native plant species, the combined species count of just 10 one-hectare (2 1/2 acre) plots of Bornean rainforest have been found to contain over a thousand vascular plant species.

A Precious Resource

With such an awesome amount of plant and animal diversity, it is easy to forget that rainforests also have a human element. According to the UN Food and Agriculture Organization, more than 25 per cent of the world's population rely on forest resources for their livelihoods.

However, rainforests are not simply a resource: for many indigenous tribes they are still home. It has been estimated that across the world's tropics there are more than 100 uncontacted human tribes, not counting the many that have been contacted but prefer to remain in varying degrees of isolation from the modern world. Many other tribes have felt the impact of the outside world, either choosing or often being forced to give up their traditional ways of life by government resettlement and deforestation programmes.

Earth's Green Lung

Taking a deep breath of the clean, damp air in a rainforest is invigorating and refreshing, but this is not just a spiritual reaction: you are quite literally getting an oxygen boost. Huge amounts of sunlight fall on the green canopy of a rainforest, especially those in tropical regions, characterized by relatively constant levels of daily sunlight throughout the year. Through the complex chemical process of photosynthesis,

plants use the energy absorbed from sunlight to split water and carbon dioxide into their component parts, namely oxygen, carbon and hydrogen. These three elements are then recombined to form glucose, the nutrient that plants use to grow, in the process releasing huge amounts of oxygen as a by-product. In fact, so much oxygen is released from the world's rainforests that they are thought to be responsible for replenishing between 20 to 30 per cent of the oxygen in the air we breathe.

The Climate's Beating Heart

As well as producing much of the world's oxygen, rainforests are intimately linked with our planet's climate. As scientists improve and refine their understanding of the processes that drive and control global weather patterns, they are beginning to realize the immense role that rainforests play appears to have been vastly underestimated.

The connection between rainforests, clouds and rainfall was first observed by Western scientists as far back as the early nineteenth century. However, investigations into the extent to which they may be driving worldwide air movements only began in earnest at the beginning of this century. Recent research has discovered that, through the process of photosynthesis, rainforests pump vast amounts of water into the atmosphere. A single tree can pump upwards of 1,000 litres (220 gallons) of water from the ground below into the atmosphere above in a single day.

It is this water that condenses above the rolling green sea of trees, forming clouds above the canopy. As water condenses it releases heat, causing the clouds to rise, reducing the air pressure below and drawing in more air from the surrounding landscape. The trees absorb this fresh, carbon dioxide laden air. Then, through the cycle of photosynthesis, they pump up yet more water, forcing the expanding clouds higher up into the

atmosphere. These pressure changes drive an enormous volume of water vapour out across the oceans in vast, invisible sky-rivers, eventually falling as rain in distant regions across the world.

Importantly for humanity, much of this rainfall supplies water for the breadbaskets of the world. Rainforests are thus not only the engines that drive our global climate, but also the beating heart of our shared global water and agricultural security. In other words, deforestation in South America, for example, may result in more frequent and more intense droughts across the world, from the great plains of North America to the savannas of southern Africa.

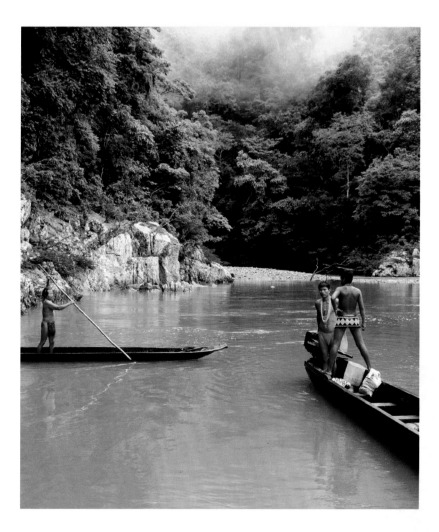

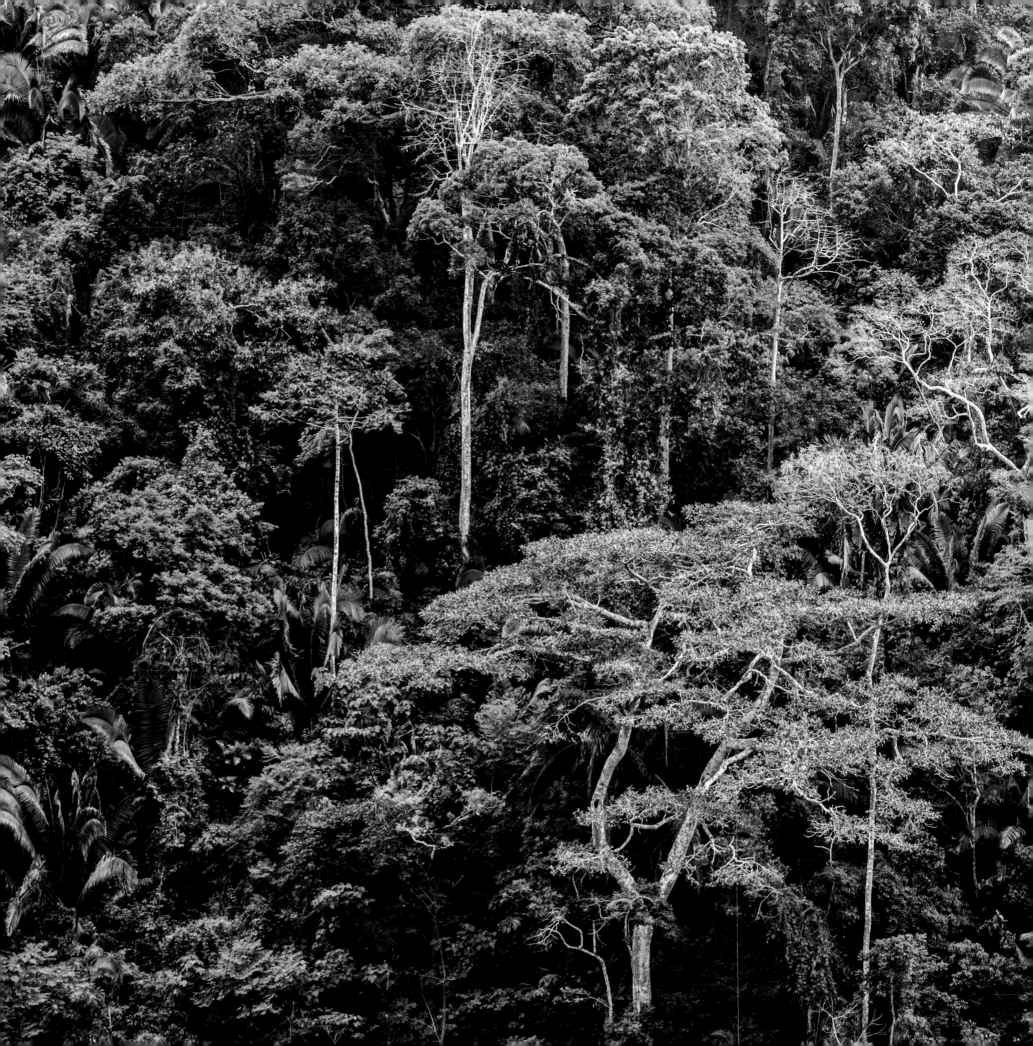

The Rainforest

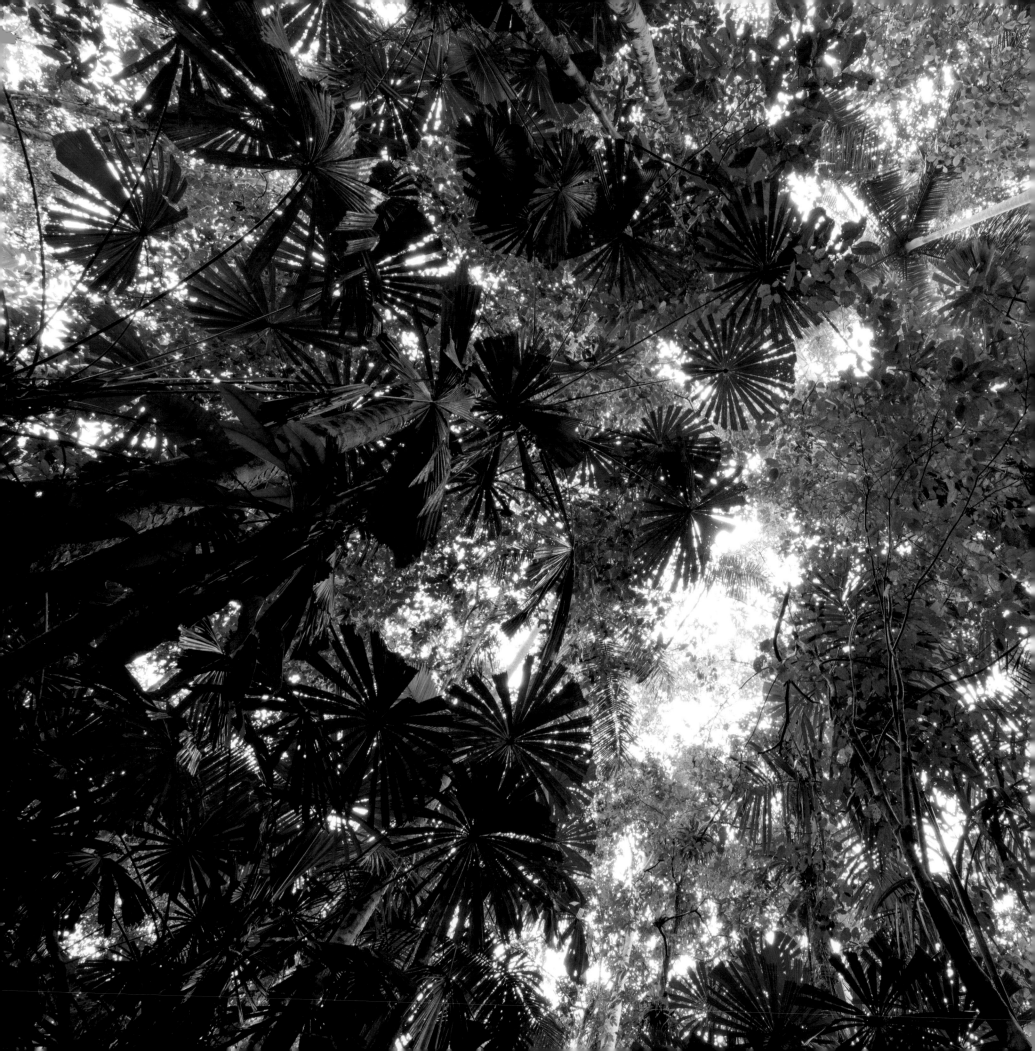

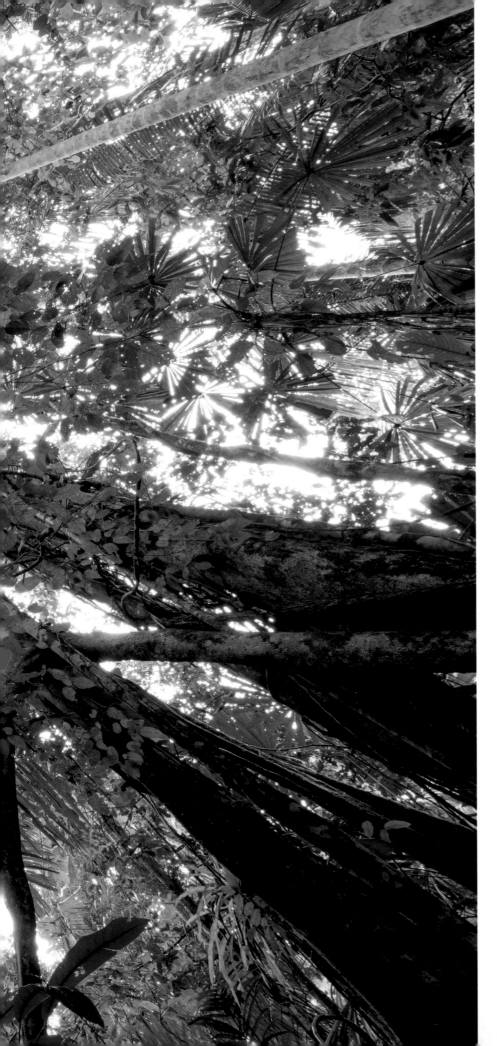

A Living Wonderland

Stepping into a rainforest is to enter a living wonderland. They are like no other place on Earth. As the fresh, damp air envelopes you and the humidity rises, your senses will be overcome by the rich buzz of life. The world's rainforests are complex ecological tapestries, in which each and every organism depends on a multitude of others. It is this complexity that makes rainforests such fascinating and beguiling places.

Where Are Rainforests Found?

Rainforests can be found on all of the Earth's continents except Antarctica. However, the majority are found in a broad swathe running around the girth of our blue planet, like a stroke of green paint. This green band is the tropical forest, found in the warm equatorial zone that falls between the tropics of Cancer and Capricorn. In the Americas this can be found in almost every country, from Mexico down to the north of Argentina. In Asia and Australasia the northern reaches of the rainforests start in southern China at the tropic of Cancer and stretch as far south as the north-eastern tip of Australia. In Africa the tropical rainforests are much more tightly confined to the equator.

All rainforests are in regions with a low annual variation in temperature, although this temperature may not be especially warm. Most people, when they think of a rainforest, picture a warm, humid forest, more colloquially referred to as 'jungle'. However, rainforest is not confined to tropical

Previous page: The thick rainforest canopy, with tall, emergent trees towering above, absorbs most of the sun's energy. Only 10 per cent of the sunlight reaches the dark forest floor below.
Left: Towering fan palms of the understorey layer of lowland rainforest in New Guinea. Many such ferns in these forests are closely related to similar species that existed in prehistoric times .

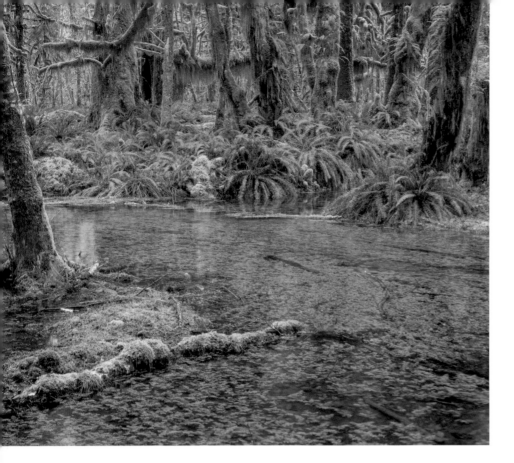

Above: Thick mosses and lichens coat tree trunks in temperate rainforests, as here in Olympic National Forest, Washington, USA.

regions. While tropical rainforest is certainly the most abundant type, with a mean monthly temperature exceeding 18°C (64°F), temperate regions also have their own rainforests. These temperate rainforests tend to have mean annual temperatures falling between 4°C to 12°C (39°F to 53°F) – certainly not warm. These temperate rainforests bear little resemblance to their tropical cousins, but do share their defining feature – plenty of rain!

Aside from the Himalayas, most of the temperate rainforests are found in cool, moist, oceanic climates. They can grow anywhere that has enough cloud cover and precipitation, either as rain or snow, to allow them to thrive.

As well as tropical and temperate rainforests, there is a third type of rainforest that is less well-defined. It is known as cloud forest, a name that gives away its defining characteristic. Persistent fog and cloud weaves its

Right: The temperate rainforests of the Pacific Northwest are home to the Roosevelt elk. President Theodore 'Teddy' Roosevelt established the protected Mount Olympus National Monument largely to protect this animal.

Rainforest: Endangered

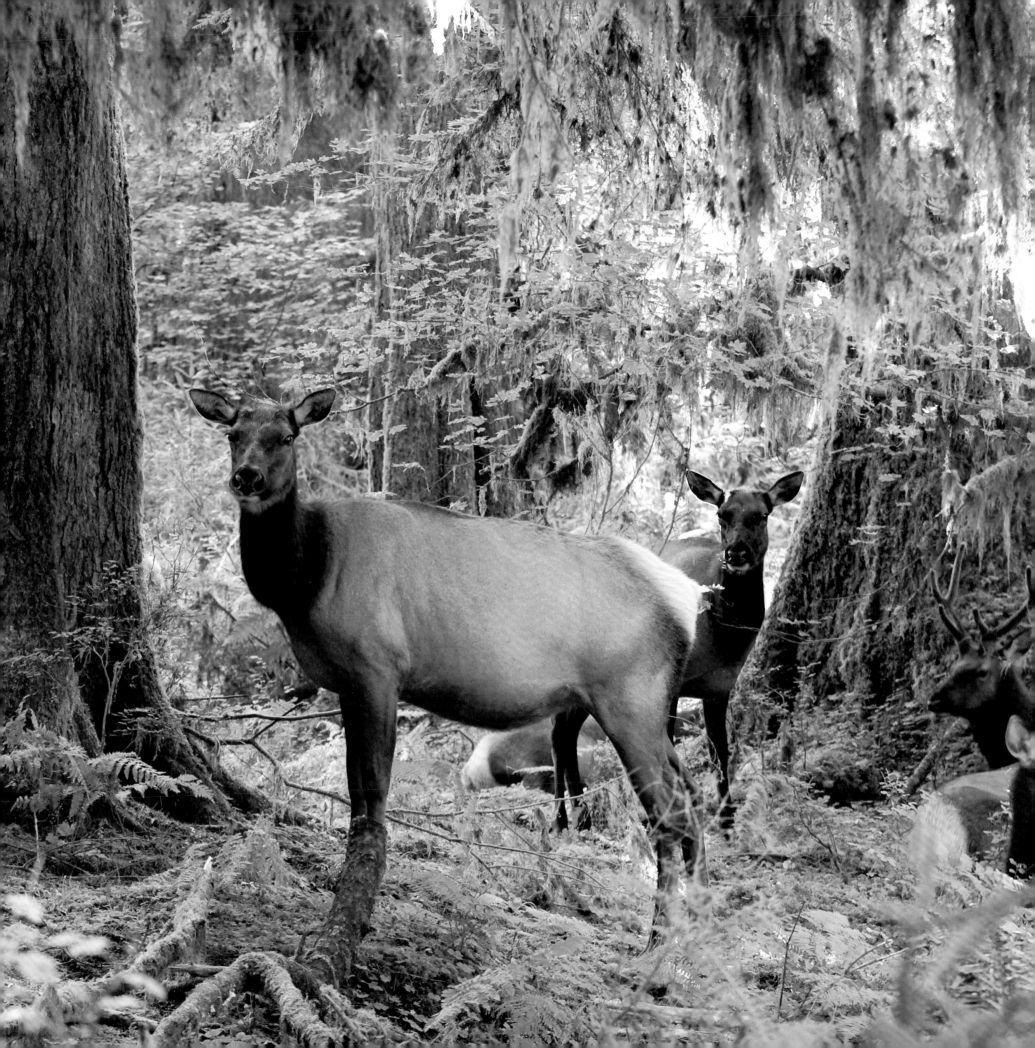

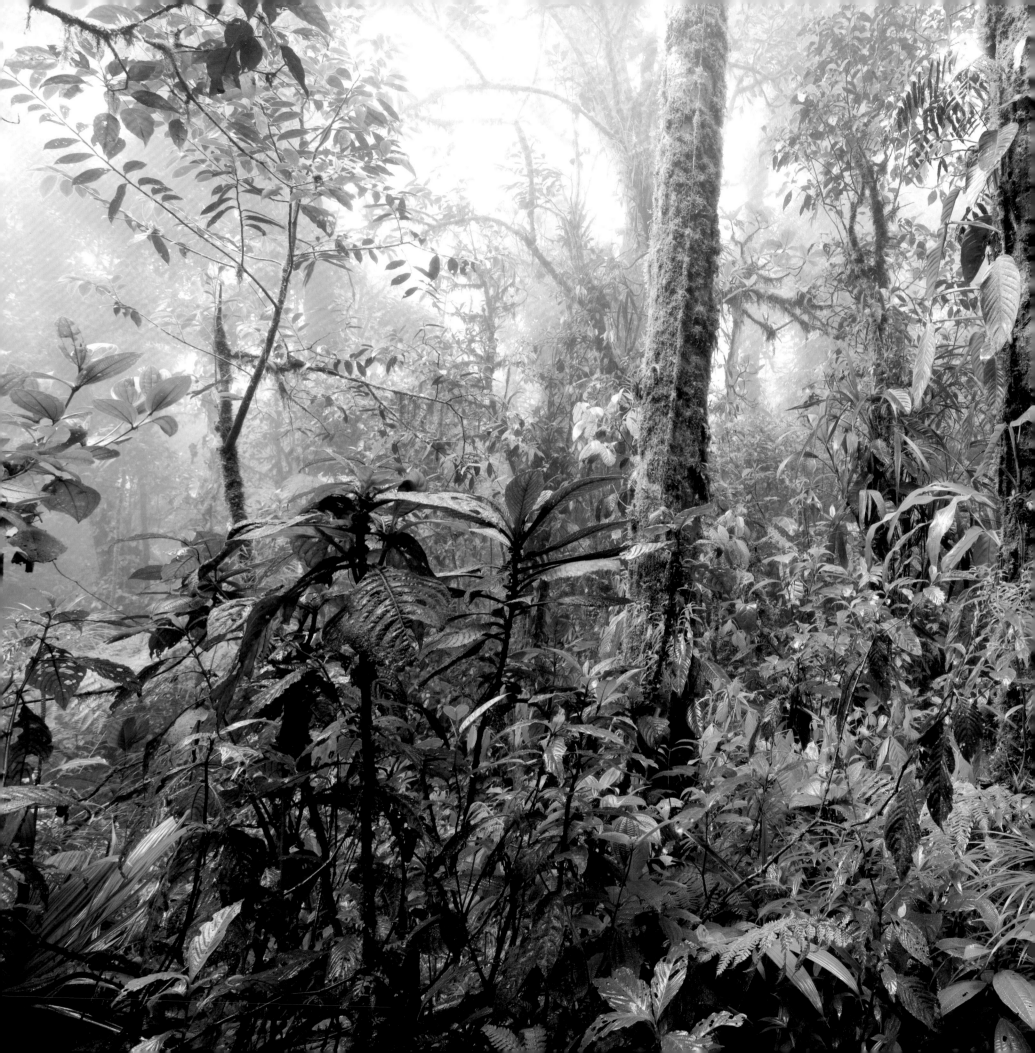

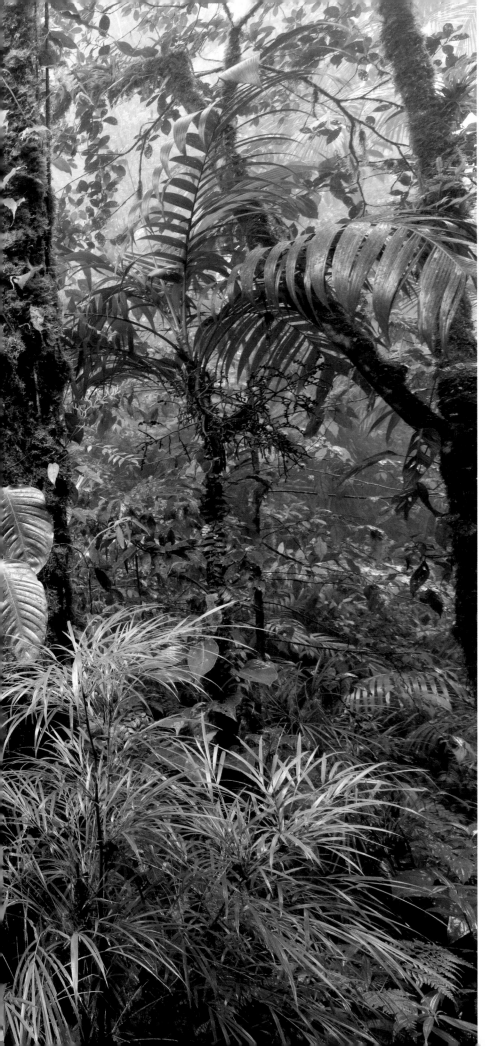

way through the vegetation here, making every surface damp to the touch. Cloud forest has a far less defined distribution. It occurs across broadly the same range as tropical rainforest, but is far sparser. Cloud forest tends to be either coastal or at high altitudes, with a delicate dependency on the local climate's ability to generate fog and cloud.

What is a Rainforest?

As the name suggests, rainforests are a tree-dominated ecosystem characterized by high levels of year-round rainfall and humidity. In the tropical rainforests this is typically at least 200 cm (78 in) of rainfall each year, although it can be well over 1,000 centimetres (394 in) each year. The cycle of transpiration, condensation into clouds and resulting rainfall, means that as much as 75 per cent of all the rain falling over a rainforest is self-generated. All this water, combined with high levels of sunlight, results in a growth race among plants to absorb as much of the sunlight as possible. This leads to a thick and enclosed canopy of leaves, with almost every gap filled by lush green growth. Thus, in essence, a rainforest is simply a forest that generates much of its own rain.

This enclosed canopy is characteristic of rainforests. Even more apparent, however, is their extremely high species diversity. With this comes a complex web of symbiotic relationships, linking each and every organism in some fashion. No matter where they are found, rainforests are finely balanced networks existing within precise and easily disturbed biogeographic boundaries.

The intricate relationships between rainforest species may take many forms. For example, birds feed on fruit trees and in turn disperse the seeds; insects provide pollination and receive food in return; epiphytes – plants

Left: Monteverde Cloud Forest Reserve, Costa Rica

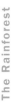

17

that grow on the surface of other plants – grow at the tops of the trees to reach the sunlight above the canopy better. They help the tree by reducing water loss through transpiration and, in turn, provide habitat for other species. Of course, not all the relationships are equal; while many are symbiotic, predation, parasitism and scavenging also occur. Rainforests are the battleground for evolution's ultimate arms race.

How Rainforests Work

Rainforests are composed of four broad layers: the forest floor, the understorey, the canopy and the emergent layer.

Competing for light, the trees grow high above the ground and form a thick, closed canopy of leaves, trapping over 90 per cent of all available sunlight. This canopy layer contains the majority of the trees and, particularly in the tropical rainforest, the highest density of biodiversity. In fact, the complex ecological tapestry of the forest canopy is estimated to contain some 50 per cent of all plant species and 25 per cent of all insect species found on Earth. Only by entering this rich canopy can the true majesty of the rainforests be observed.

Protruding from this dominant canopy layer tower the forest giants of the emergent layer. These enormous trees can rise as high as 100 m (328 ft) from the ground and comprise the tallest trees in the world.

At the base of the trees, the forest floor forms a dark contrast with the bright canopy high above, receiving just two per cent of all the sunlight falling on to the forest. Unlike the fictional image of an 'impenetrable jungle', healthy tropical rainforests are usually open and easy to walk through. The forest floor is covered by a litter of fallen wood and leaves,

Right: *Deep in the forest in Khopra, Nepal*

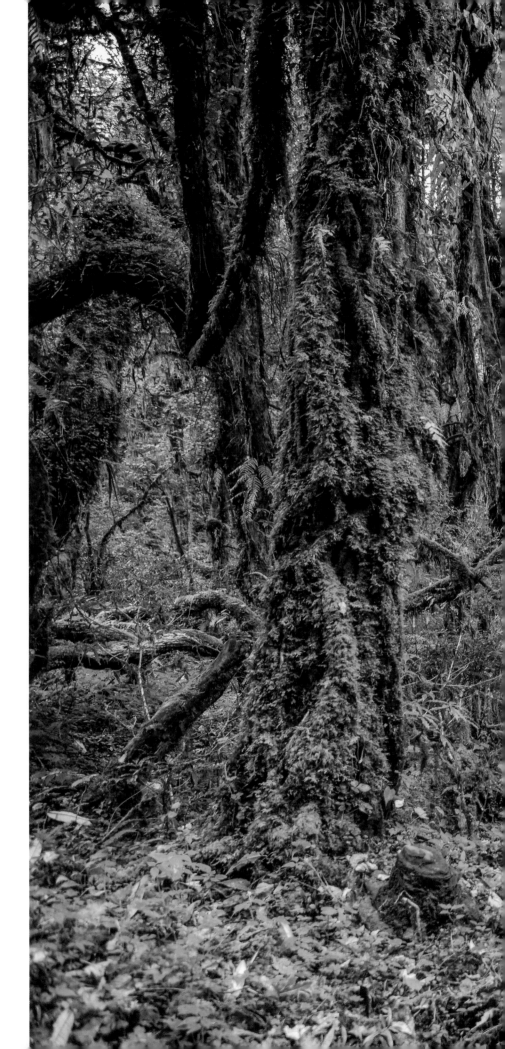

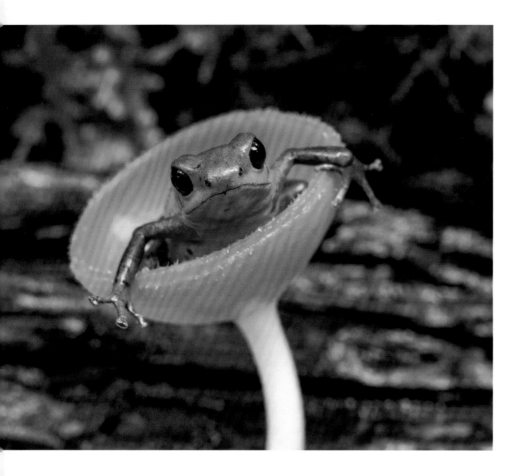

Above: A strawberry poison dart frog keeps moist in a small pool of water. The liquid has collected in one of the many colourful fungi that pepper the forest's rotting wood.

their decay accelerated by the diverse array of fungi and lichen. The darkness down on the forest floor means that few plants grow here; any that do have evolved to survive in a low-light environment. If you wish to study the plants and animals living here, you will need a torch.

Above the forest floor, the understorey layer receives slightly more light, around five per cent of the total. Here the leaves tend to be much larger than the canopy above. Small seedlings absorb as much of the sun's energy as they can, awaiting any opportunities presented by one of the larger trees falling and exposing the precious light above.

Right: Durian fruit flowering on the forest floor in Sarawak, Borneo.

Life-Support System

Rainforests are unparalleled in their biological diversity, but it is not just life within the forests that they support. The massive diversity of life they contain makes rainforests not only an important conservation asset, but also a rich source of food, raw materials and medicine for humans. The impact of these forests on our global climate means they can also influence global cooling – increasingly important as we confront ongoing, human-generated global warming.

A Natural Pharmacy

So much of the medicine we take for granted in our modern world has its origins in the plants around us. Given their diversity, tropical rainforests are the richest resource we have for new medicine. So far we have investigated the medicinal value of less than one per cent of rainforest species, yet just these few are already responsible for 25 per cent of all modern pharmaceuticals.

One of the best known of such rainforest-derived medicines is the rosy periwinkle, *Catharanthus roseus*. This unassuming, pretty little plant, originating in the Madagascan highlands, was known to traditional healers as a treatment for diabetes. Further investigation by Western scientists found some of its chemical components to have anti-cancer properties. These chemicals – vinblastine and vincristine – have since been developed into some of the world's most powerful anti-cancer drugs. Now worth over £75 million each year to drug companies, it more importantly increases the chance of surviving childhood leukaemia from just 10 per cent to over 90 per cent.

Left: The rosy periwinkle, Berenty Reserve, Madagascar, Africa.

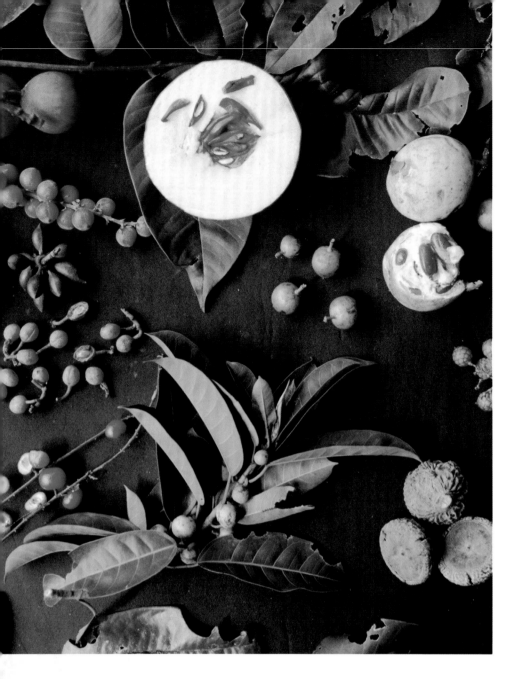

Above: The rainforest is home to a dizzying variety of fruits. All have adapted through evolution to tempt birds and animals to eat them, and so disperse their seeds throughout the forest.

The World's Larder

It is not just medicines that provide value. Many items of food and drink that you consume on a regular basis have their origins in the rainforest: tomatoes, coffee, bananas, chocolate, potatoes, rice and many more. In

Right: Picking red coffee beans from a coffee plant, Ethiopia, Africa.

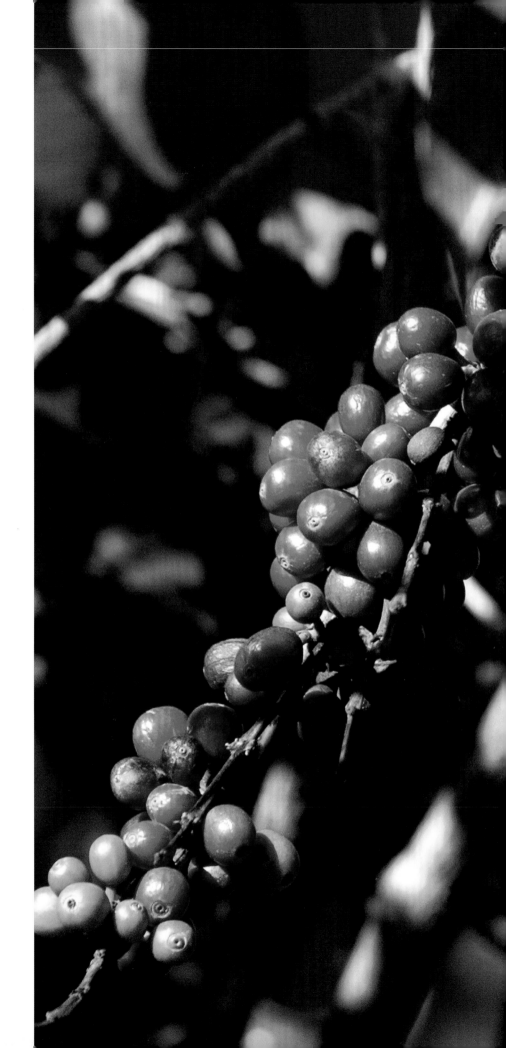

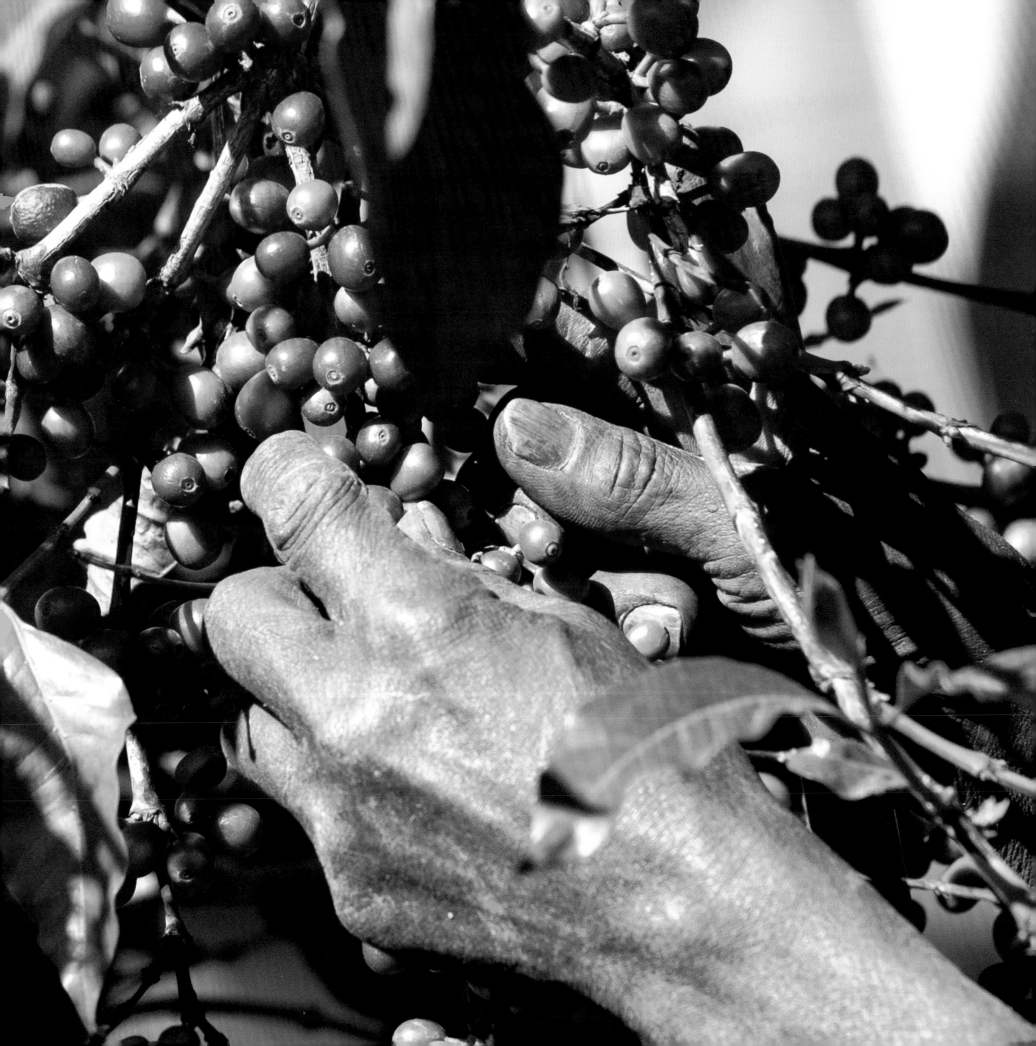

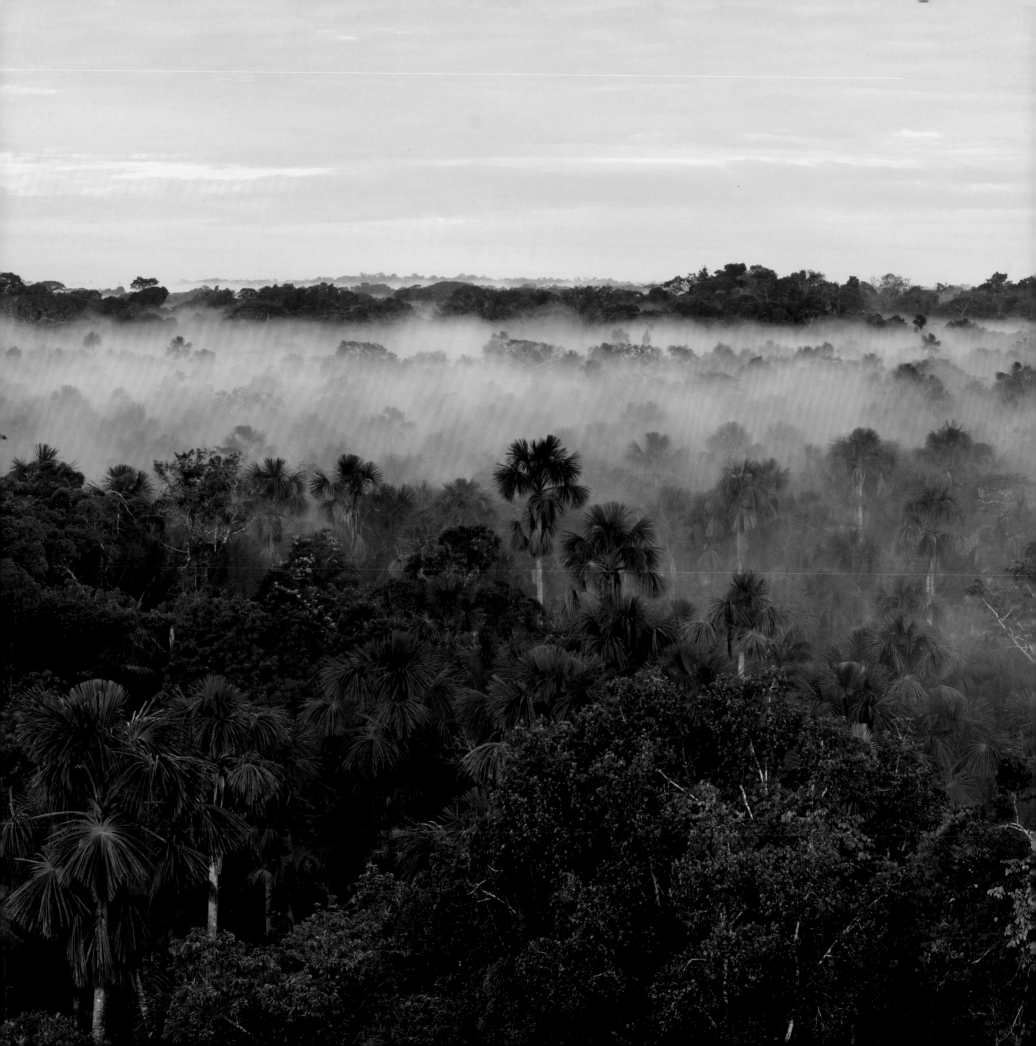

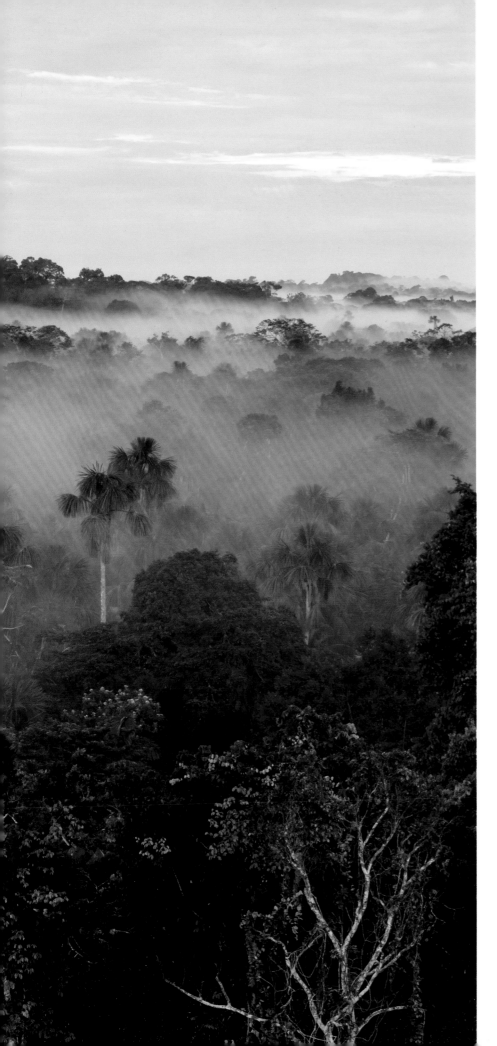

fact, around 80 per cent of the food products consumed by the world's biggest economies originate in the rainforest. Not only did many of our crops originate in the rainforests, but without the continued existence of their wild relatives, their very existence is under threat.

In the 1970s, for example, the global coffee crop came under serious threat from a disease called coffee rust. Fortunately, wild relatives of modern coffee that still exist in the rainforests of Ethiopia were found to have genes resistant to rust. These plants were bred with the modern coffee plants, incorporating the resistant genes and so saving the world's crop. Just imagine – without the continued existence of rainforests, you might no longer be able to enjoy your morning coffee!

Cooling the World

Rainforests play a significant role in driving global rainfall, air currents and climate patterns, but these are not the only global processes they influence. These magnificent swathes of green also help to keep our planet cool. By increasing cloud cover over huge areas of land, much of the sun's radiation is reflected back into space, keeping the planet cool. Areas where rainforest has been cleared have a measurable increase in temperature. In addition, the reduced rainfall means less water is available for crops, reducing the productivity of farmland. Without the rainforests, we not only lose all the sources of food and medicine they contain, but will also struggle to cultivate our crops successfully as the land slips into drought.

Left: Sunrise over the Amazon rainforest.

Under Threat

'Biodiversity is our most valued but least appreciated resource.'

Renowned ecologist Professor Edward O. Wilson

The land covered by the world's rainforest is exploited in numerous diverse ways for economic benefit – subsistence agriculture, logging for tropical hardwoods, clearing land for crops or cattle, mining for oil and precious metals or the damning of tributaries to facilitate hydroelectric power. However, there is increasing recognition that rainforests, no matter how vast, are not an infinite resource: once forest is cut and the nutrients in the soil used up, it is gone for ever.

Human Activity

On a global scale, conservative estimates place rainforest loss at 30,000 hectares (75,000 acres) each day, with the same amount being converted into degraded forest. Given the huge diversity of life found in the world's rainforests, this dramatic reduction of forest cover also results in lost habitat for multiple species of plants, animals and insects. It has been estimated that around 50,000 species go extinct each year as a direct result of rainforest deforestation. Such deforestation is the result of a plethora of human activities and demands on the delicate forest resources: timber for building and luxury furniture, rearing cattle for food, and access to mineral resources beneath the forests such as gold and diamonds.

Right: A Western Gorilla silverback skull with butterfly, Odzala Kokoua National Park, Republic of Congo.

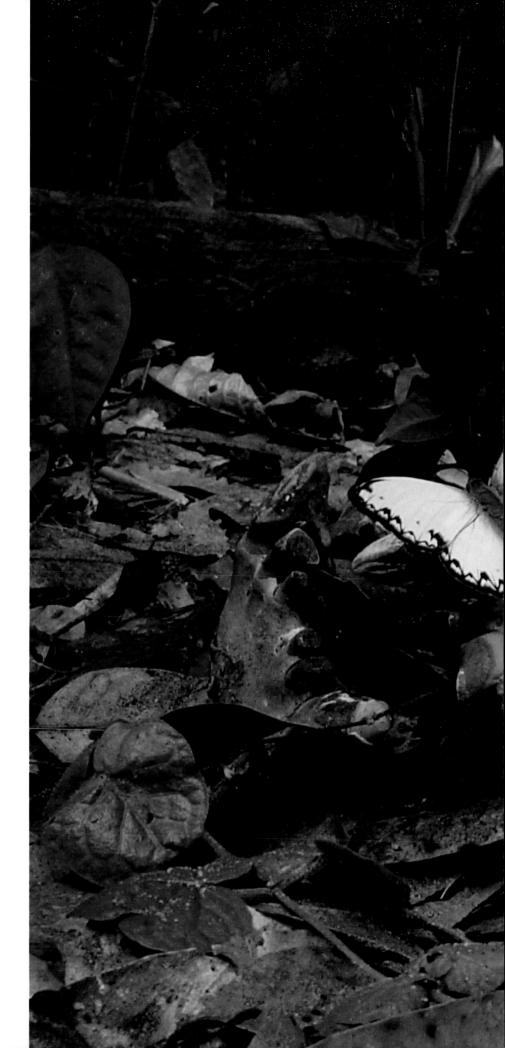

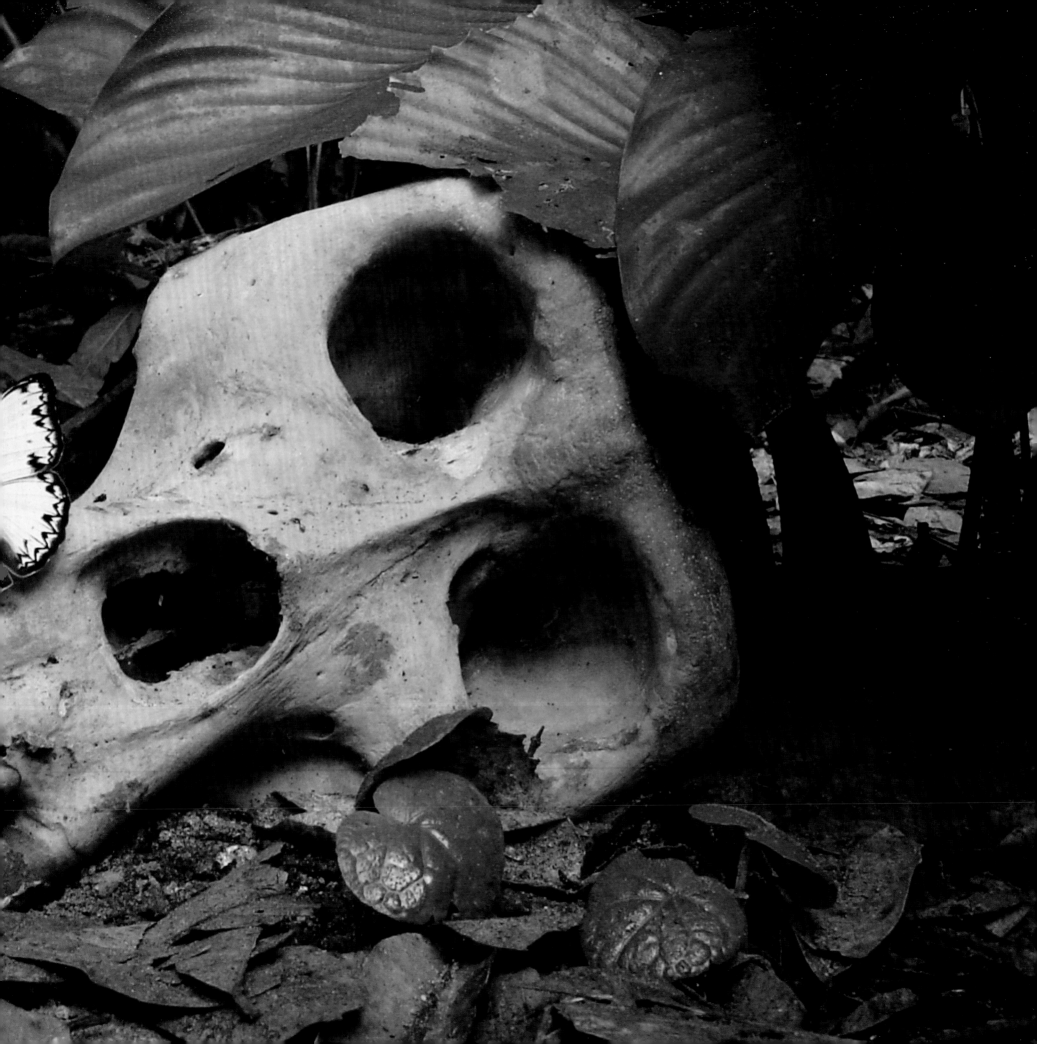

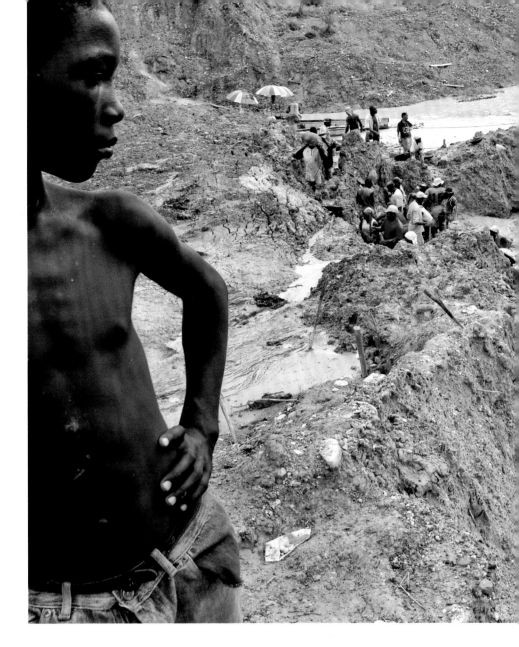

Actions Have Consequences

While rainforests provide benefits on a global scale, it is often the people living closest to them who reap the least rewards, yet are charged with the forests' stewardship. Much of the pressure on rainforests is not driven by the local population, but rather by rich economies' demands for products that are either cheaper to produce in rainforest-rich economies or which can be sourced nowhere else.

Above: Gold mining in Chocó, Colombia. Mining removed the jungle's vegetation cover and leaves pools of water contaminated with potentially toxic chemicals.
Left: The Tocantins River in Brazil has become heavily polluted by mercury, used by miners to extract gold from sediment.

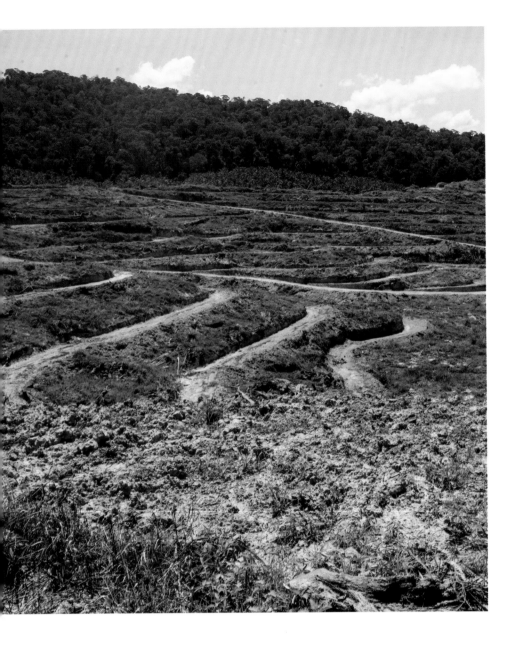

It is ultimately small actions and decisions by people around the world that collectively lead to forest loss – the demand for gold or diamonds, much of which is sourced in biodiverse areas, for example, or the global population's increasing appetite for ever greater quantities of meat. Even the simple desire to enjoy your morning coffee plays a part. Each of these choices results in a litany of damage to the rainforest, from deforestation

Above: Much of the deforested land, as here in Malaysian Borneo, is used to plant oil palms, found in innumerable products from moisturizer to pizza.
Right: Huge swathes of rainforest are cleared on a daily basis all over the world to obtain agricultural and grazing land. This image shows a small clearance in the Peruvian Amazon.

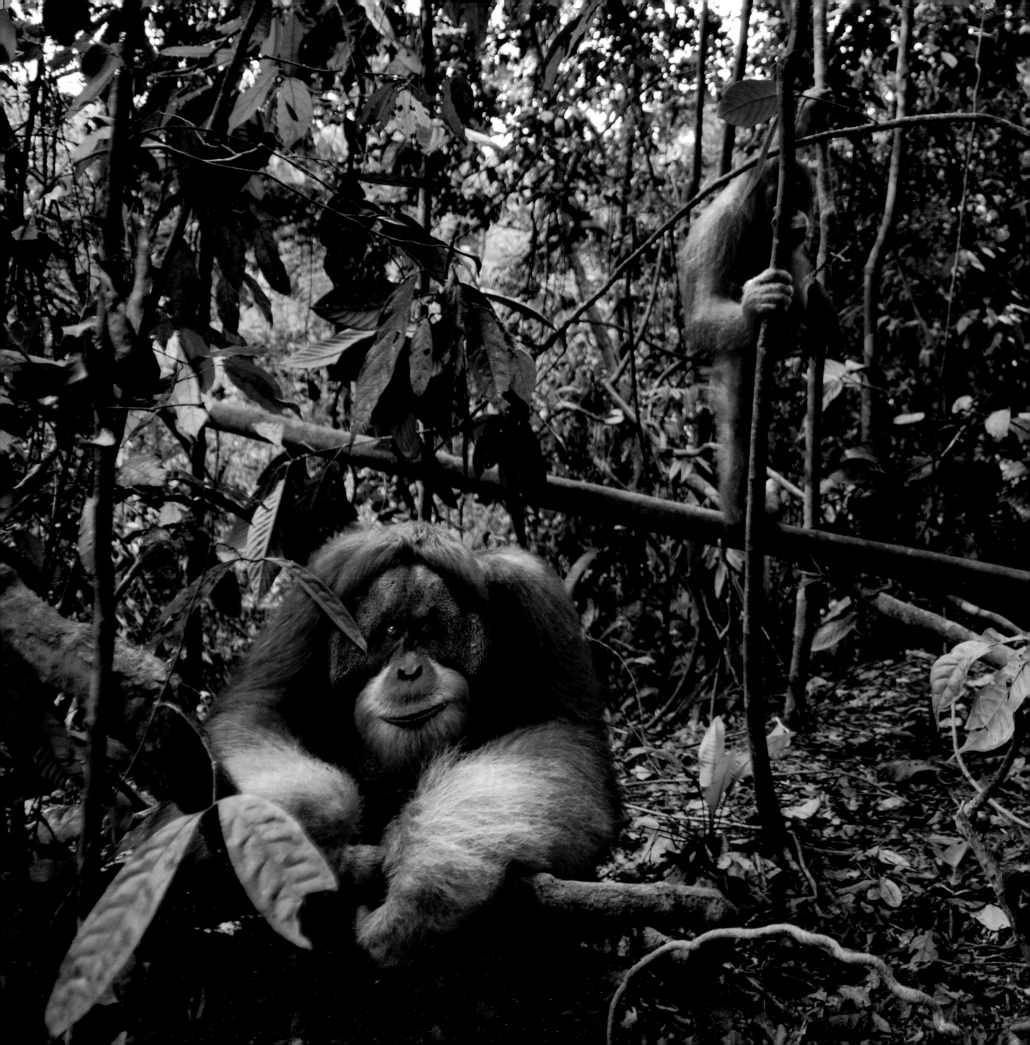

and degradation of the soil to fires that spiral out of control and the pollution of water sources. Nor are the consequences 'only' local. There is also increasing evidence of reduced global rainfall and increasing effects on our climate as the rainforests shrink. If we do not act quickly and decisively to save rainforests, the consequences for our planet could be dire.

Optimism for the Future

Despite the poor state that much of the world's rainforests are in, and the global consequences of this, there is optimism to be had. In our drive to save the ever-vanishing species on our planet we also study them; through such observation, we learn their unique characteristics. This opens pathways for industry to exploit these characteristics and glean value that they may otherwise not have recognized. Increased global scrutiny of multinational businesses is leading to increased remuneration to those countries and people who live in and around the rainforests, providing them benefit and incentive to protect these precious resources.

The Earth's population is ever growing, a fact that increases the pressure we exert on the world's resources, including those of the rainforests. However, as the global population becomes more aware of humanity's impact on our global natural heritage, and the life support mechanisms it provides, there is increasing positive action to reduce deforestation, and a greater understanding of our need to reforest much of what has already been cleared.

The simple act of reading this book – and hopefully being inspired by it – is one step closer to valuing our rainforests and taking small actions to save them. We can all play a part.

Left: The number of Sumatran orangutans has decreased dramatically over recent decades. Dedicated organizations rehabilitate orphaned or homeless individuals, eventually releasing them back into wild areas that might afford better protection.

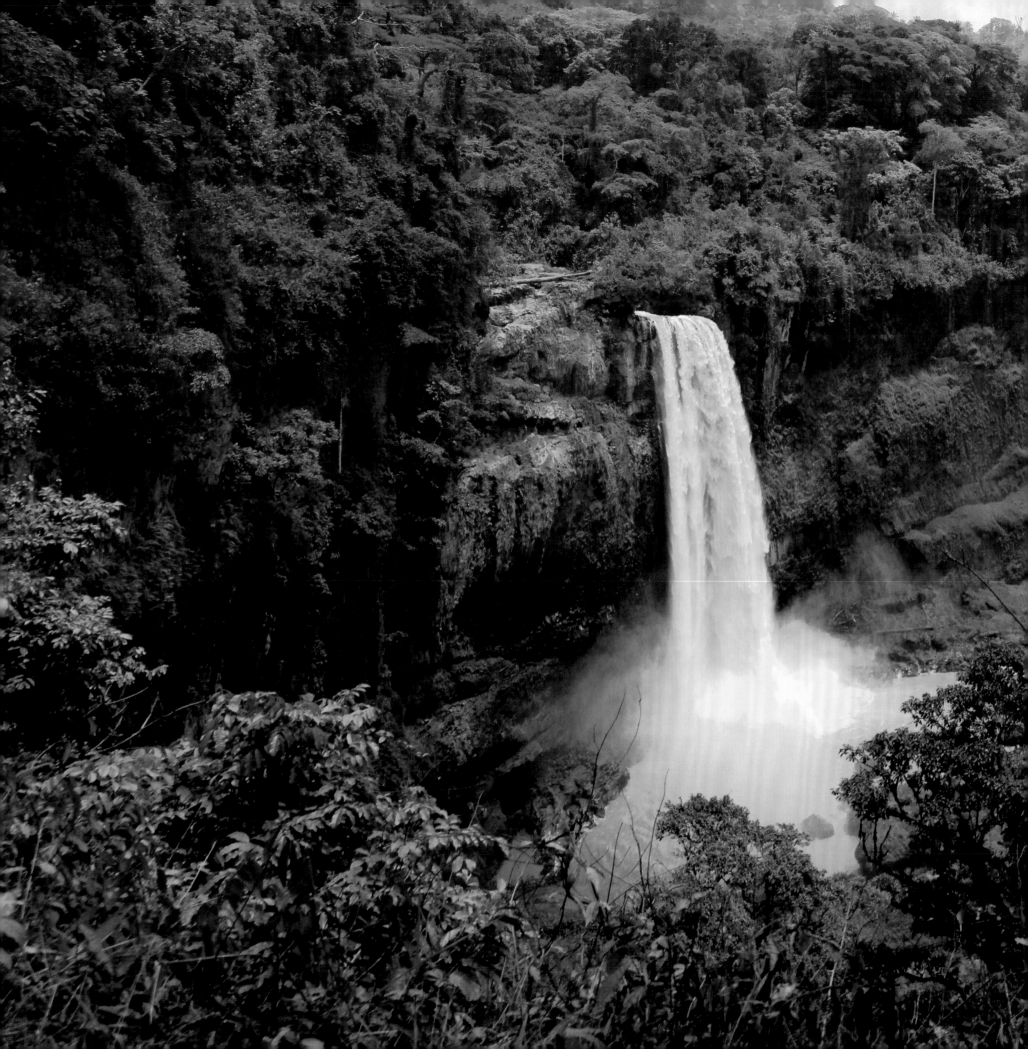

Africa's Rainforest

Central Africa

Deep, dark forests spread out across Africa's centre, dominated by majestic, towering trees that reach high into the clouds. Peppering the forests, large, grassy clearings are kept open by elephants who pull at the low-hanging branches around the edges and tear up trunkfuls of sodden grass. Through the middle of this great wilderness snakes the mighty river that shares the same name as the forests. This is the Congo.

The Congo Basin

A place for intrepid explorers and dauntless biologists, the Congo basin is not for the fainthearted. Spanning seven countries and covering an area of over 1.7 million sq km (656,374 sq miles), the rainforests of the Congo basin form the second largest block of tropical forest on Earth. They lie at the centre of a continent once labelled by Europeans as the Dark Continent; the author Joseph Conrad dubbed these forests Africa's 'Heart of Darkness'. Having been explored by Europeans only relatively recently has meant that Africa has endured the onslaught of commercial progress for a relatively short period of time. As a result, this vast carpet of trees is one of the world's most intact tropical rainforests. In more recent times, violent political turmoil and brutal civil wars have extended the lack of ingress into these deep forests. No matter the reason, the relatively intact nature of this vast rainforest wilderness provides a unique opportunity to set in motion measures to preserve its vast biodiverse riches – before they too are enveloped by the spread of humanity.

With as many as 10,000 plant species, a thousand different species of bird, 400 species of mammal and 700 species of fish, this 'Heart of Darkness' is

Previous page: *The thundering cascades of Ekom-Nkam Waterfalls, Cameroon, on the Nkam River are a big attraction for tourists to Cameroon.*
Right: *Trails in and out of this mineral-rich salt deposit in the Congo rainforest show the passage of forest elephants, buffaloes and gorillas. Many animals gather here, attracted by the mineral salts.*

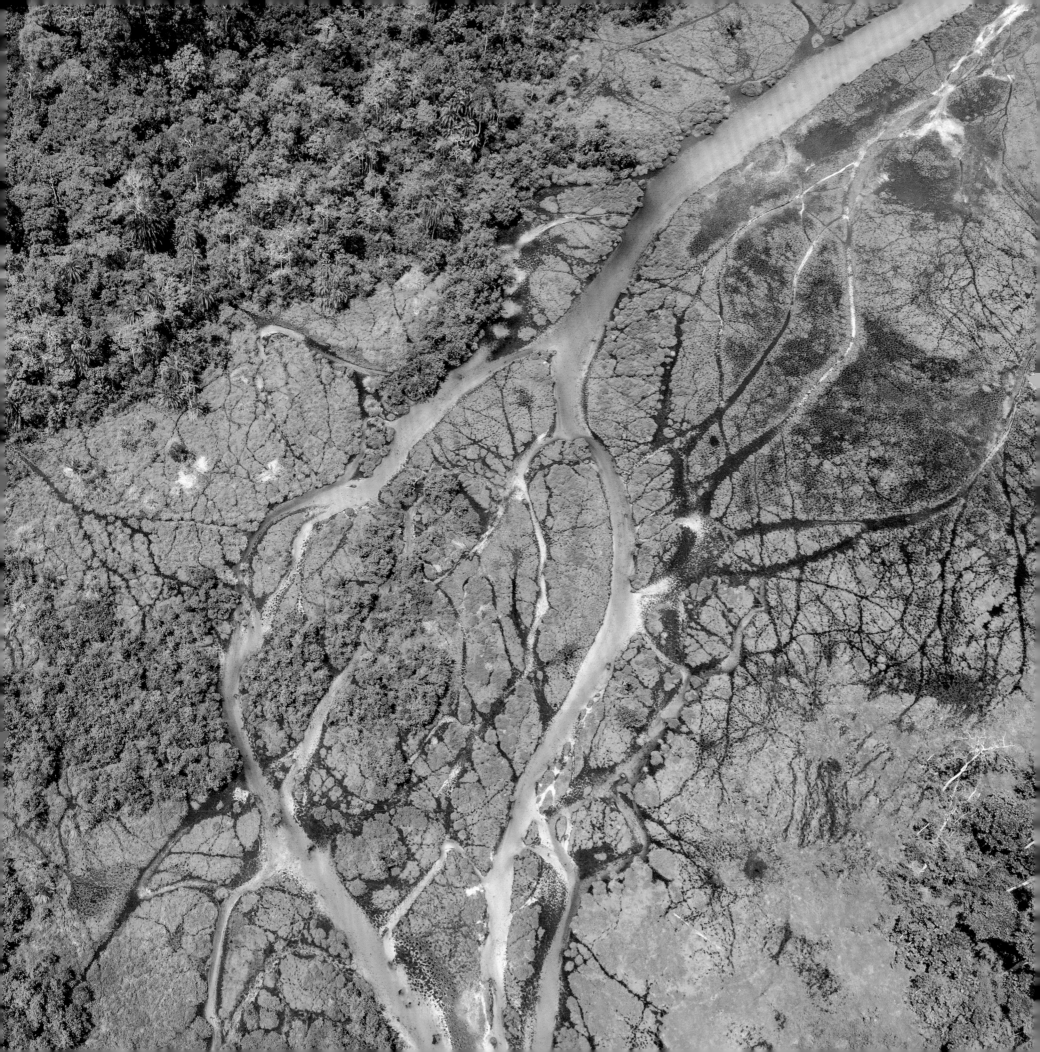

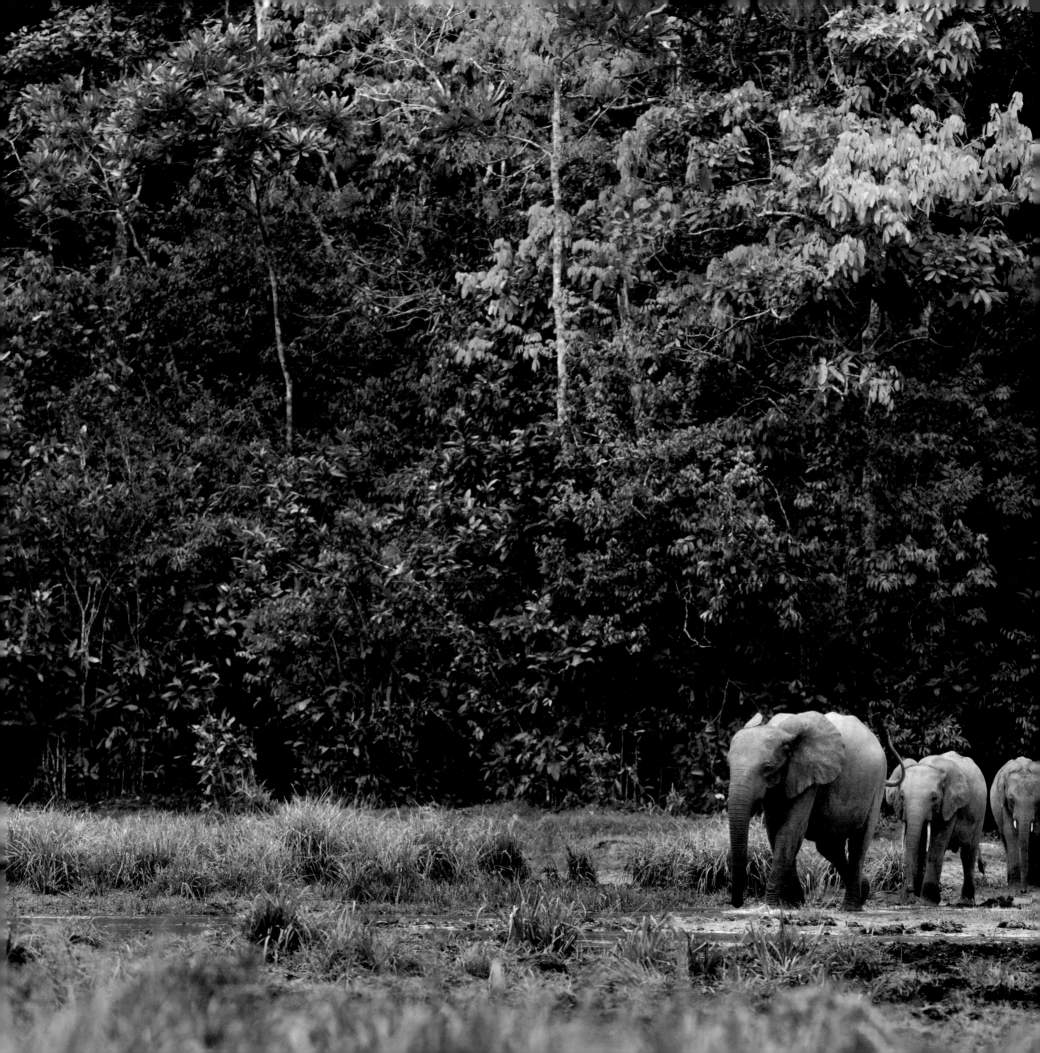

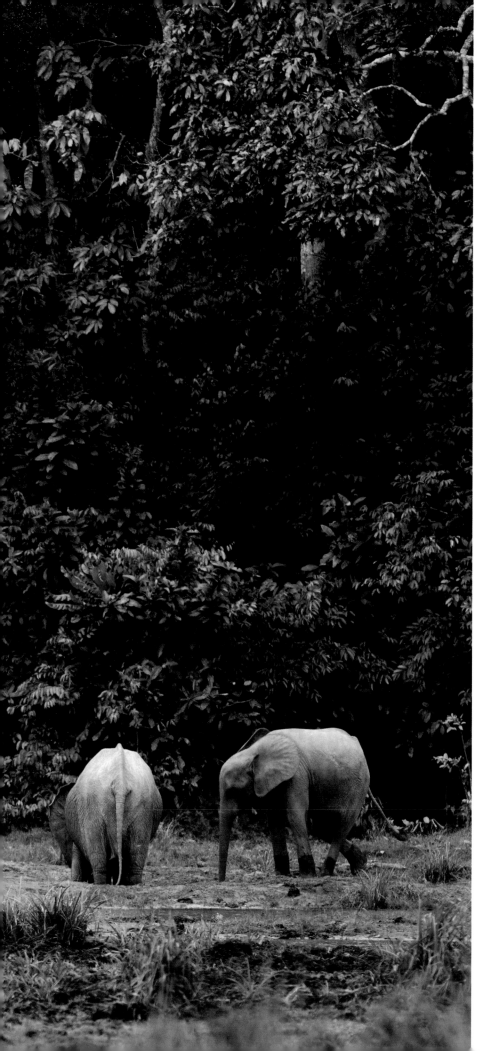

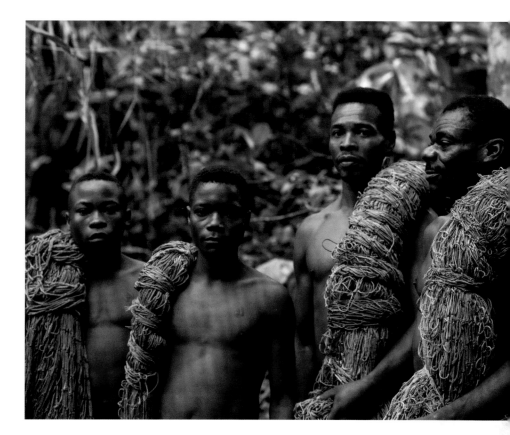

in fact Africa's green and throbbing heart. Nor is it just plants and animals that this wilderness supports: humans have lived under its green canopy for over 50,000 years. The indigenous people of the Congo forests are perhaps the most celebrated of the world's forest inhabitants. Collectively known as the 'Pygmies', the tallest among them rarely exceeds 1.5 m (*c.* 5 ft). Despite their small stature, they fearlessly climb the dizzying heights of forest trees to steal honey, armed with little more than a smoking branch.

Land of Giants

The long relationship these forests have with people has afforded its other inhabitants plenty of time to learn that humans are a highly efficient predator and to be avoided. Compared with the other great rainforests of the

Above: Ba'Kola Pygmies in Odzala-Kokoua National Park, Republic of Congo. They carry traditional nets, used to hunt duiker and other antelope of the forest.
Left: Forest elephants keep openings in the vegetation clear and revel in the muddy pools that they create.

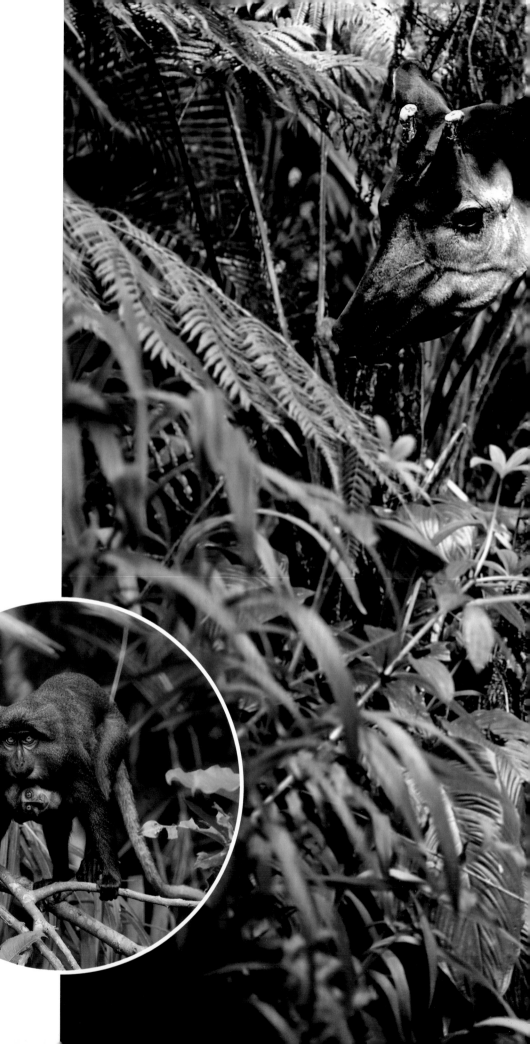

world, those of Central Africa have maintained most of their megafauna. This has resulted in a noticeably different forest structure, engineered by the large mammals that still call the rainforest home. Most notable for this 'ecosystem engineering' are the forest elephants. They keep the understorey clear by pushing over smaller trees to feed from the lush growth at the top of the branches – leaving a forest of huge, towering trees with a very sparse understorey. Elephants are not the only large mammals, however. Troops of gorillas, the largest of the primates, knuckle their way through the understorey during the day and climb the trees to make their night-time nests.

Only a rumour to Europeans until 1901, shy okapi, known as the 'forest giraffe', are reminiscent of zebra. Their dark, reddish-black coat is broken by white stripes across their legs and rump. These magnificent creatures are highly secretive, hiding deep within the forests. To see one in the wild is a very special sighting indeed – ,and will most likely be a fleeting glimpse of its rump vanishing into the forest depths. Other creatures have emerged even more recently. Until 1984, modern science was not even aware of the sun-tailed guenon, a monkey with a bright orange tip on its tail. Such discoveries demonstrate just how much the rainforest still has to show us.

Of course, it is not just large mammals that call this forest home. Huge colourful butterflies flit through the canopy in striking ultramarine, metallic greens and deep yellows. Search around rapids and waterfalls and you might find giant goliath frogs, weighing over 3 kg (6 lb 9 oz), gorging on the vegetation. Even our closest living relatives, the chimpanzees and the diminutive bonobos that each share 98 per cent of our genes, call this wild forest home.

Right: *An okapi in the forest.*
Inset: *A sun-tailed guenon mother with baby, Franceville, Gabon.*

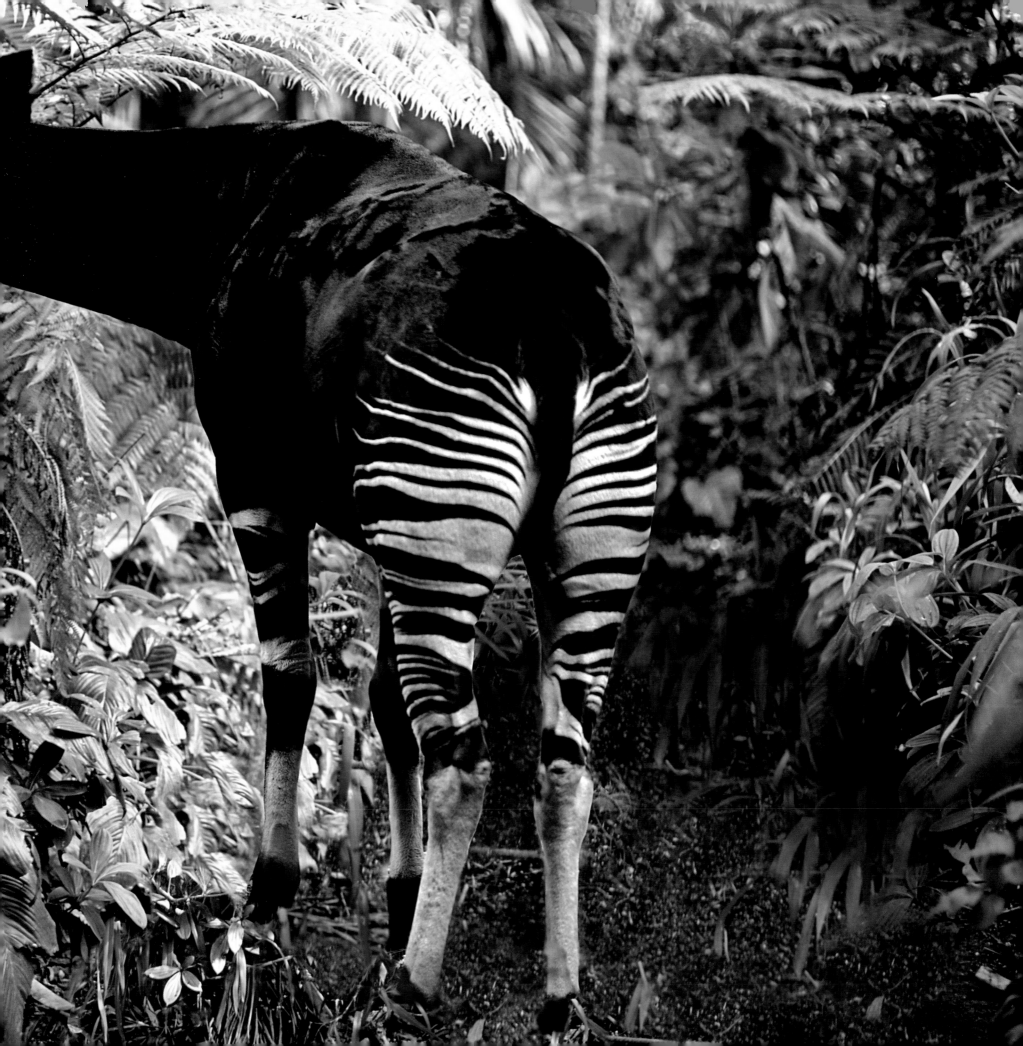

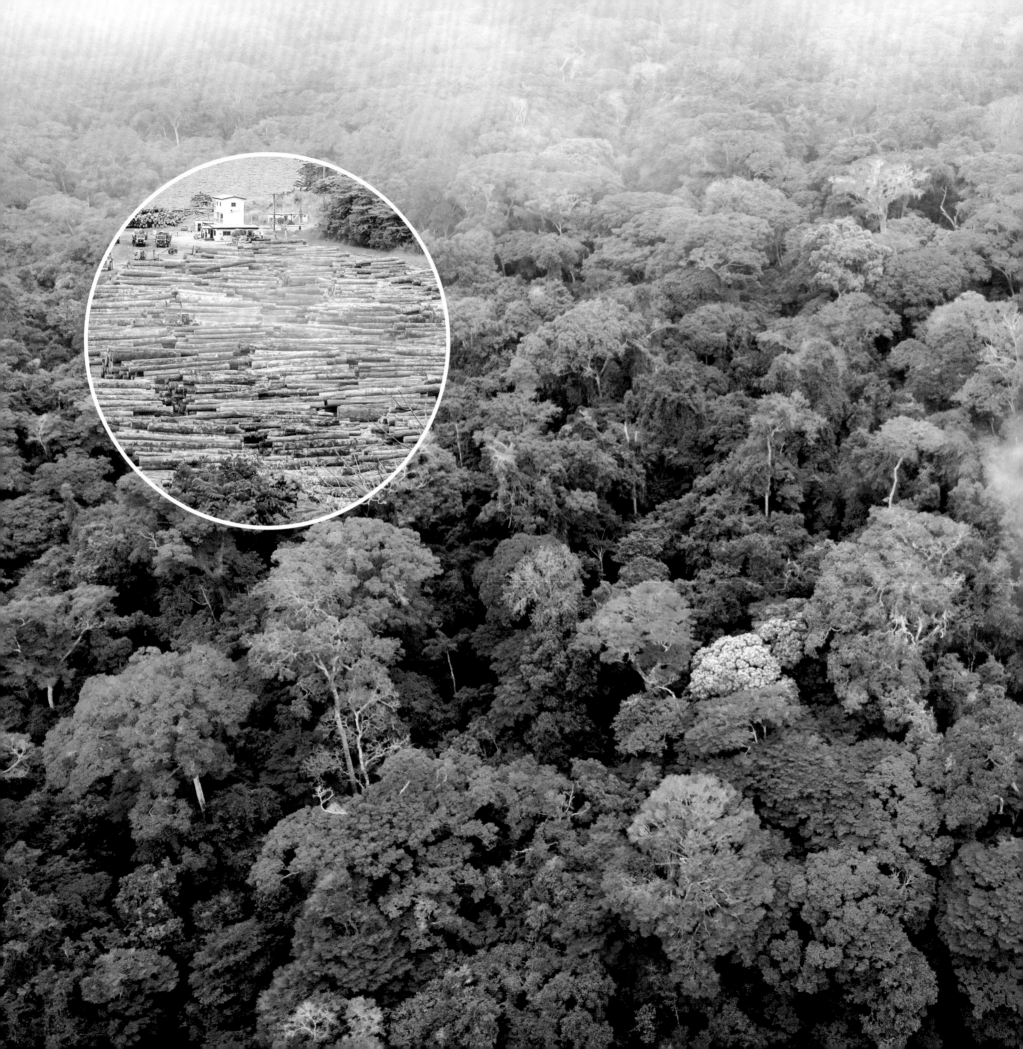

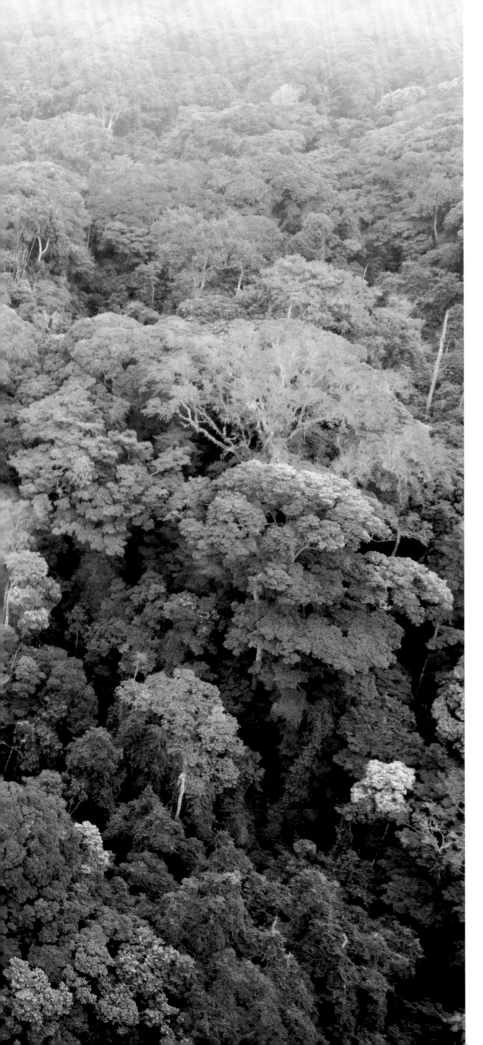

Fantastic Flora

The plant life of this rainforest is quite spectacular and extraordinary. The normally open understorey of a rainforest is exaggerated by the engineering of the large mammals. In reducing the low vegetation even further, they leave more of the soil's energy to be absorbed by trees. This results in vast, towering giants, far bigger than the trees found in the tropical rainforests on other continents. One of the best-known is the okoumé tree, which grows up to 60 m (197 ft) in height. An economically valuable species, it provides an aromatic and flammable resin used both to light homes and to scent water. In fact, the okoumé is such an important export crop for Gabon that it appears on the country's coat of arms.

But it is not just the visual majesty of these giant trees that makes this forest so spectacular. A walk through this vast wilderness will enchant every one of your senses. First, allow the fresh aroma of wild ginger to tickle your sense of smell. Then, if you are careful and know where to look, you can savour the berries of the serendipity plant, containing compounds 3,000 times sweeter than sugar. Be careful what you touch, however: the leaves of the Gasso nut can irritate your skin, causing stinging and itching. Throughout your search you will be serenaded by the calls of countless tropical birds and the hooting, chirping and howling of distant primates.

A River Runs Through It

While the rainforests of the Congo are impressive, we must also acknowledge the mighty Congo river. This enormous waterway snakes its way across the continent for 4,700 km (2,920 miles), crossing the equator not once but twice. In fact, it discharges a volume of water second only to the mighty Amazon.

Left: *Aerial view of the rainforest at Ivindo, Gabon.*
Inset: *Felled okoumé trees at the timber port of Owendo, Gabon.*

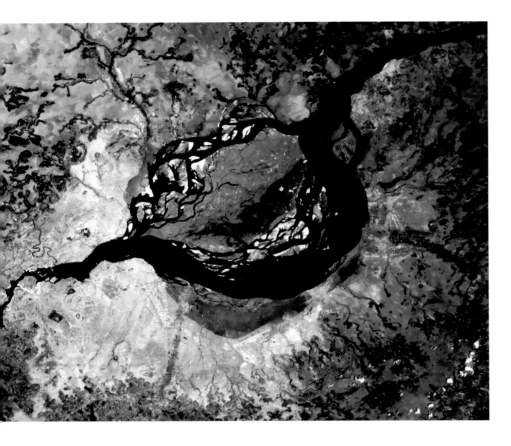

Winding its way sinuously through the green tapestry, the Congo river's muddy brown waters boast an impressive diversity of life, just like the crowded forests that surround it. From the shallows of the smallest tributaries to its deepest, darkest channels, the river is infused with a dizzying array of fish. Almost 700 species are known to exist within its waters, of which 548 are found nowhere else on Earth. Nor is it just fish that make up the denizens of this aquatic highway. Crocodiles lurk in its depths, as do semi-aquatic tortoises, several species of water snake, hippopotamuses, otters and, most notably, the West African manatee. The nocturnal manatee, or sea cow, is a very rare sight. Despite its slow, lolling nature and large stature, the manatee is responsible for numerous legends. The best-known of these is Mami Wata, a goddess of the sea and a symbol of wealth and beauty – not dissimilar to the Western legends of mermaids.

Above: The Congo River, viewed from the International Space Station.
Right: A village on the banks of the Congo river, Democratic Republic of Congo.

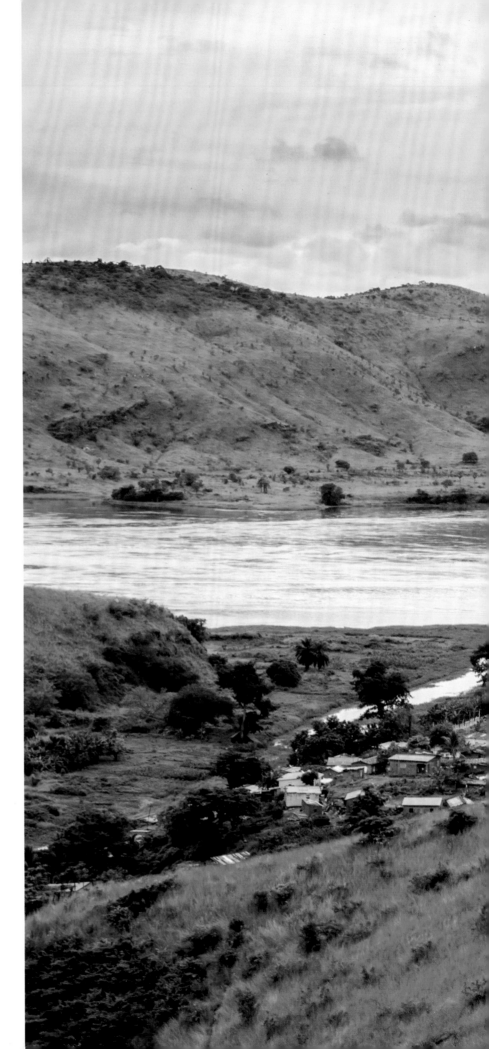

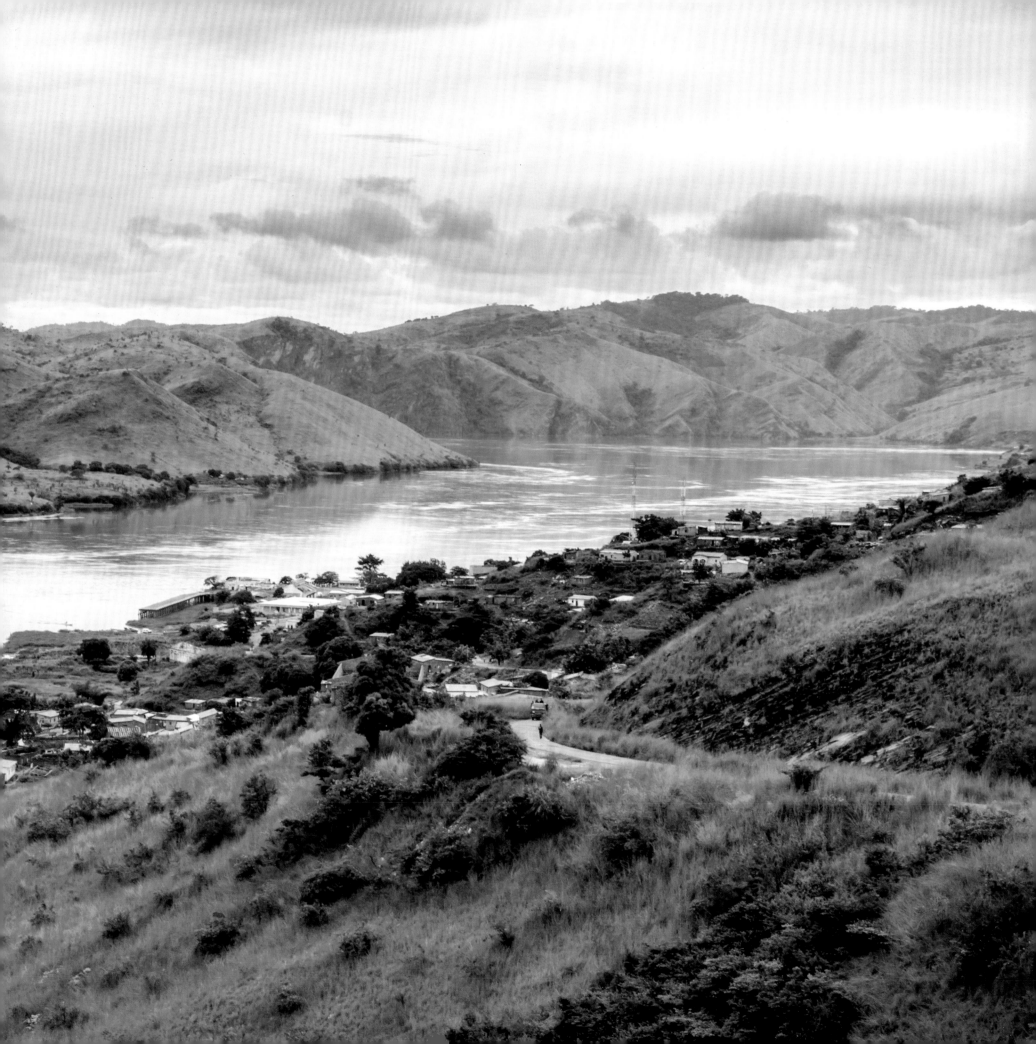

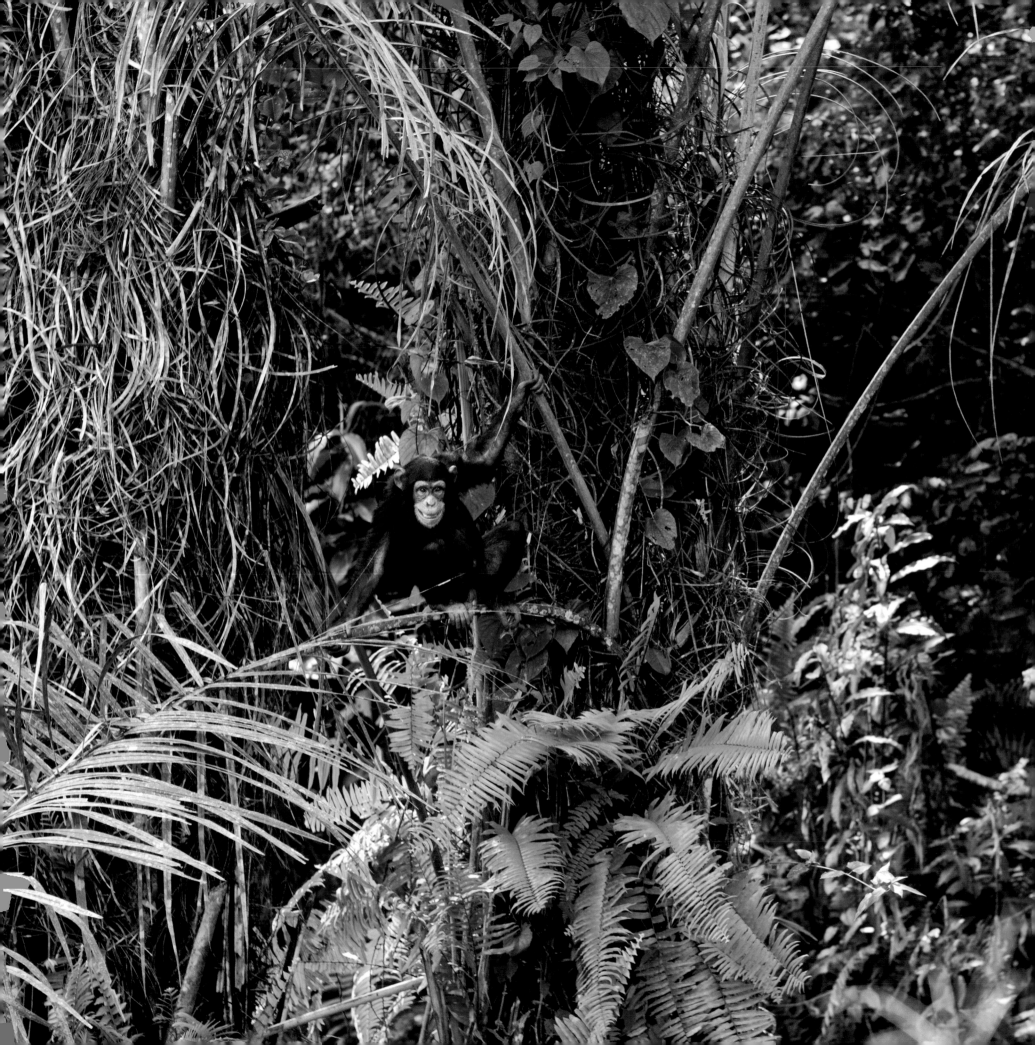

West Africa

The **rainforests** of West Africa have a much greater human presence, providing an accessible treasure trove of spectacular biodiversity. Also known as the Guinean Forests of West Africa, they once stretched for 1,500 km (932 miles) along the African coastline, from Guinea to Cameroon, and for hundreds of kilometres inland. Unfortunately, these may now be the most threatened rainforests on Earth. Efforts to help both the forests and the people who rely on its rich resources may still ensure their survival.

Forest Giants

Walking through the West African rainforests, the sound of monkeys chirping in the distance, it is the sheer bulk of the trees that overwhelms. It is not uncommon for these trees to measure up to 30 m (98 ft) in circumference; it would take 18 people holding hands to circle them. This great size is believed to be due, in part, to the low species diversity in these forests – although 'low' is relative, as they still support over 9,000 plant species found nowhere else on Earth. The lower tree diversity, when compared to other rainforests, results in reduced competition between the dominant trees. It appears to allow them to grow to considerably larger sizes, on average one-and-a-half times bigger. Such a massively increased bulk leads to far better carbon storage; an African rainforest stores around 25 per cent more carbon per hectare than its Amazonian equivalent.

As well as being giants, each and every tree species is unique. Distinguishing one from another can be a daunting task: with the leaves of the trees far up in the canopy, it is only the bark that can be seen, and

Left: 'Here's looking at you, kid!' A Western chimpanzee in Bossou Forest, Guinea. Along with bonobos, chimpanzees are our closest living relatives.

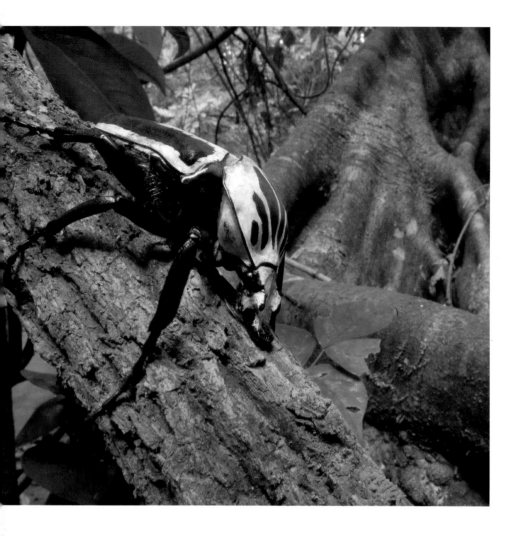

this is often indistinguishable from tree to tree. However, foresters have developed many techniques to tell them apart. Cut the bark on many of these trees and, as elsewhere in the world, they will ooze sap. But in these forests this sap may flow red, white or even blue. If this does not work, the bark may be strongly scented; many trees have their own unique perfume. Failing this, it may not even be the tree itself that is used to tell it apart. The 'elephant comb' tree, for example, is often identified by the muddy smears and scratches found 2 to 3 m (6½ to 10 ft) from the ground – clear evidence that elephants have been using the tree's rough, hard bark for a good back scratch.

Above: Beetles, such as this goliath beetle in Guinea, are the most diverse type of organism living in a tropical rainforest. Several million species are likely to inhabit the world's rainforests.
Right: A kapok tree, the largest tree species in Guinea-Bissau, in Cantanhez Forests National Park.

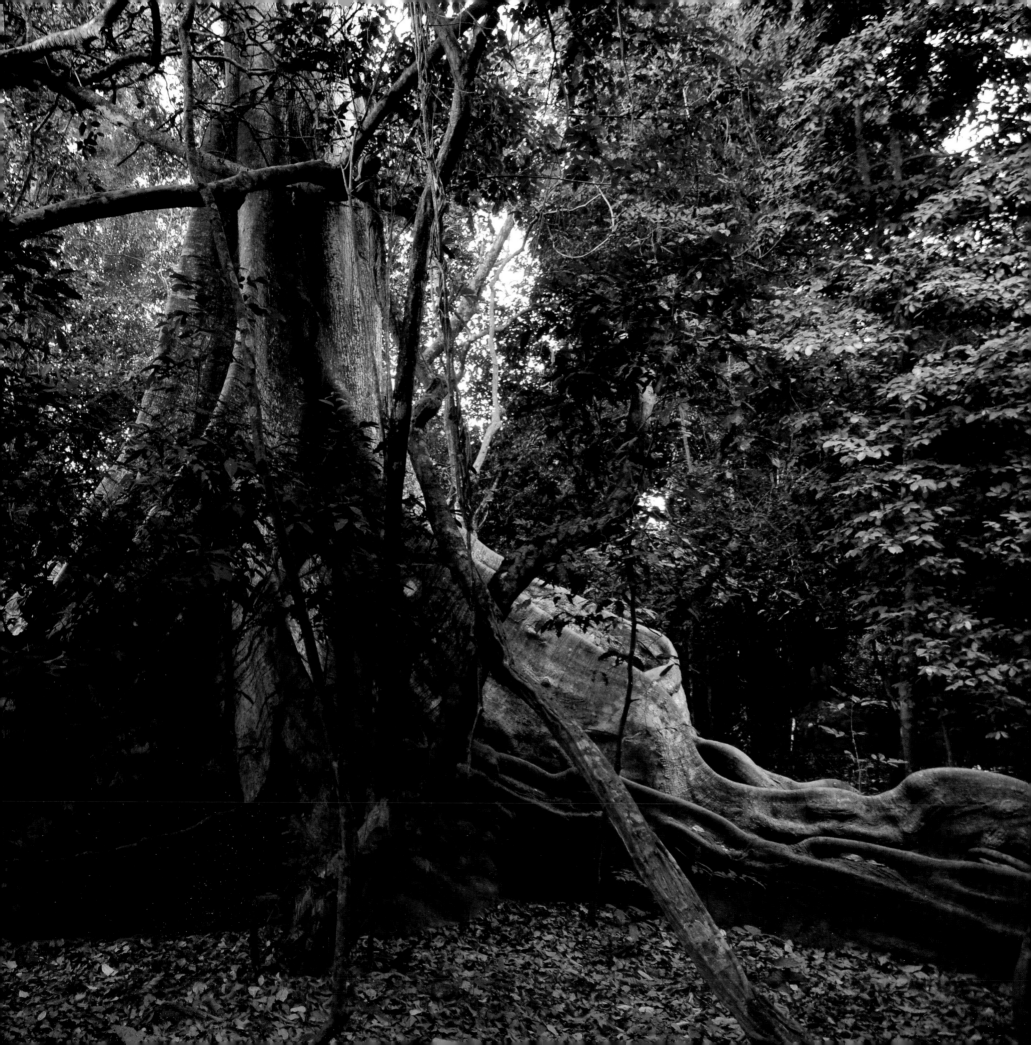

While the trees may make up a forest, it is often the vivid colours of the flowers that bring the fantasy image of a rainforest to life. However, the orchids of the Guinean rainforest understorey tend to be more muted greens and yellows. In these forests it is the trees that give the forests colour, sporadically and inexplicably 'flushing' with rosettes of thousands of brilliant red or ghostly white young leaves. Exactly what drives the trees to do this is still something of a scientific mystery.

A Forest Home

The African savanna is famous around the world for its mammal life. However, the rainforests of West Africa are in fact the quiet champions in this regard, home to around one-quarter of all the mammal species on the continent. Sit quietly in these forests, especially during the golden light of a new dawn or after a late-afternoon tropical storm, and you will hear a myriad of chirps, hoots, howls and barks. These are all coming from an astounding diversity of primates – so many, in fact, that the Guinean forests are considered one of the top global priorities for primate conservation, due both to the level of primate diversity and endemism.

If you could climb high into the canopy, where much of the rainforests's life thrives, you would see all sorts of interactions between these monkeys: fighting, co-operation, tolerance, affection and more. It is these complex interactions and the high primate diversity that is such a draw for behavioural scientists – and also for leopards! The faeces of these sleek cats have been found to contain the hairs of red colobus monkeys, which occupy the very highest reaches of the forest canopy. It thus appears that leopards must climb up to the topmost branches in search of prey.

Right: The diminutive yellow-backed duiker is widespread throughout West Africa's rainforests. The most heavily hunted species of the forests, they provide a vital source of protein and income for local people.

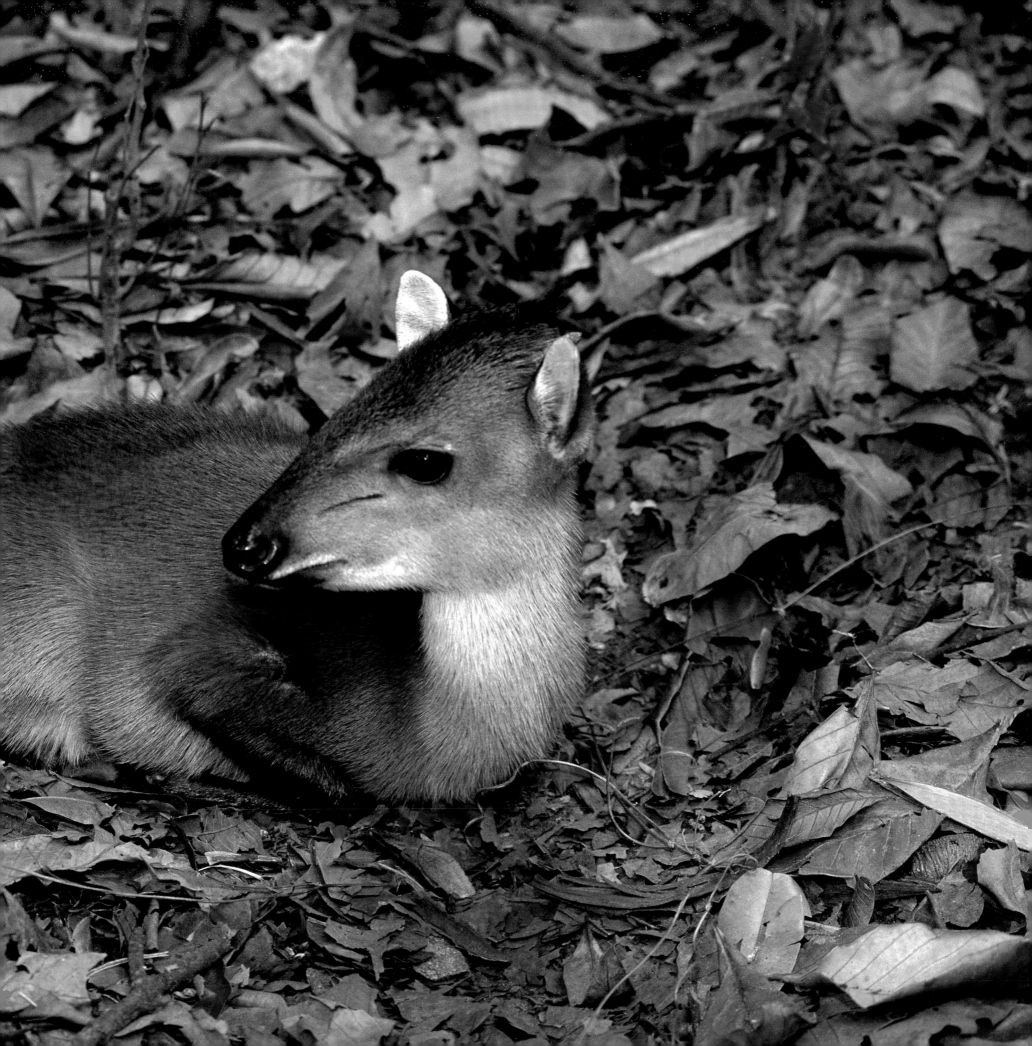

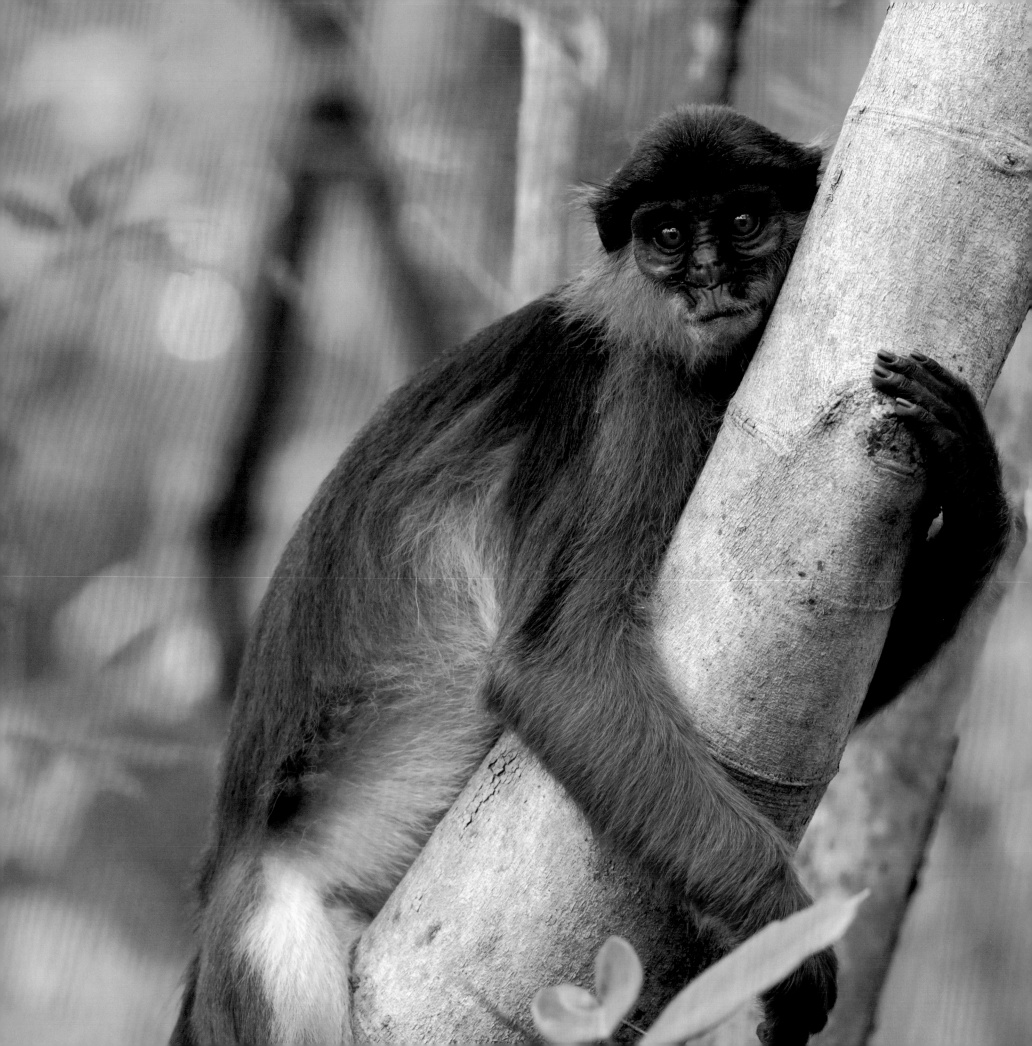

Of course, it is not only wildlife that calls the forest home. Many indigenous human occupants have considered these forests to be their native land for millennia, and have survived by hunting and gathering all they need from the forest. Rainforests are rich providers, if you know what to look for. Such knowledge is passed on by word of mouth through the generations of people who live there: which plants are safe to eat, which ones provide effective medicine, how to make tools with which to hunt and build. Until recently, even textiles were made from the rainforest's plants, the bark from particular trees gathered and processed to produce a soft material known as 'bark cloth'. Unfortunately, increasing extractive use of the forest is pushing out these native people; both their homes and their ancient knowledge of the rainforest are irrevocably lost.

Precious Fragments

Today, these forests are barely a shadow of what they once were, with less than 10 per cent of the old-growth forest still in existence. Unfortunately, this region is also the world's largest exporter of cocoa, the raw ingredient of chocolate. Alongside other valuable commodities, such as palm oil and diamonds, the cultivation of this non-native crop has led to the extensive felling of the forests.

The clearance of such huge swathes of forest makes the region's remaining rainforests immensely precious. In an effort to preserve what is left, the areas have been designated as one of the world's 36 'Biodiversity Hotspots'. These hotspots represent areas of the world that conservation biologists have calculated contain the most unique, as well as most threatened, species across the smallest areas of land. Targeting conservation efforts on these hotspots is considered of vital importance. Recognizing the vast biological wealth these forests hold, as well as

Left: A Western red colobus female in tree, Bijilo Forest Park, Gambia.

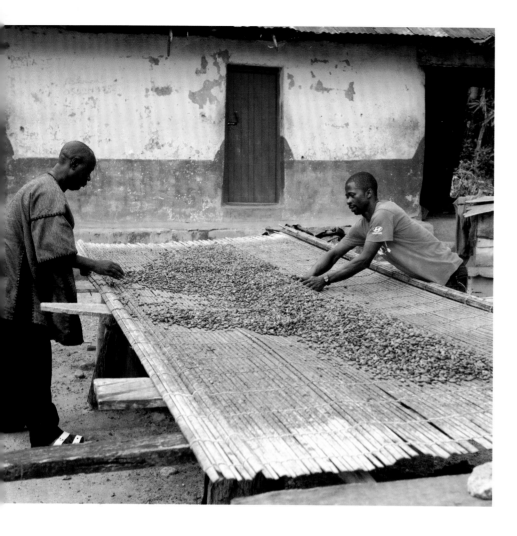

theirrpotential for carbon storage, should provide incentive for sustained pressure to preserve what is left.

Of course, it is important to appreciate that these forests do not only support wildlife; as well as their ecological importance, there is a large human population. These rainforest people live mostly in poverty; they are currently reliant on the forest resources for food, building materials and any chance of economic empowerment. Any conservation efforts must work to help the people reliant on the forest, as well as the sustained survival of the forests themselves.

Above: Two cocoa farmers lay out their cocoa beans on bamboo matting to dry in the sun, Ghana.
Right: Among the most endangered of Africa's mammals, the drill population has been steadily declining. As few as 3,000 are believed to exist today, due to illegal hunting and deforestation.

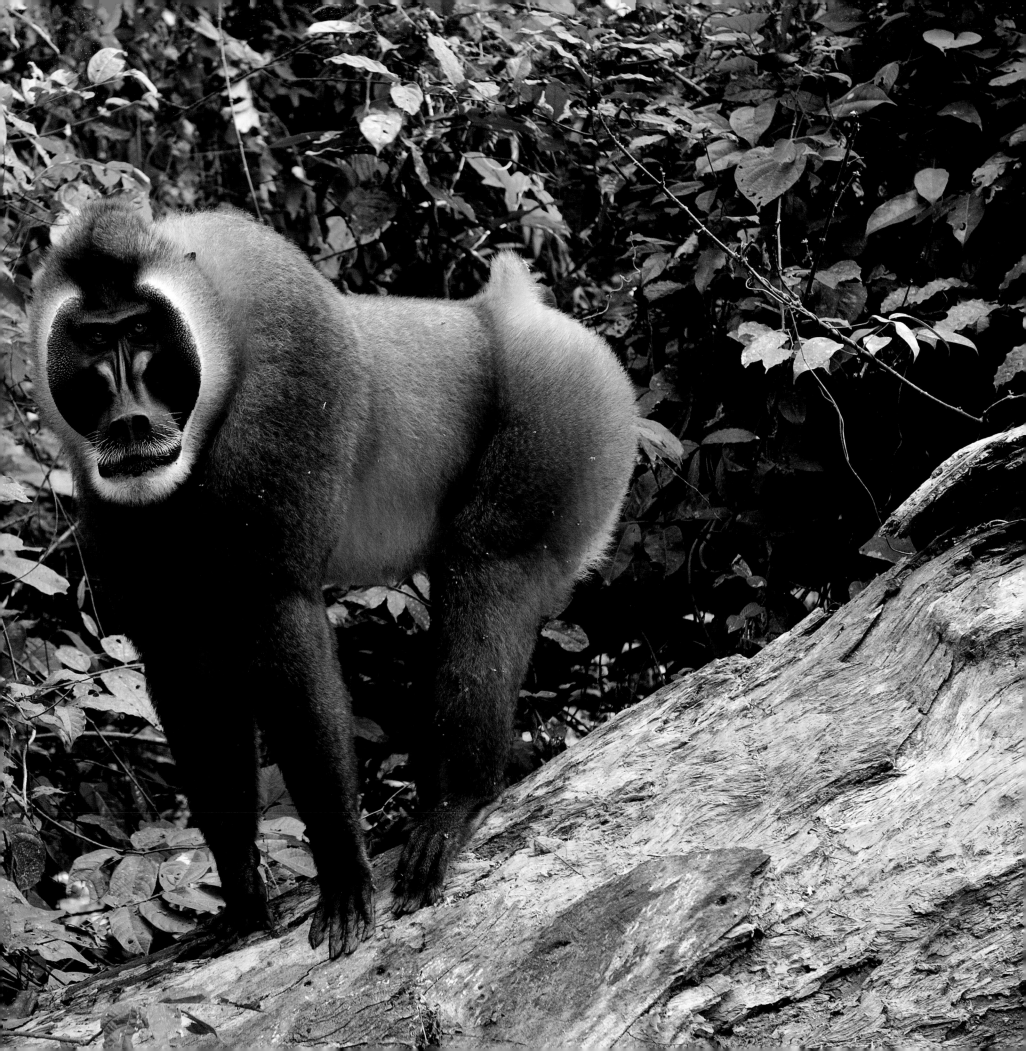

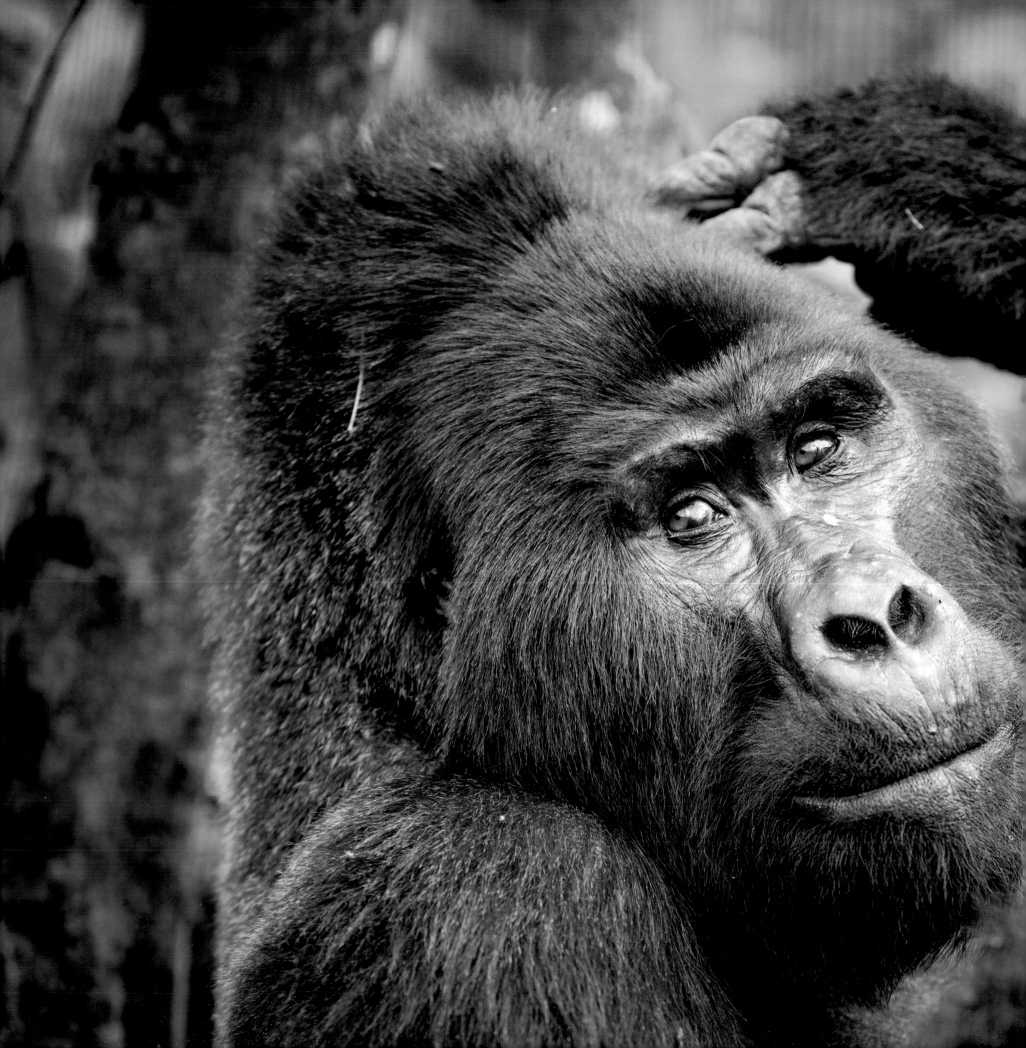

East Africa

From the mountain gorillas, inhabiting the aptly named Bwindi Impenetrable National Park, to the magical sifaka, dancing through the canopy of the Madagascan rainforests, East Africa is a biological wonderland. Despite the increasing pressure from human exploitation and forest clearance for crops such as sugar, teak and tobacco, huge efforts have been made to preserve these biological jewels for future generations to use and admire.

Up in the Montane

Much of the rainforests of East Africa are to be found high up: here it remains warm, but there is enough rain to support the montane rainforest vegetation. Running from the Taita Hills in southern Kenya down to the mystical-sounding Udzungwa Mountains in south-central Tanzania is a swathe of peaks, known collectively as the Eastern Arc Mountains. This is a misty, mountainous, rainforest wonderland. You have to be prepared for a hot, muddy and steep trek if you wish to venture into these thick, dark rainforests.

Spreading across 13 separate mountain blocks, these Eastern Arc Forests were once connected to the Congo. As the prehistoric climate changed, they became isolated in the high mountain ridges, separated from one another by dry, lowland woodland and open savanna. The isolation has led to unique evolutionary trajectories and has resulted in this forested montane region becoming another biodiversity hotspot: it is one of the most biologically diverse places on Earth. So far 10 mammals, 19 birds, 29 reptiles and 38 amphibian species have been discovered that can only

Left: The thick forests of Bwindi Impenetrable National Park, Uganda, are one of the last refuges of the critically endangered mountain gorilla. Fewer than a thousand still survive in the wild.

be found in these rainforests; some are isolated to just a single peak. As recently as 2014, 27 species new to science were reported in the region.

Further north from the Eastern Arc in the Ethiopian highland rainforests, where one of the world's favourite drinks, coffee, was first discovered, the rainforests have a predatorial surprise. Well known across the savannah and lowland woodland areas of southern and eastern Africa, lions are not normally considered residents of the rainforest, despite their somewhat inappropriate moniker of 'king of the jungle'. However, a small number do exist in these forests. They remained unknown to science until their very recent 'discovery', prompted by knowledgeable locals who perform coffee ceremonies and talk of their spiritual connection to these forest lions.

Right: *View over Bwindi Impenetrable Forest National Park, at the borders of Uganda, Congo and Rwanda.*
Below: *The Harenna Escarpment in Ethiopia's Bale Mountains National Park overlooks one of the country's largest remaining forests. It is one of the few places where wild coffee is still harvested.*

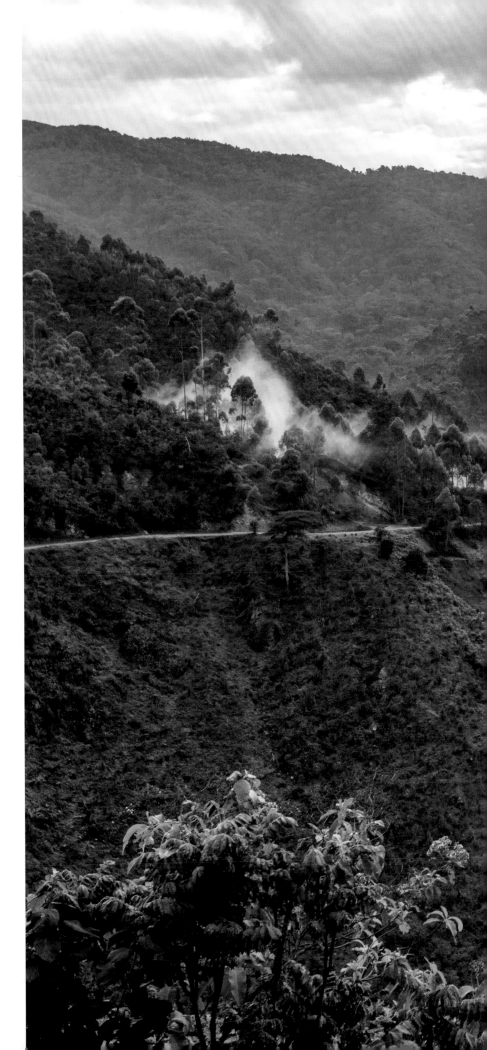

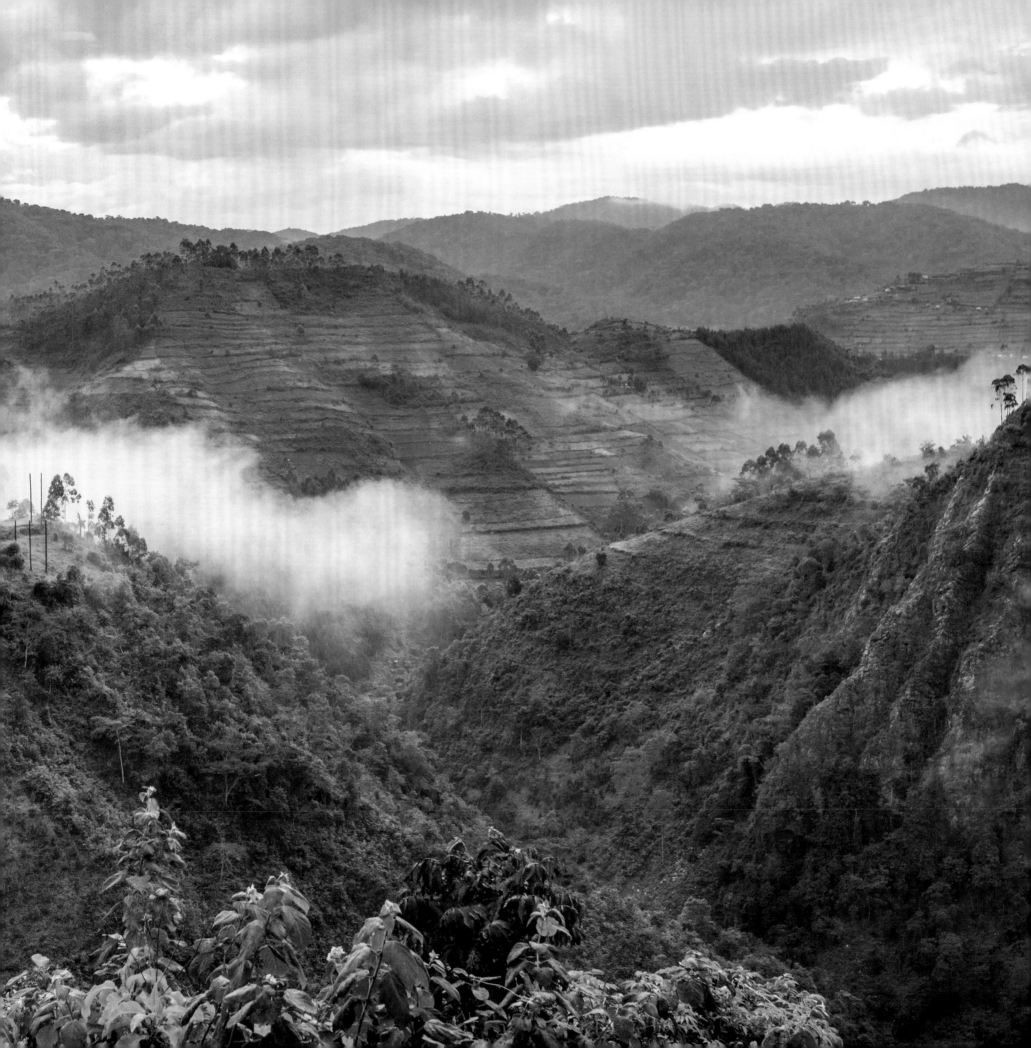

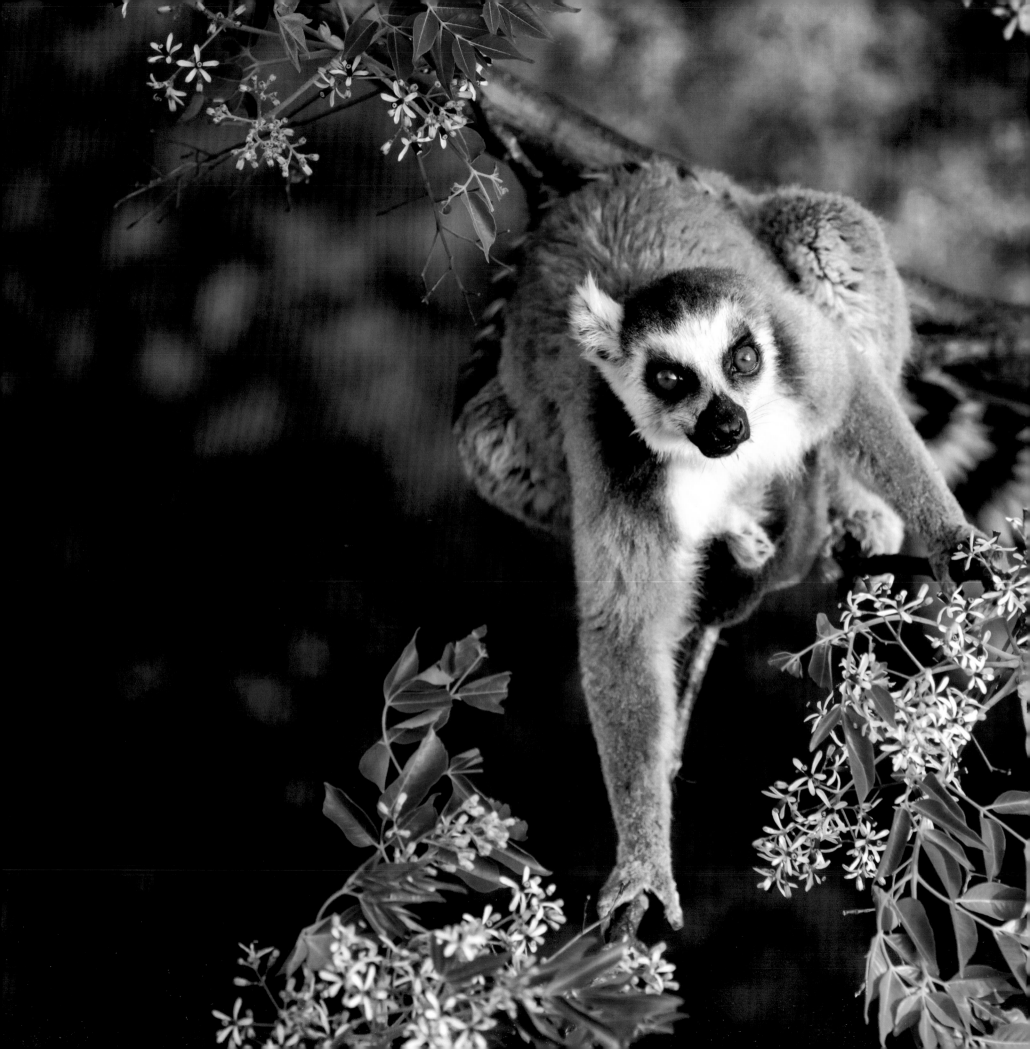

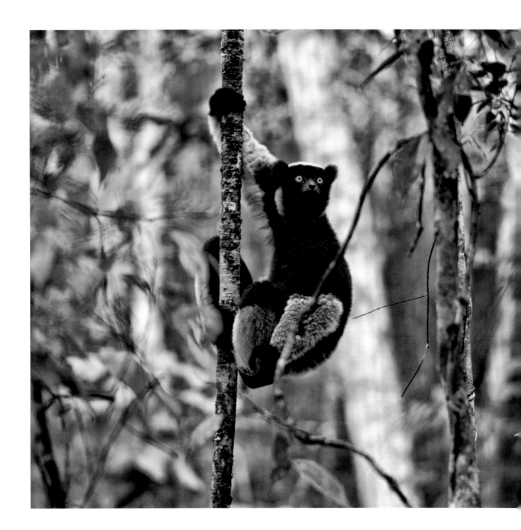

Land of the Lemurs

Travel to the coast of Mozambique, the edge of mainland Africa,
then sail a further 500 km (310 miles) towards the rising sun and you
will encounter an almost mythical island, Madagascar. Examining the
rainforests of Madagascar feels like looking at a slightly distorted version
of the rainforests on the rest of the African continent. It is similar, but
also incredibly different: isolated from the rest of Africa for long enough
to have evolved strange and distinct fauna and flora, but recently enough
for there to be obvious similarities. The creatures that fill the trees look

Left: The endangered ring-tailed lemur is probably the most recognizable of Madagascar's lemurs – a group of
primates that exists nowhere else on Earth.
Above: Indri, the largest species of lemur, Mitsinjo Reserve, Madagascar.

almost like the primates of the mainland, but they are too different to be considered monkeys, more like a cross between a monkey and a teddy bear. These are the lemurs, existing in a multitude of colours, shapes and sizes. They range from the tiny mouse lemurs which, with a body length of less than 7 cm (2¾ in), are the smallest primates in the world to the largest lemur species, the indri or babakoto, which measure around 70 cm (27½ in); from the shy, nocturnal aye-aye, with its long, almost alien finger used to pick insect grubs out of deep tree crevices, to the gregarious, black and white sifaka that dances sideways through the canopy.

The Little Things that Crawl and Fly

From the steep slopes of the Madagascan highlands to the thick canopy of the Udzungwa Mountains, the unique diversity of the East African rainforests is nothing less than astonishing. However, with such a plethora of incredible wildlife it is all too easy to overlook the diminutive creatures of the forests. They may be small, but they are equally fascinating. In the Udzungwa Mountains of Tanzania, look out for the pocket-sized elephant shrew. This insect-eating mammal may be small, but it can jump almost 1 m (3 ft 3 in), even though an adult will measure no more than 30 cm (12 in), including its tail.

In Madagascar, you might also be lucky enough to find the world's smallest chameleon, at 29 mm (1⅛ in) in length, and if you look very, very carefully you may be able to spot one of the smallest frogs in the world. Only discovered in 2019, three related species measure between just 8 and 15 mm (0.3 and 0.6 in) in length and have been given the amusingly appropriate scientific names of *Mini mum*, *Mini scule* and *Mini ature*.

Right: A Parson's chameleon in the rainforests of Andasibe, Madagascar. The island is home to around half of the world's 150 chameleon species.

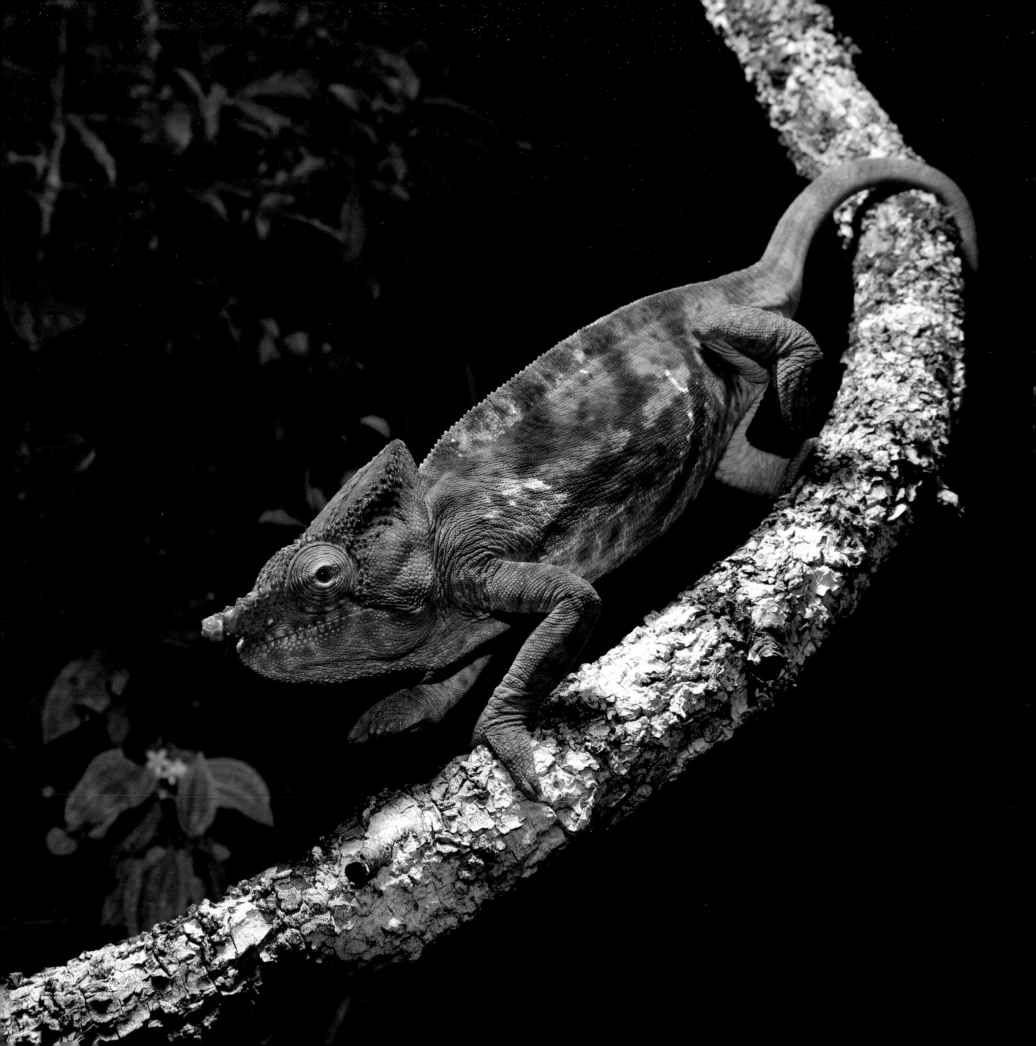

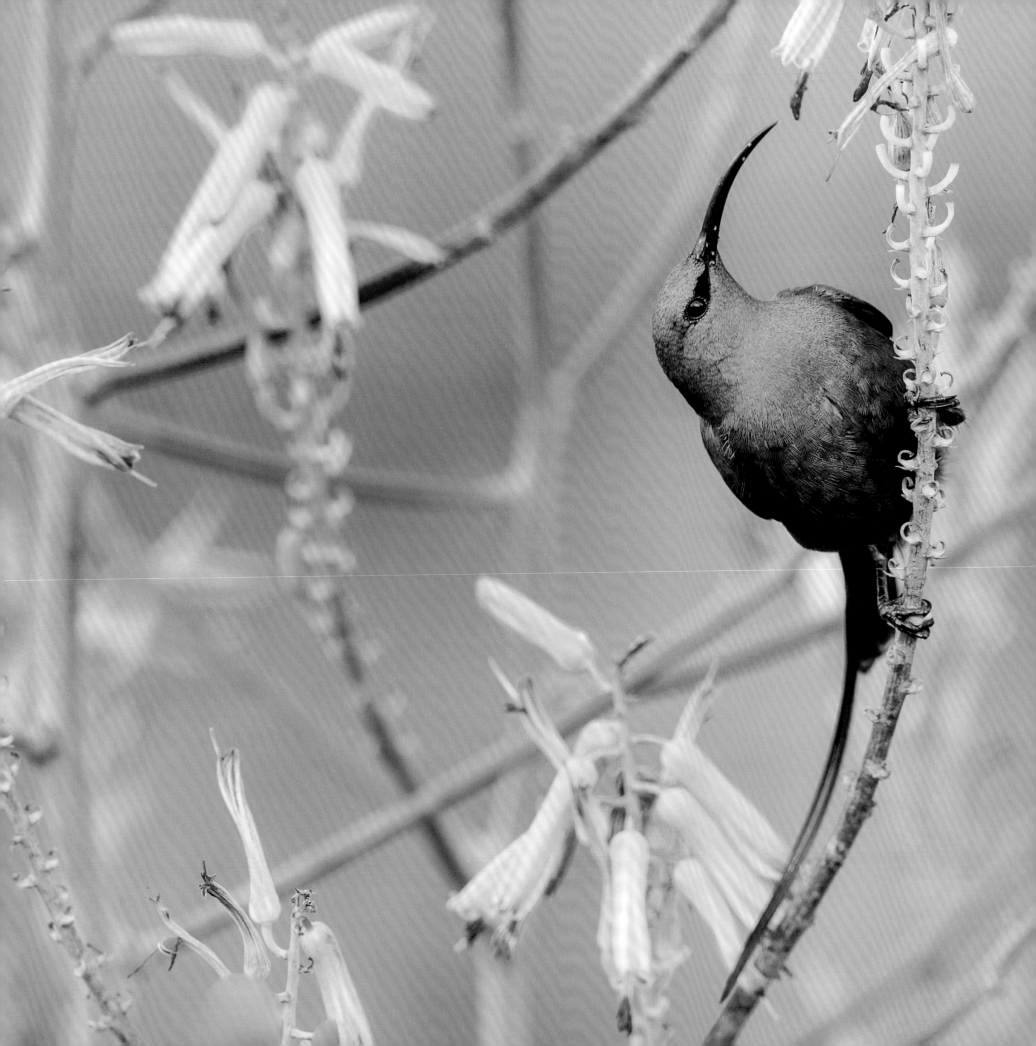

When it comes to birds, the East African rainforest really shines. If you can make your way into the Kakamega Forest you will be overwhelmed with resplendent birdlife: African grey parrots, bee-eaters, honeyguides, weavers making their intricate grass nests, sunbirds, trogons, white-eyes, cuckoo-shrikes, the distinctive 'kewee-kewee-kewee' of Africa's most powerful bird of prey, the crowned eagle, as well as chats, thrushes, flufftails and so many more. It is truly a birder's paradise, with 410 bird species in just this one park. Of course, this is before you have even tried to identify the 120 species of tree, 60 different orchids and an incredible 487 butterfly species. The East African rainforests may well be threatened by human encroachment, but they are still truly magical worlds, full of living biological jewels.

Left: *A malachite sunbird feeding on aloe flower, Serengeti National Park, Tanzania.*
Below: *Krefft's warty frog, Udzungwa Mountains National Park, Tanzania.*

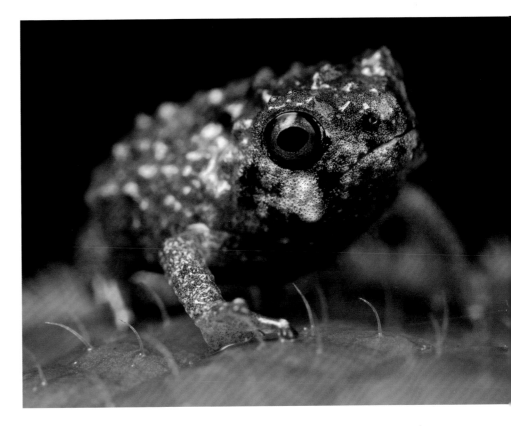

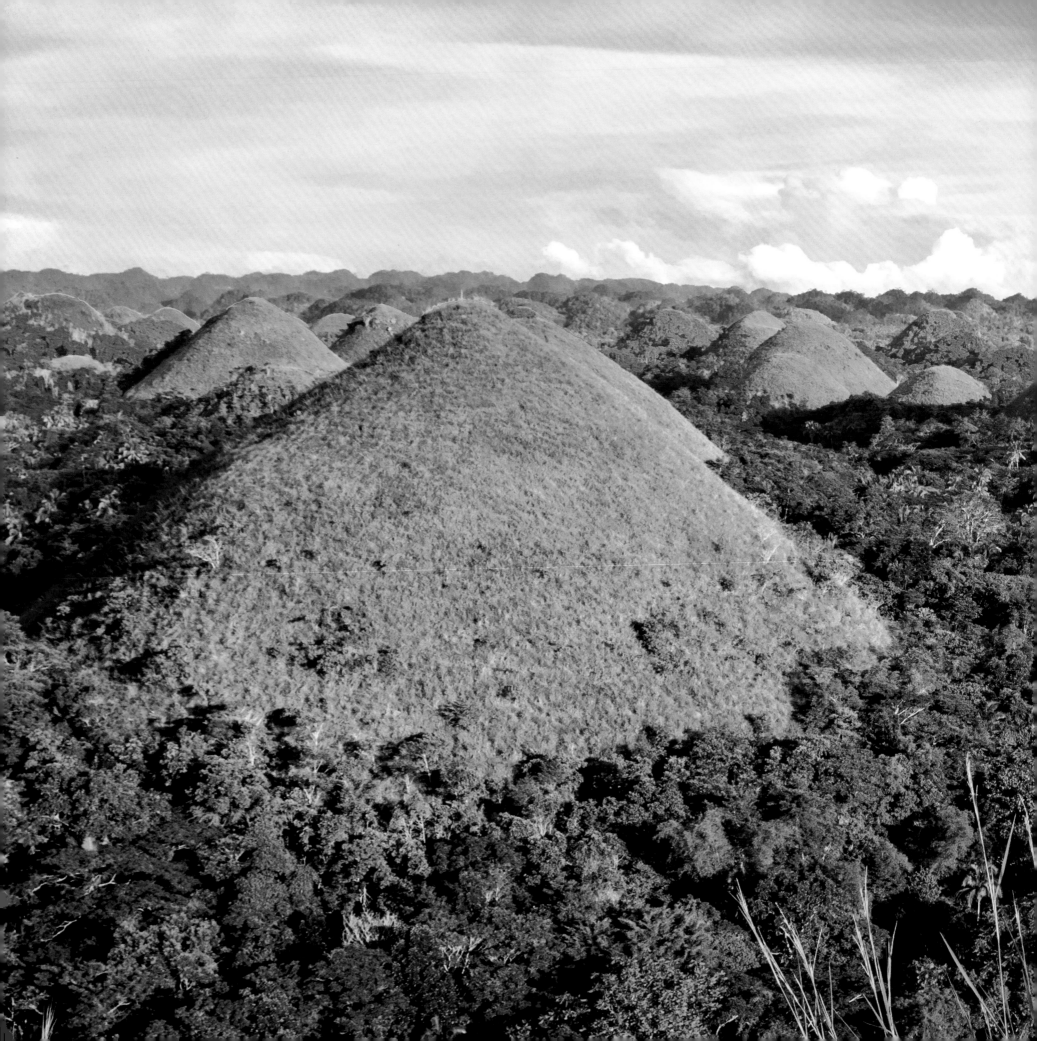

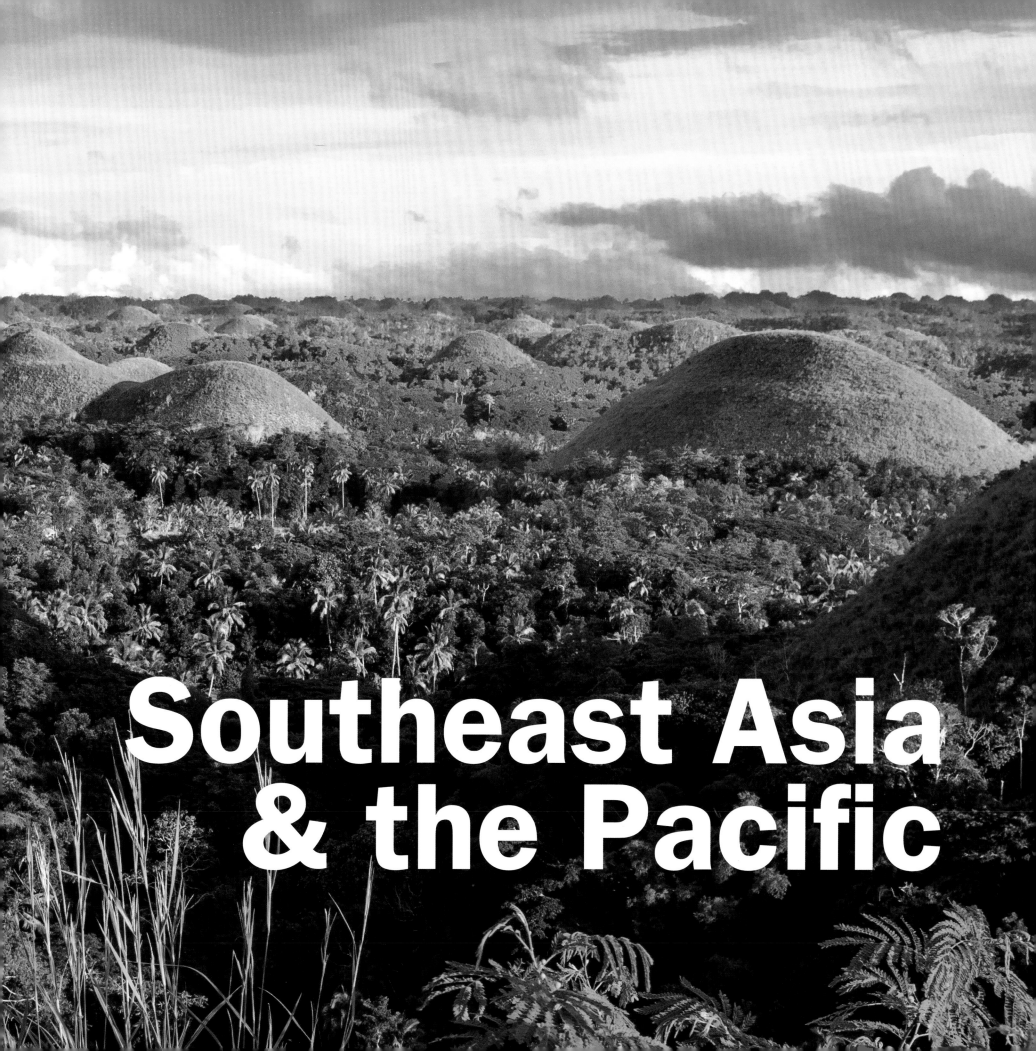

Southeast Asia
& the Pacific

Mainland Southeast Asia

Visiting the rainforests of Southeast Asia means clambering through the remains of ancient cities and roaming forests populated by tigers, elephants and wolves; the hot, sticky air carries the scent of jasmine. These forests underpin the myths and legends of many of the world's most advanced civilizations and are also home to the world's most widely consumed drink, tea. Southeast Asia's ancient rainforests are fascinating remnants of undisturbed nature in a sea of humanity.

Building Empires

The oldest rainforests on Earth are to be found in Southeast Asia, on the islands of the Pacific and in Australasia. The combination of a generally warm climate with a location close to the equator and proximity to the sea help to stabilize the local climate. These ancient forests may have been around for over 100 million years, and more people depend on them than anywhere else in the world.

The ancient ruins of long-vanished civilizations are hard to miss in the forests. Temples of crumbling stone with statues of the Buddha are wrapped in the tight embrace of ancient strangler figs. While scholars still debate why these temples were abandoned, they are certainly evidence of an ancient empire, the Khmer (*c.* 802–1431 AD). This empire once

Previous page: The green, grassy stumps of the Chocolate Hills rise up out of rainforests in the Philippines. In the dry season they turn brown, hence their name.
Right: Strangler figs of the Cambodian forests slowly entwine themselves over and around Siem Reap, the ancient capital of the Khmer, gradually reclaiming the land on which it was built.

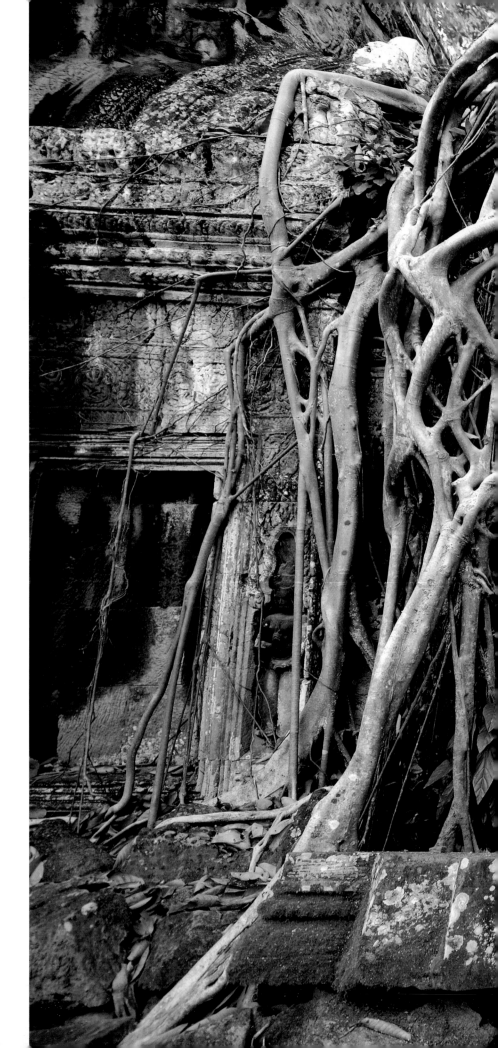

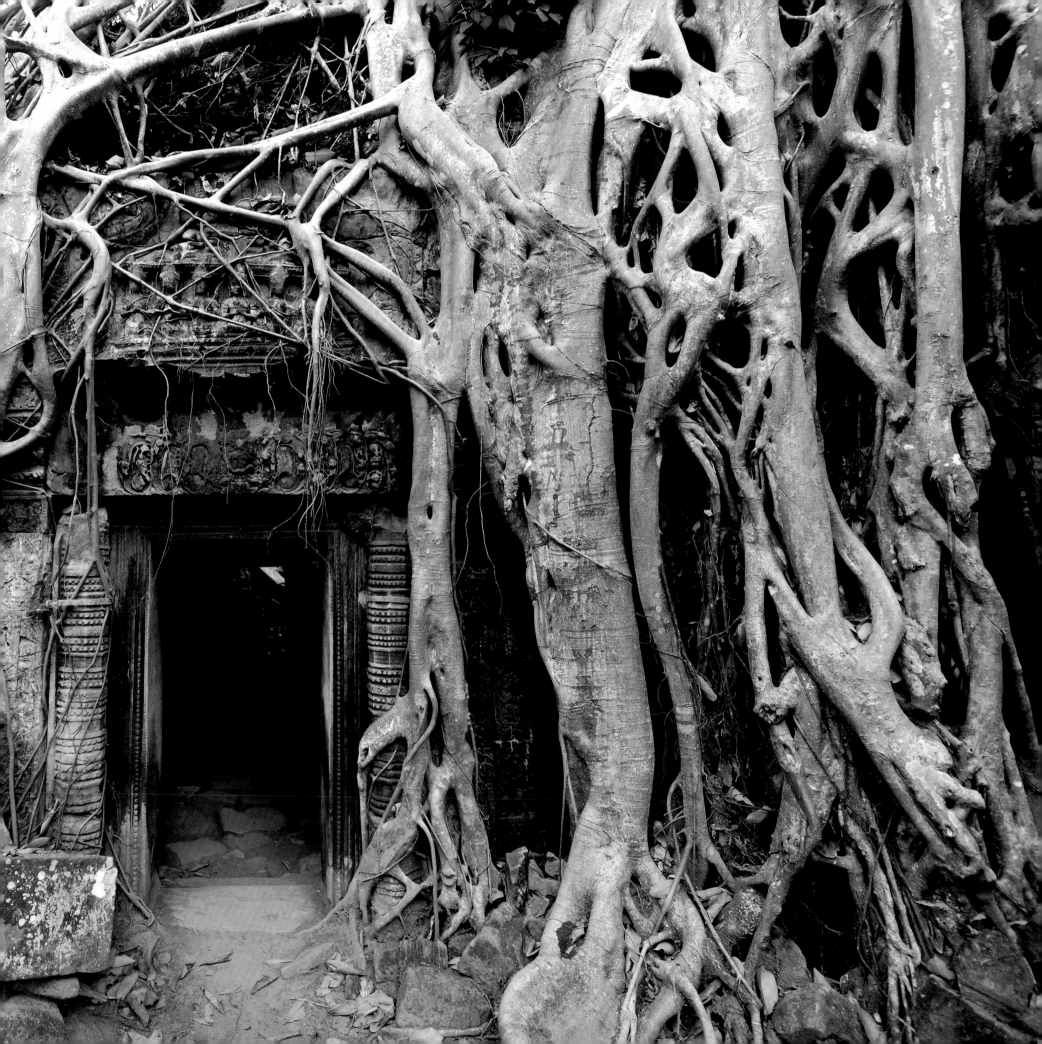

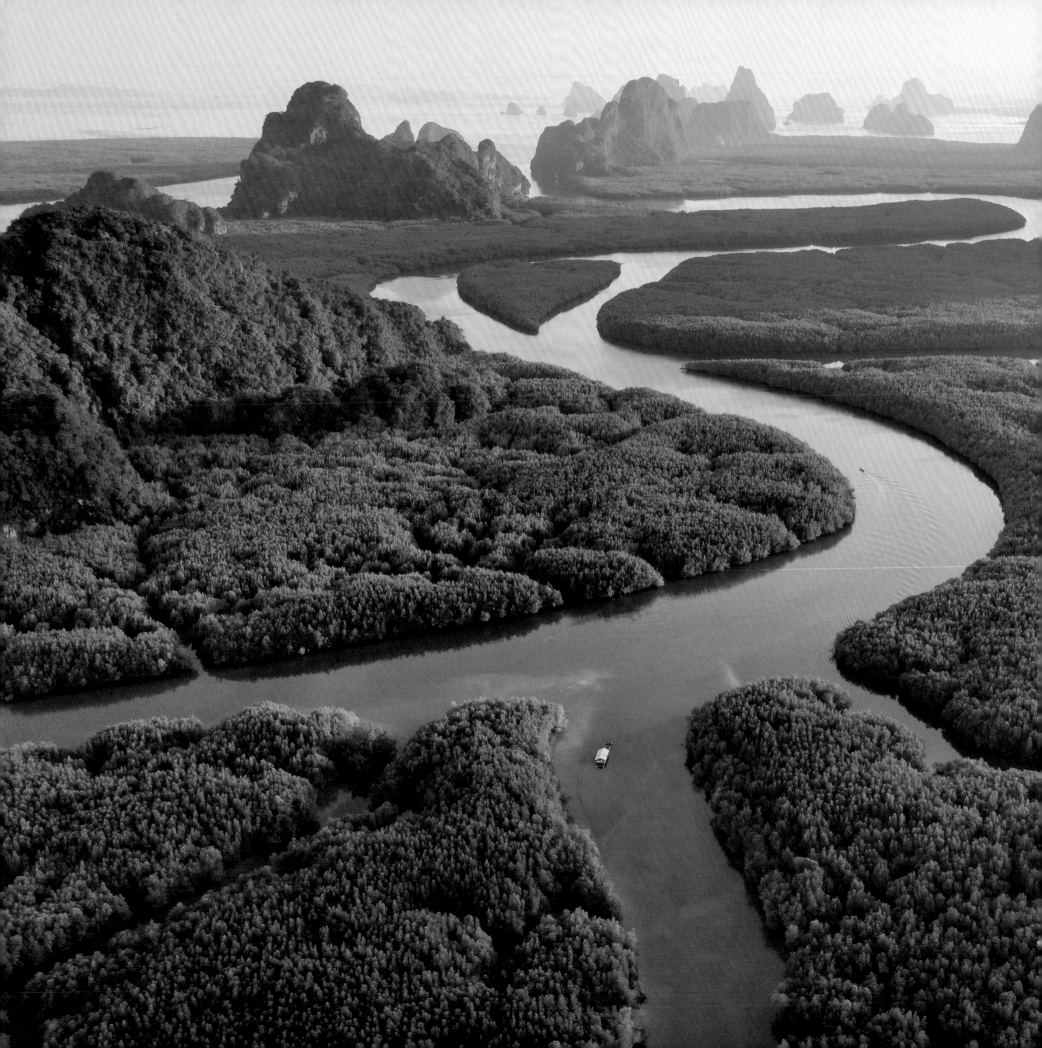

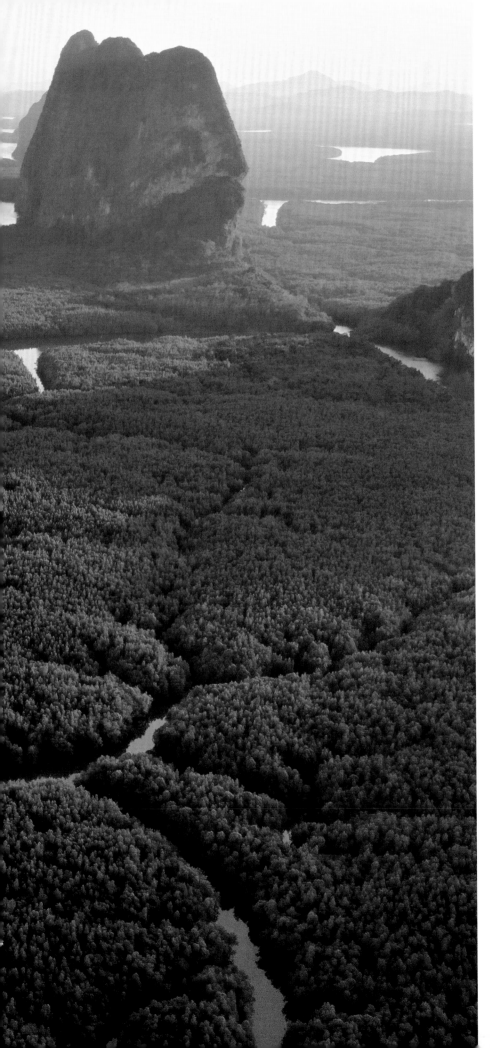

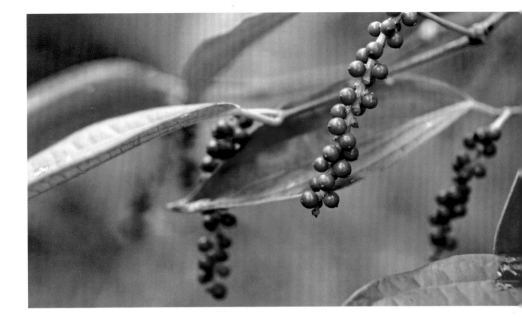

extended over much of this region, with its capital Angkor Wat, now a UNESCO World Heritage Site, at its centre. Much of mainland Southeast Asia was then covered in archetypal rainforest. Its towering trees and lush vegetation provided the empire with abundant resources to support their booming population. According to the most prominent theory, however, the successful Khmer empire collapsed when it outstripped the forest resources on which it relied. With the forest so depleted, the empire could no longer support its population.

Centuries after the collapse of the Khmer empire, the first transnational companies, the Dutch East India Company and the British East India Company, emerged on the back of the valuable forest resources that this region could supply to Europe. These included spices, exotic foods and vast hardwood timbers, but one forest product in particular drove much of this trade. In the shade of the forest floor grows a small, green, woody vine, supporting itself against the stronger trees and shrubs. Among the heart-shaped leaves dangle pendulous flower spikes, §each between 7 and

Above: Black pepper plant, Kerala, India.
Left: Another sunset takes place over the channels and peaks of Phang Nga Bay, Thailand, while a cacophony of unique and diverse bird calls fills the air.

15 cm (2¾ to 6 in) long. These flowers eventually develop into a long mass of fruits, at first small and green in colour, then bright red. These fruits are collected while still hard and unripe. They are laid out to dry in the strong tropical sun, leaving a hard, dark spice and the pungent aroma of pepper.

Roaming Wild

'The air was full of all the night noises that, taken together, make one big silence – the click of one bamboo stem against the other, the rustle of something alive in the undergrowth…' Rudyard Kipling, *The Jungle Book*

The stories of Mowgli the human, Baloo the sloth bear, Bagheera the black panther, Akela the Indian wolf, Shere Khan the Bengal tiger, Rikki-Tikki-Tavi the Indian mongoose and many more wondrous characters from *The Jungle Book* are testament to the diversity of animals found in these rainforests. It may be hard today to find, in the wild, the animals that these stories deliver into our imaginations – but they are still there. If you are lucky, you might see Shere Khan stalking through the forest, camouflaged with black stripes on an orange coat to mimic the shadows of branches in the sunlight. Tigers are famously endangered, but huge conservation efforts over the last decade are slowly helping to increase the number of this terrifyingly beautiful cat. Around 3,000 now exist across the wilds of this continent.

If you hear branches cracking and creaking high up in the canopy, look out for Baloo. The sloth bear often comes into conflict with villagers due to the disappearing forest habitat. They may weigh over 150 kg (23 stone 8 lbs), but can be adept climbers, especially if encouraged by the sweet scent of honey or the ripest of mangoes in the tops of the trees. One character you are likely to see is Rikki-Tikki-Tavi, the Indian mongoose. This

Right: Shere Khan, the magnificent tiger that stalked Mowgli in The Jungle Book, *makes an imposing figure in any situation. Sadly, their numbers are dwindling through loss of habitat and poaching; only the dedication of conservationists has kept the species in existence.*

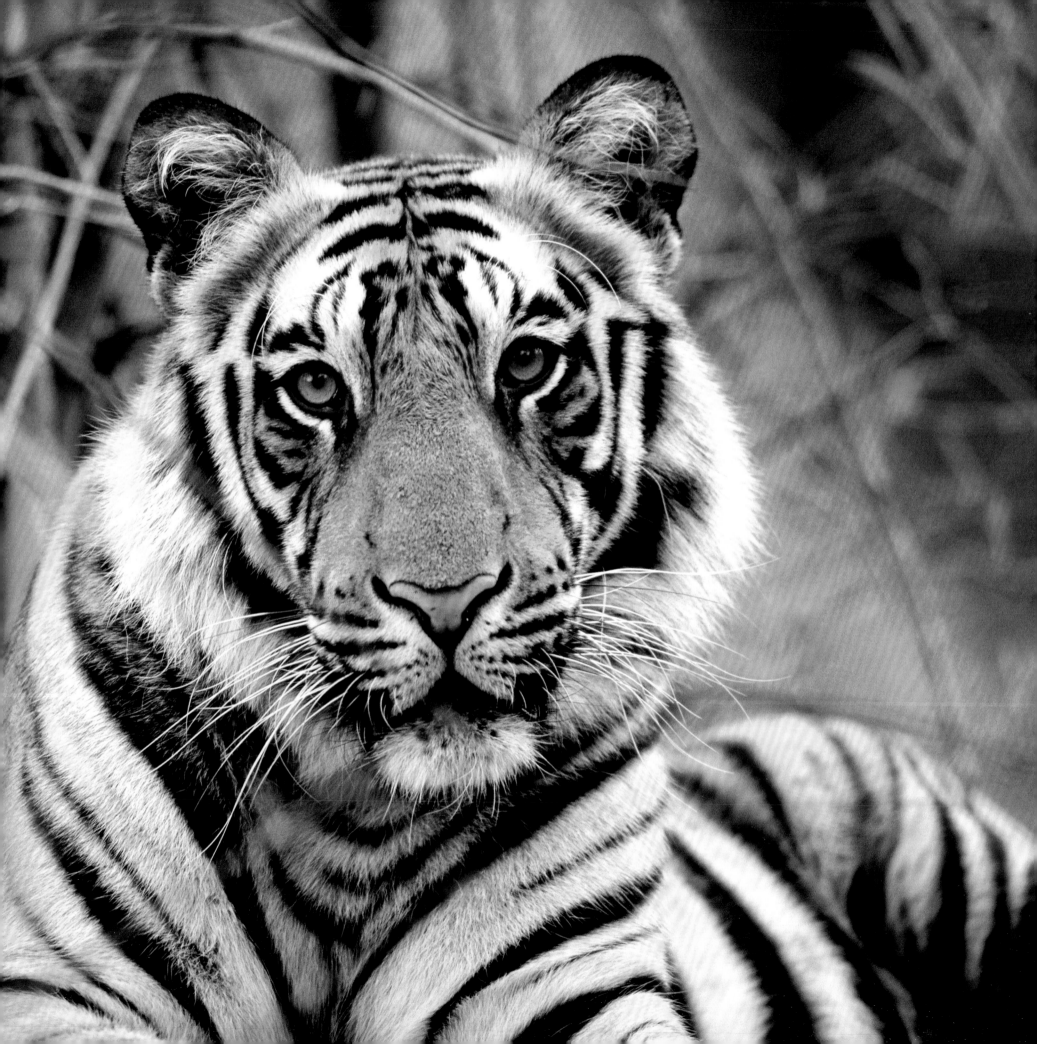

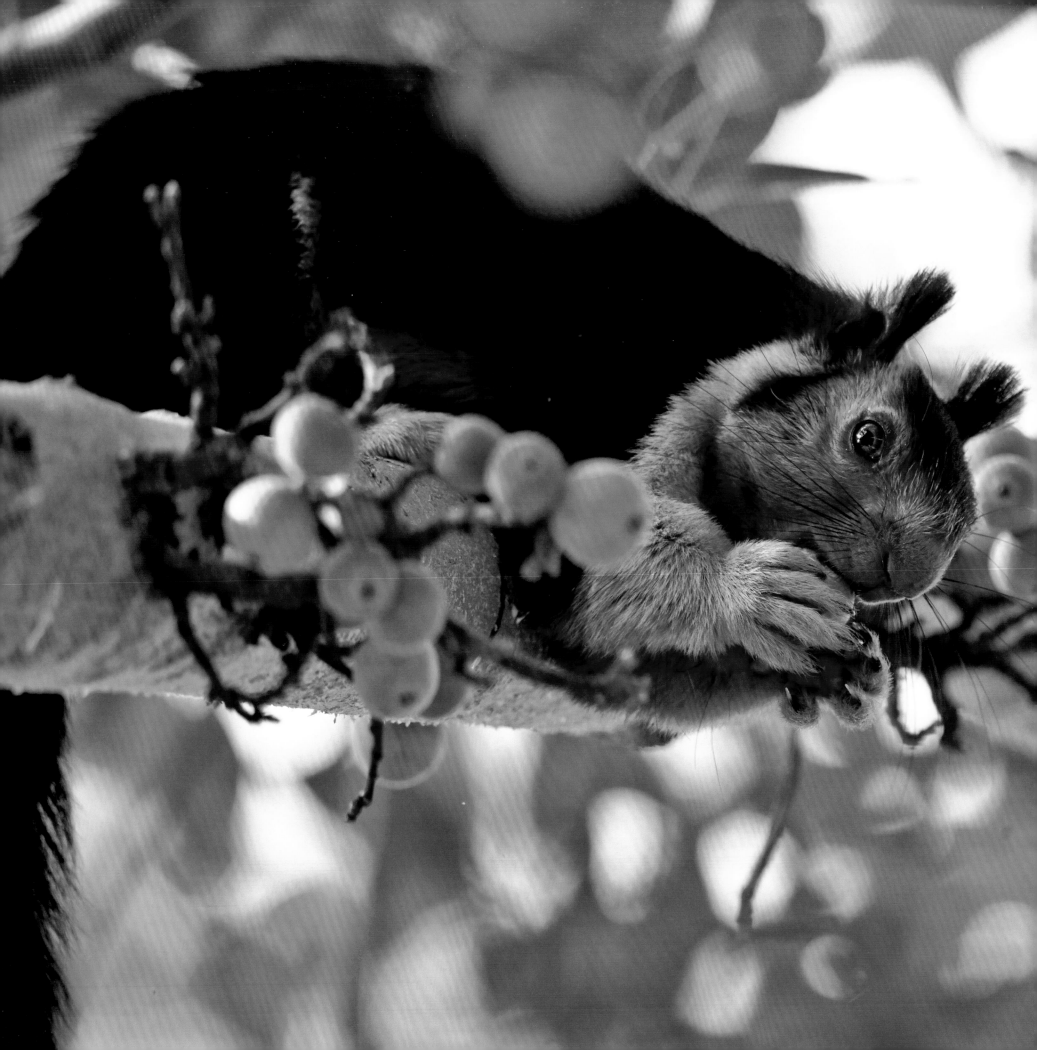

charismatic and inquisitive little creature can be found looking for almost anything to eat – bird's eggs, fruit, lizards, scorpions, grasshoppers and even snakes, to whose venom it is immune.

The Edge of Existence

Somewhere in the thick vegetation that clings to the slopes of the Annamite Mountains of Laos and Vietnam can be found what is perhaps the most elusive mammal known to man. In 1992, an unusual skull was found hanging in a hunter's home; no scientist could identify it. After much research it was determined to be a species new to science, the saola. First photographed in 1999, this small, brown, muscular, antelope-like animal, more closely related to a cow, is probably one of the rarest mammals on Earth. It stands 80 cm (31½ in) at the shoulder and sports two straight horns. Splashes of white stand out against the brown of its face and a long, black stripe runs down the length of its back. Listed on the Zoological Society of London's EDGE of Existence programme, due to its evolutionary distinctiveness as well as the fact it is critically

Left: An Indian or Malabar giant squirrel feeds on ripening fruits, helping to spread the tree's seeds across the forests of the Anaimalai Mountain Range, Tamil Nadu.
Below: Indian grey mongoose, Konkan.

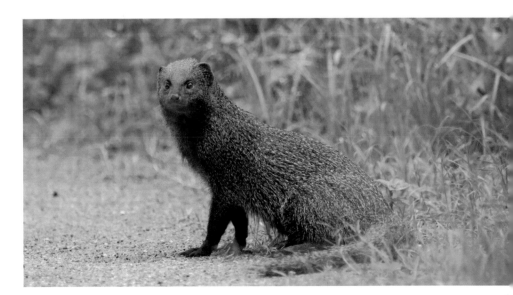

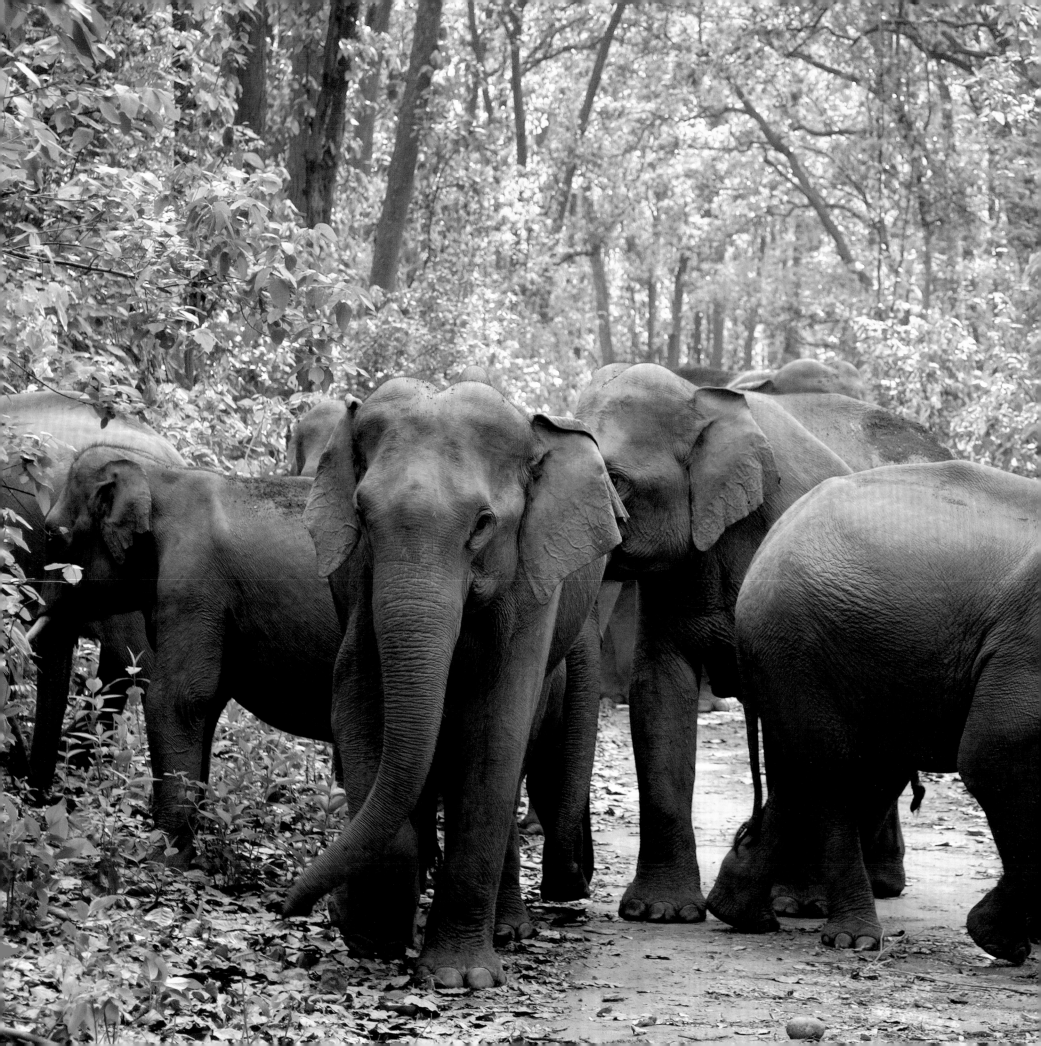

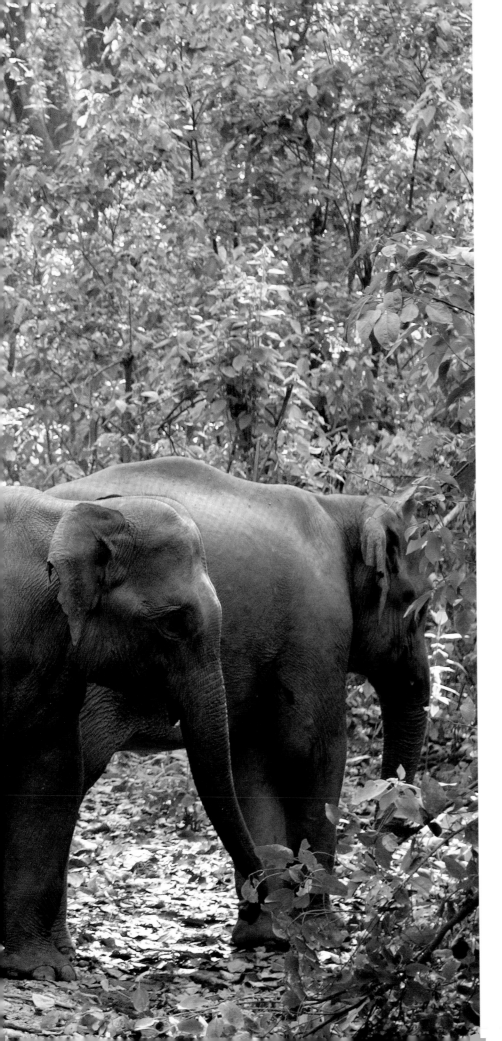

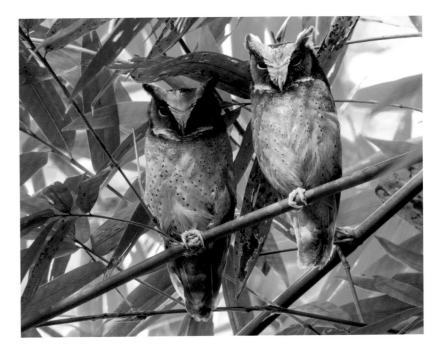

endangered, there may only be a few tens of individuals surviving today. The saola has only been catalogued in the wild a handful of times.

Unfortunately, hunting and loss of habitat through deforestation are placing the existence of this unique animal under constant threat. There is some good news, however: the discovery of such an endangered species has prompted increased efforts and funding for conservation groups to try to maintain what remains of the population. Commercial logging has been stopped within the forests and there has been an increased emphasis on anti-poaching efforts, removing tens of thousands of wire snares from the forest that the saola inhabits. This benefits not only saola, but also many other denizens of the rainforest.

The fact that a species such as the saola can remain undetected in some of the smaller fragments of rainforest that remain shows how much these areas can still teach us about our natural world.

Left: Herd of Indian elephants, Corbett Tiger Reserve, Uttaranchal, India. Like soala, the Indian elephant population is under threat due to loss and fragmentation of habitat.
Above: *Pair of white-fronted scops owl, Phetchaburi, Thailand.*

Maritime Southeast Asia

In **contrast** to the mainland, many of the islands of maritime Southeast Asia still maintain large swathes of their original, virgin rainforests. These forests are true wildernesses, complete with undiscovered species, uncontacted human tribes, misty mountains and large, dangerous carnivores. These are the Spice Islands, valuable in past centuries supplying Europe with exotic foreign flavours. While there is still value in the products these forests supply, their true value may now be more intrinsic: the continued existence of these extraordinary biological riches.

Plant Life

Exploring the rainforests that coat the islands of Southeast Asia reveals an astounding diversity of plant life. New Guinea alone is estimated to have up to 25,000 species of plants of which anything up to 16,000 are thought to exist nowhere else. These numbers are only estimates, and excludes the countless mosses, liverworts, hornworts and algae, simply because so many plants on this island have yet to be documented by modern science. Almost every scientific expedition to New Guinea reveals new species.

This is partly due to its terrain: steep, tooth-like mountains falling to deep, lush valleys lead to a huge diversity of forest types. Lowland forests are tall and luxuriant. A single hectare (2.5 acres) contains upward of 200

Right: The value of rainforests lies not just in the resources they contain or the services they provide – millions of tourists also visit every year. This impressive cable bridge in Langkawi, Malaysia helps people explore the diversity of life in the tropical forest's canopy.

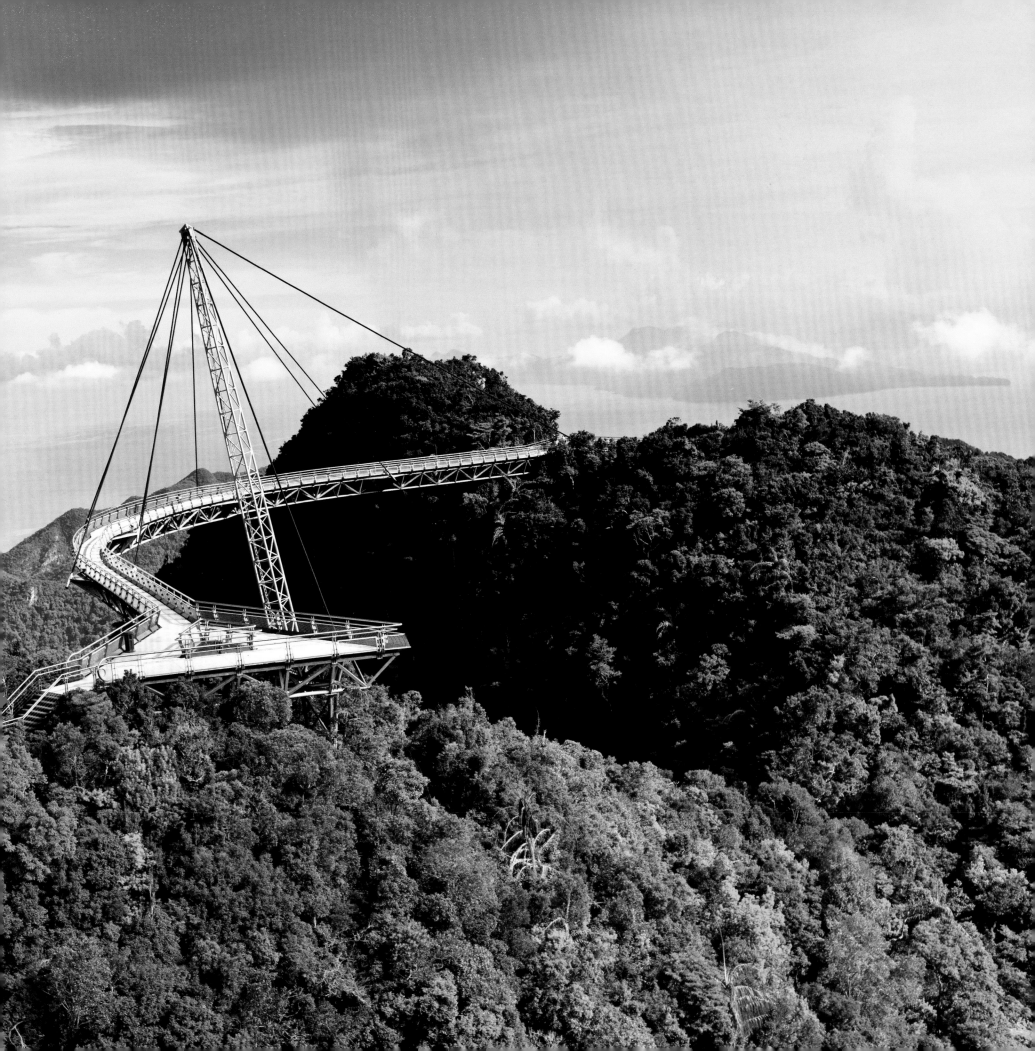

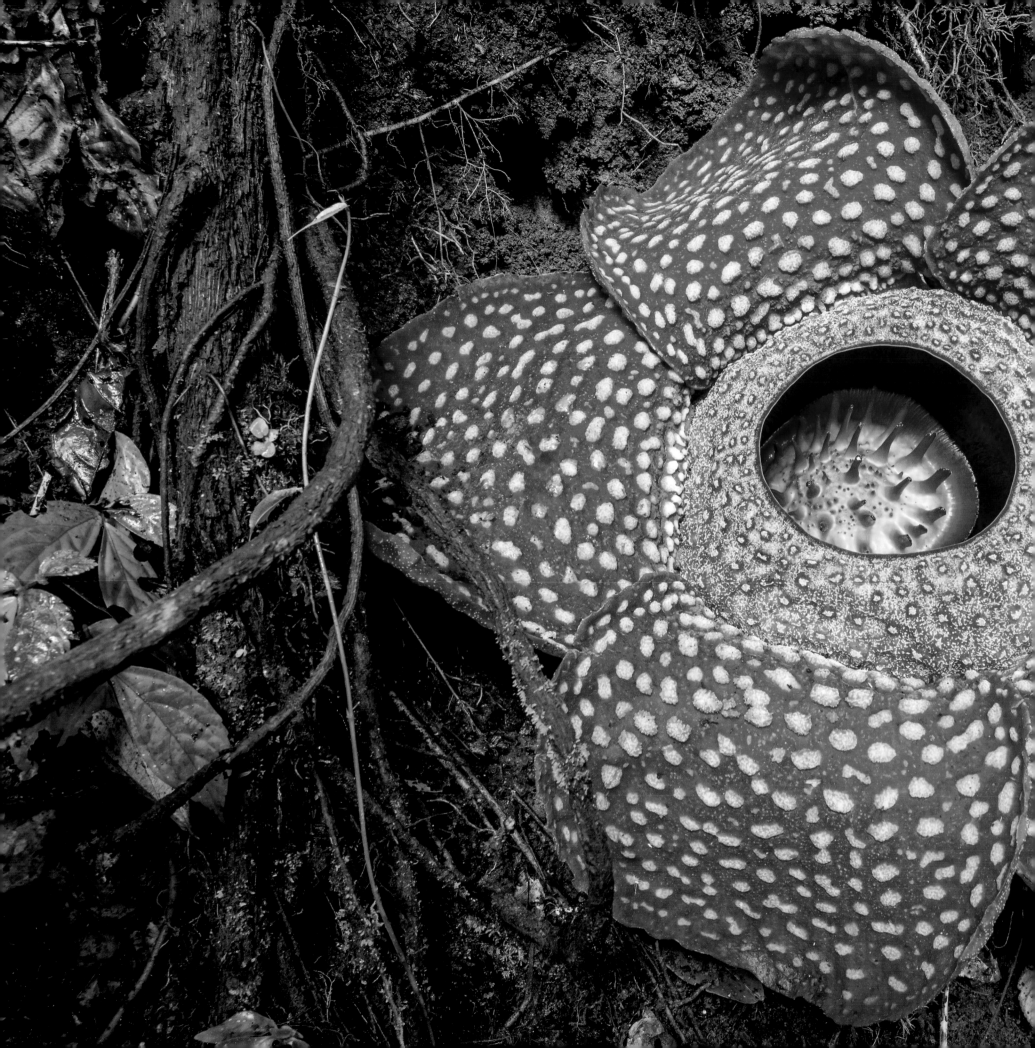

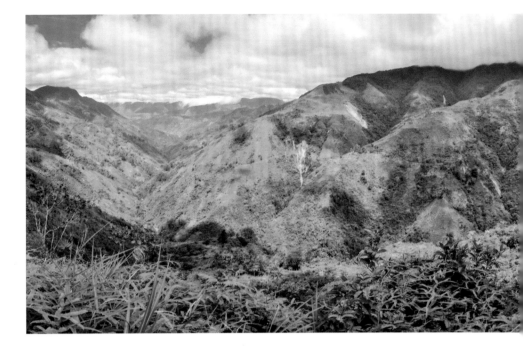

tree species, from mahoganies and laurels to figs, eucalypts and fragrant nutmegs. The high forests topping the inaccessible highland ridges, where many of the unknown plant species are still to be found, have a lower canopy but equally rich species composition.

It is not only the sheer numbers and diversity of species that is astounding: the plants themselves can amaze. Take the titan arum, a plant that grows into a compound leaf stalk 5 m (16 ft) in height and then, after 12 to 18 months, topples over and dies back. This cycle repeats over the course of four to five years until the plant has stored enough energy, after which it will finally send up a leafy spike. One night this giant green spike will burst into an enormous, deep purple flower. Growing up to 3 m (10 ft) in height, it is the largest flower in the world. However, as the arum bursts into flower it also releases its dreadful perfume, an overpowering stink of rotting flesh. It is this foul smell, which attracts carrion beetles and flesh flies to act as pollinators, that gives the plant its nickname, the corpse plant.

Above: *The Kubor mountain range, Papua New Guinea.*
Left: *Rafflesia, the titan arum, is the biggest flower in the world. Its livid red colour and repulsive perfume, imitating rotting flesh, attract pollinating flies and beetles from far and wide.*

Not all the plants of these forests are so magnificently revolting. The bark of the rainbow gum, the only eucalypt tree found within a rainforest, is smooth with a light orange tint. As the tree ages the bark peels, revealing a multitude of colours: blues, purples, oranges, maroon and green. It is a truly spectacular tree.

Creatures High and Low

High in the branches of Sumatra and Borneo's rainforests live the most arboreal of the world's great apes. Long, strong arms and powerful legs allow them to climb the towering trees. Their hands and feet each have an opposable thumb or toe, allowing them to use and manipulate tools. The ape's wide face has deep-set, friendly, brown eyes. A thick, red beard flows from the side of the flat nose, around the broad mouth and down from the

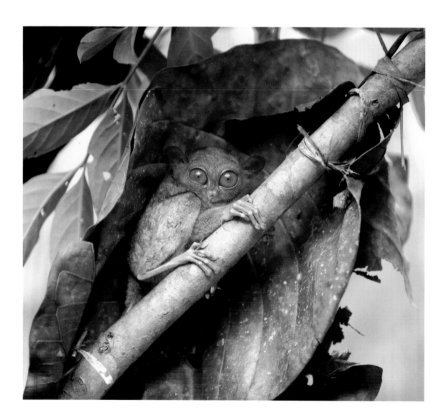

Above: This tarsier is the world's smallest primate, found in the Philippines. The stem this one is gripping is barely as thick as your little finger.
Right: Male orangutan resting on a log, Tanjung Puting National Park, Borneo.

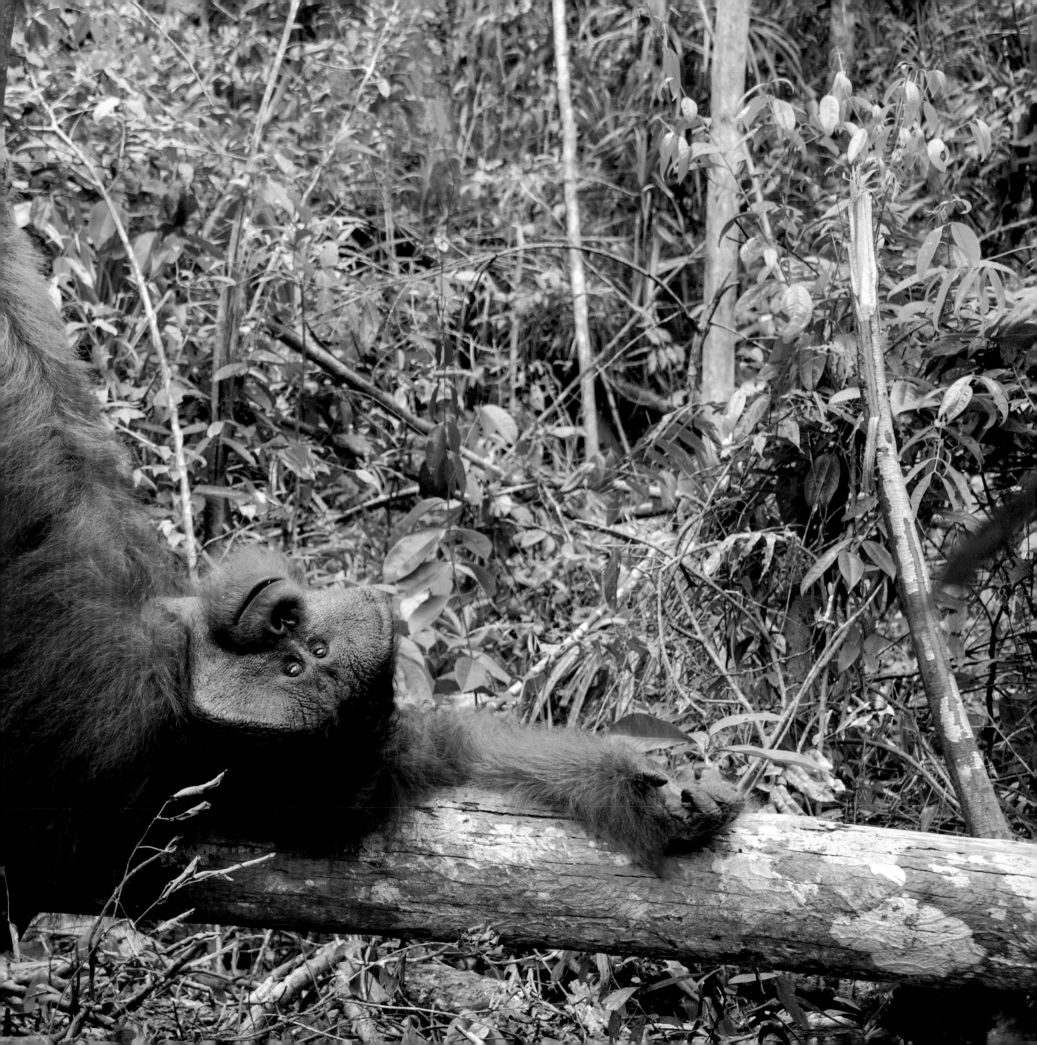

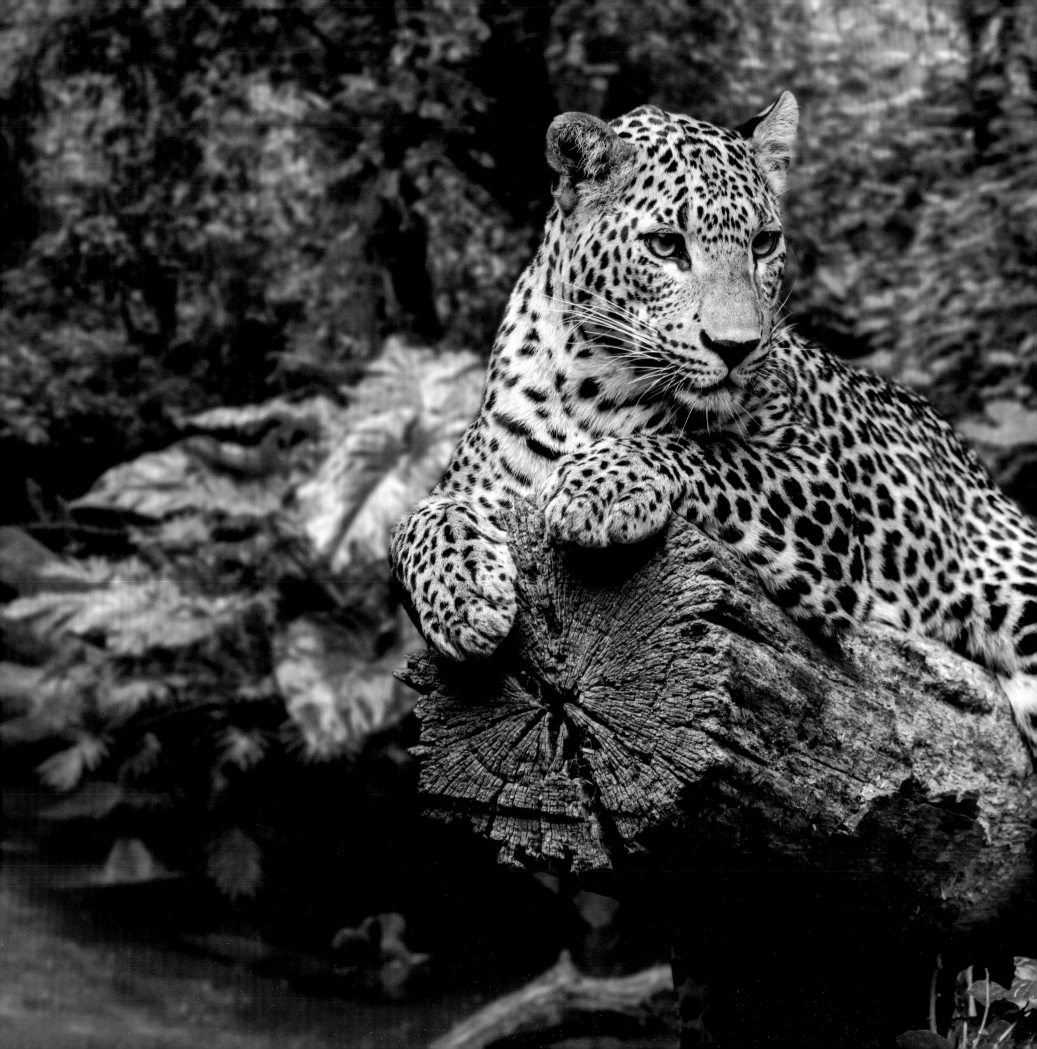

chin. In fact, the ape's whole body is covered in the same thick, red-brown hair. This is the orangutan, a name that in the Malay language means 'person of the forest'.

Orangutans are highly intelligent animals, arguably the most intelligent of the non-human primates. They are known to use a multitude of tools for extracting insects, harvesting seeds and even amplifying their calls. It has been suggested that orangutans from different areas have unique cultures, and rescued individuals have been taught rudimentary sign language. Largely solitary animals, orangutans spend most of their life high in the rainforest canopy searching for fruits, succulent new leaves, honey and protein-rich insects; they consume up to 11,000 calories a day, a figure that any bodybuilder would envy. Living high up is, in part, the orangutan's way of avoiding the predators that inhabit these forests. Magnificent but deadly tigers, secretive and elusive clouded leopards and packs of dholes, the wild dogs of Asia, roam the land, while at the water's edge await the menacing 70 white teeth of a lurking crocodile.

Another creature, believed to be fictional when it was first reported to Europeans, inspired the artist Albrecht Dürer (1471–1528). He described this animal thus: 'Its colour is that of a freckled toad and it is covered by a hard, thick shell. It is of the same size as an elephant but has shorter legs and is well capable of defending itself. On the tip of its nose is a sharp, strong horn which it hones whenever it finds a stone.'

You may be forgiven for not recognizing this description to be that of a rhino, but Dürer had never seen his muse. Three hundred years ago, a creature such as the rhino would surely have seemed an imaginary beast. Yet such incredible creatures can still be found roaming the rainforests today.

Left: *A Sri Lankan leopard rests on a long-ago felled log, waiting for the day to come to a close. Under the cover of darkness, its hunting can begin.*

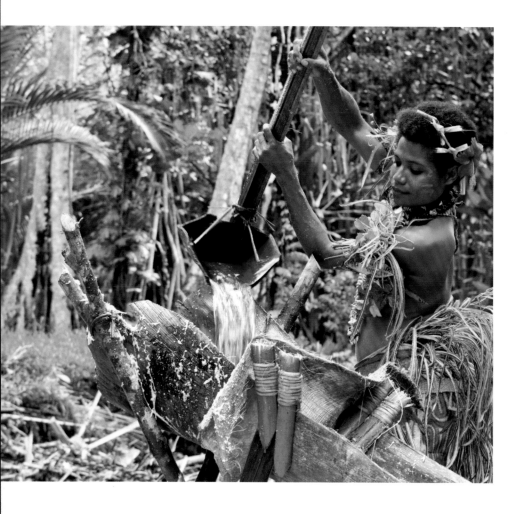

Precious Landscape

Dominated by the hot, humid rainforest, New Guinea is the most species-rich island on the planet; it still retains around 70 per cent of its undisturbed natural vegetation. Unfortunately, along with Borneo, these are the last of Southeast Asia's islands to retain any significant amount of contiguous rainforest. Of the thousands of islands that once had large swathes of rainforest, little remains intact, and even this is under constant threat of deforestation. What drives this deforestation is a variety of timber harvesting, much of it illegal, and much of it sent to Europe to make garden furniture.

Above: A young woman in the forests of Papua New Guinea washes the crushed pith of the sago palm to extract starch from its thick fibres. Palm starch provides a staple food for many rainforest people in Southeast Asia.
Right: The Lion's Rock Fortress of Sigiriya, Sri Lanka. Unfortunately, lions no longer roam these forests, but it is easy to imagine one roaring across his territory from this monolith.

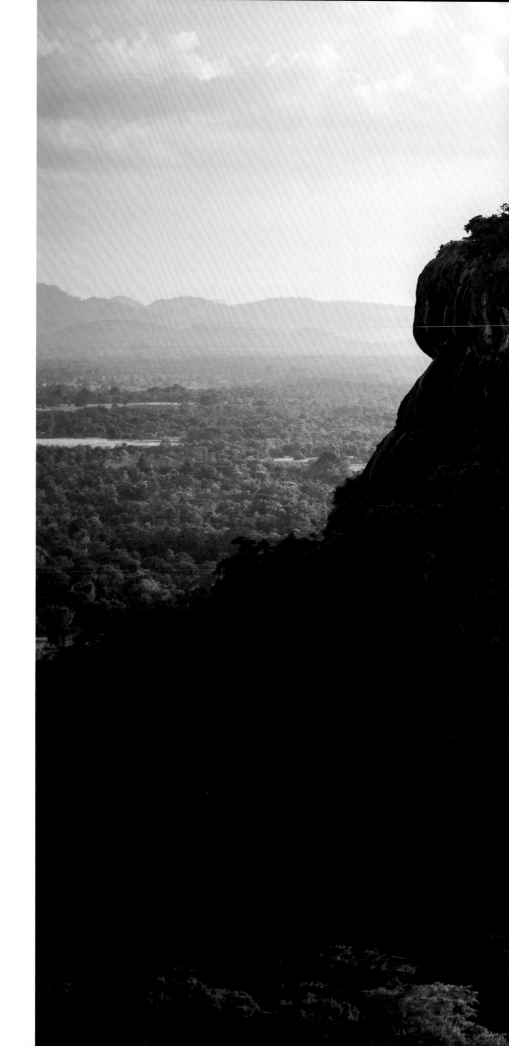

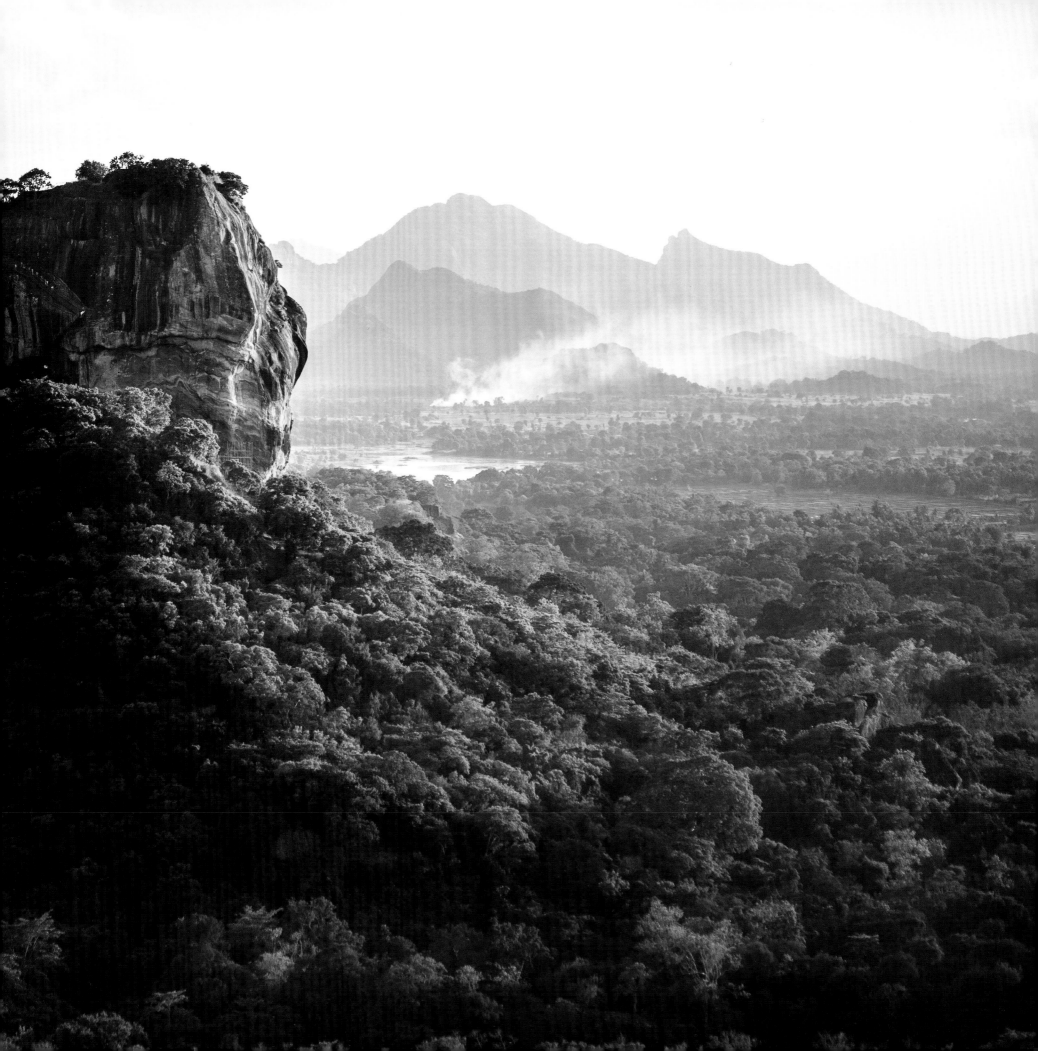

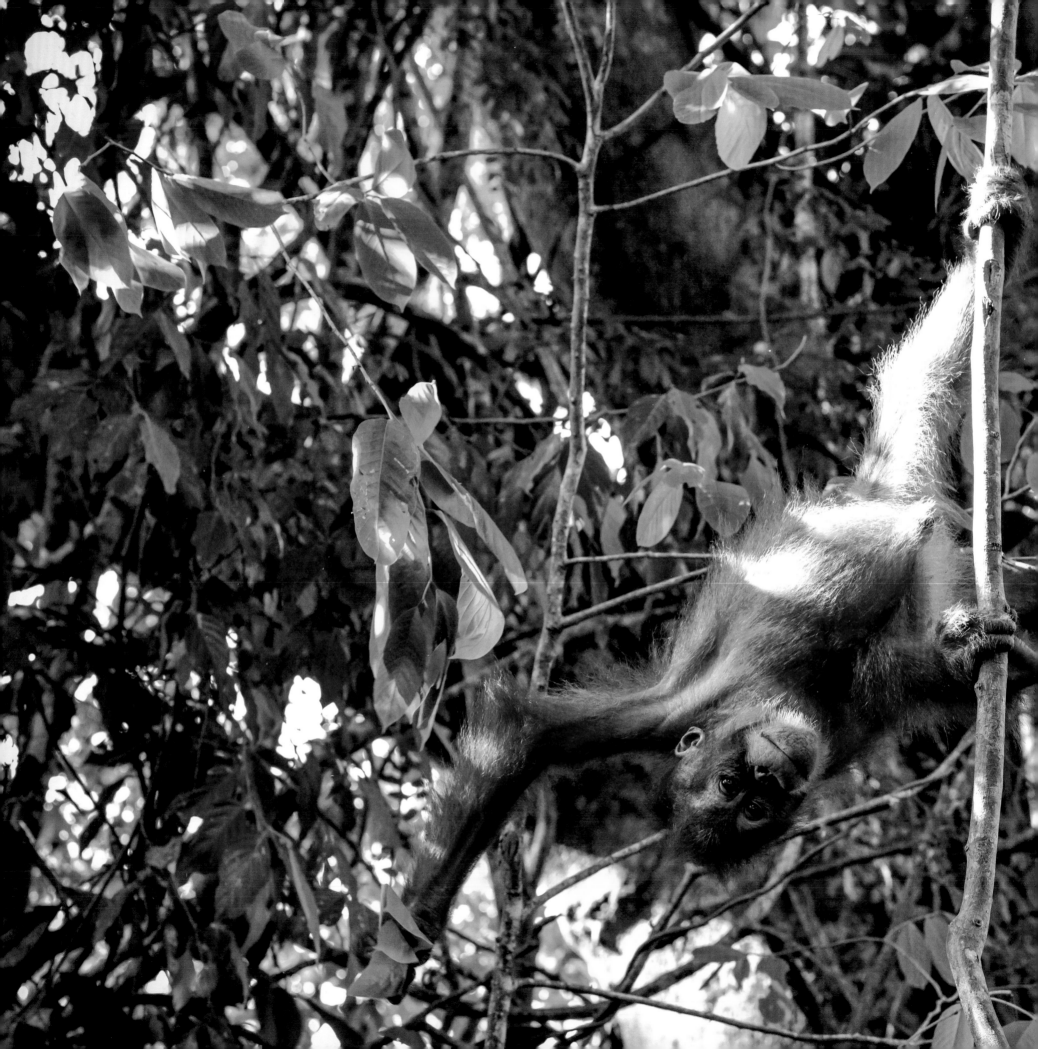

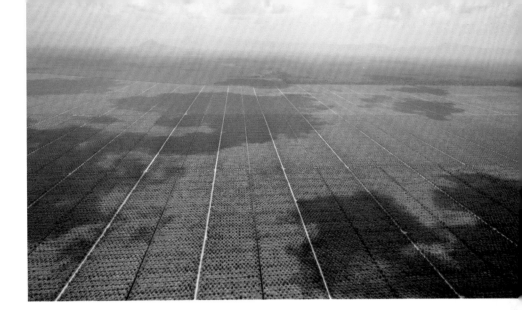

The rich but shallow soils that remain on the cleared land are then planted with crops such as coffee or, more commonly, oil palms. Here the palm is less at risk from the diseases found in its native Africa. The climate is more conducive too, resulting in more rapid growth and a bountiful harvest. Producing five times more oil per hectare than rapeseed, the yellow flowers of which cover much of the UK's farmland, the oil from this palm is the most widely consumed vegetable oil on Earth. It is used in a dizzying array of products: pizza bases, noodles and ice cream; washing detergent, soap and shampoo; chocolate, cookies and cakes; lipstick, moisturizer and toothpaste – the list seems endless.

Sadly, such forest clearance is happening all over the region, and is unfortunately also slowly spreading to the remaining untouched rainforests. Borneo has declined from having 75 per cent of its rainforest intact to less than 30 per cent in that condition over a mere 40 years – little more than the lifetime of a single orangutan. Of course, loss on such a scale has also highlighted the rainforest's plight. This has encouraged the development of more sustainable ways of growing oil palm, the designation of protected areas and international pressure to reduce illegal logging. For the sake of the orangutan, it is vital that we stay optimistic and keep pushing to preserve these forests far into the future.

Left: *Baby orangutan, Sumatra, Indonesia.* ***Above:*** *An oil palm plantation in Kuching, Malaysia.*

Pacific & Oceania

Tropical islands and truly ancient and unique species characterize the rainforests of this region. Many of the diverse array of species they contain represent the evolutionary history of the past 200 million years, when the continents were still connected as a single landmass. While little of the rainforests of Oceania and the South Pacific Islands still remains, what does is a truly fascinating glimpse back in time.

Tropical Paradise

When asked to imagine a tropical paradise, many people would describe remote islands in an azure blue sea, the sun beating down on golden sands and coconut palms bending under their own weight, their leaves tipping the crests of gentle waves. However, walk inland a little way, especially on the islands of the South Pacific, and you will probably find yourself in damp, steamy rainforest. Here stunning fire-red heliconia flowers, each tipped with canary yellow, dazzle against the lush green where a tree has fallen, allowing the sun's rays to trickle through. While these island forests have less in the way of big animals than their mainland cousins, they possess an amazing variety of birds.

The Solomon archipelago, for example, holds a greater diversity of bird species than any other place of comparable size on Earth – almost half of these species are found nowhere else. Many of these islands have a volcanic history. This has left steep, rugged terrain, affording many of the forest areas protection from logging. The Solomon Islands, for example,

Right: Mont Tohiea, a dormant volcano, towers over the rich forests of the island of Mo'orea in French Polynesia. The island's fertile volcanic soil enriches the biodiverse vegetation.

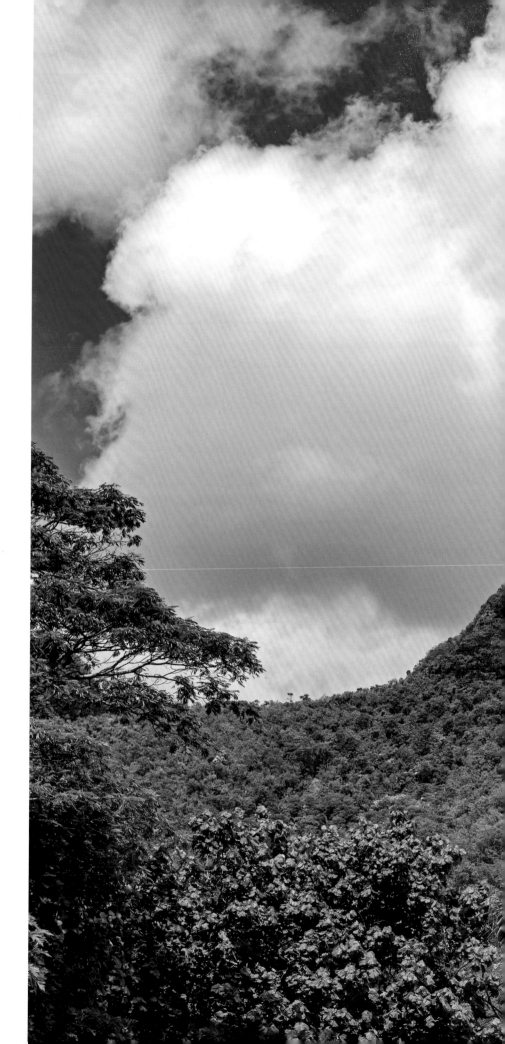

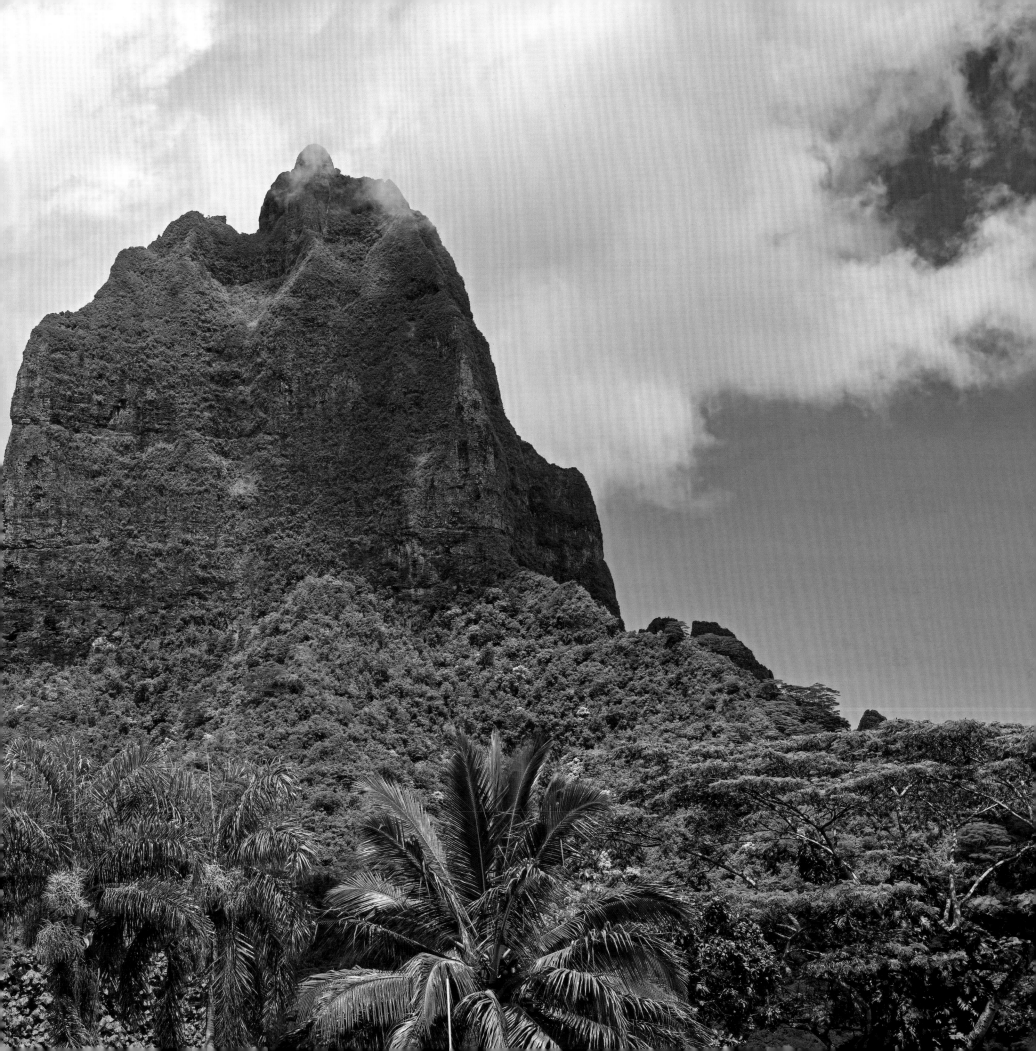

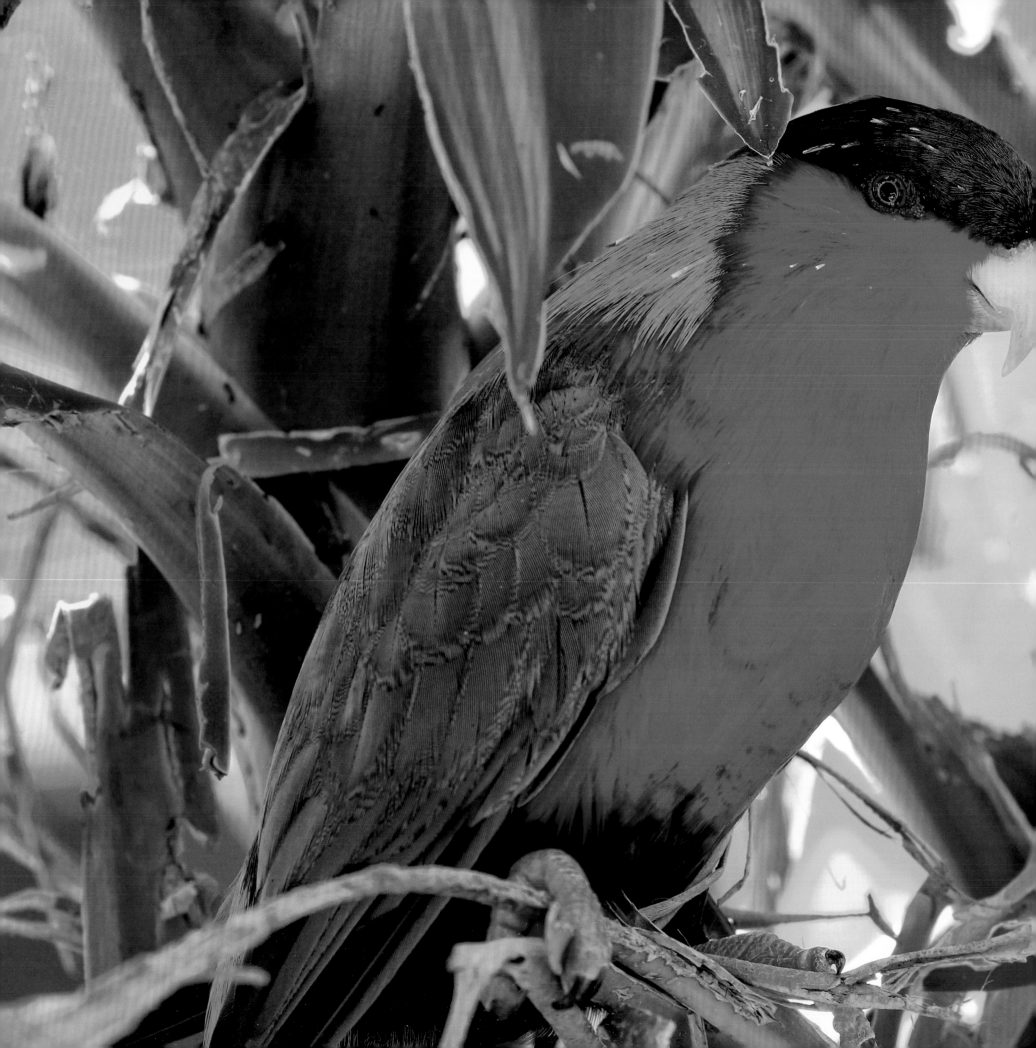

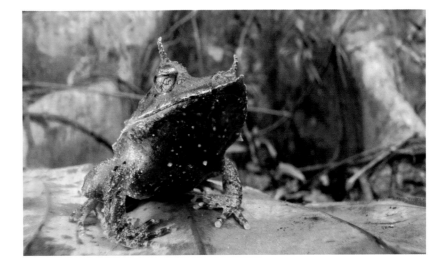

still retain 75 per cent of their original forest cover. Unfortunately, logging is not the only threat that rainforests face. Many other islands in the Pacific, while retaining their forests, have suffered a devastating loss of animal life. This is largely due to invasive species that have been carried to the islands on ships. Animals such as cats, rats and mongooses hunt and kill birds in habitats all across the world, but in rainforest areas, where such species are a novel threat and may lack predators, their presence becomes devastating for native creatures.

A more mysterious example of rainforest disappearance is evident on Easter Island, or Rapa Nui as it is known to the native people. The island is dotted with almost a thousand enormous statues of people, the largest almost 10 m (33 ft) long and weighing 82 tonnes – yet when Europeans first arrived, Easter Sunday 1722, the island had a very small population. These statues have inspired a multitude of mythologies, and even the suggestion that they are evidence of alien interference on the island. However, over time, and after much research into the archaeology of the island, it has emerged that the population deforested the island to use its resources. This deforestation, combined with invasive Polynesian rats that

Above: The Solomon Island eyelash frog, from the islands that bear its name, has incredible camouflage – it is almost impossible to see in the leaf litter of the forest floor.
Left: *A collared lory on Viti Levu Island, Fiji.*

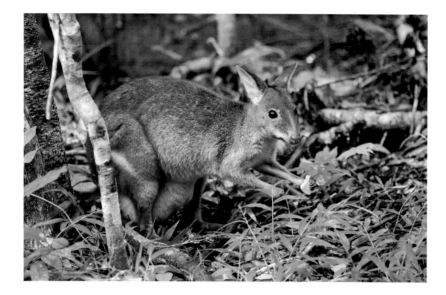

prevented any regeneration of the native flora, resulted in a complete collapse of the island's complex civilization in just a single century. Perhaps there is a lesson to be learned here about the preservation of our own natural resources, if we want to maintain human civilization long into the future.

Living History

For some reason we tend to associate rainforest regions with lower levels of economic development. Yet perhaps the most ancient rainforest on the planet exists within one of the most economically developed countries in the world: Australia. The 'red continent', most frequently associated with desert, kangaroos and Aboriginal culture, is also home to the Gondwana rainforests. These incredible forests contain many of the same kinds of species that existed when the Earth's terrestrial land formed a single supercontinent, Gondwanaland. The plant species that call these Gondwana forests home are both primitive and extraordinary. They show you the world as it might have been 200 million years ago, a time when dinosaurs still roamed the forests. Giant tree ferns rise up into the canopy,

Above: A red-legged pademelon in the rainforest, Daintree, Australia.
Right: The Ngerukewid Islands, Palau.

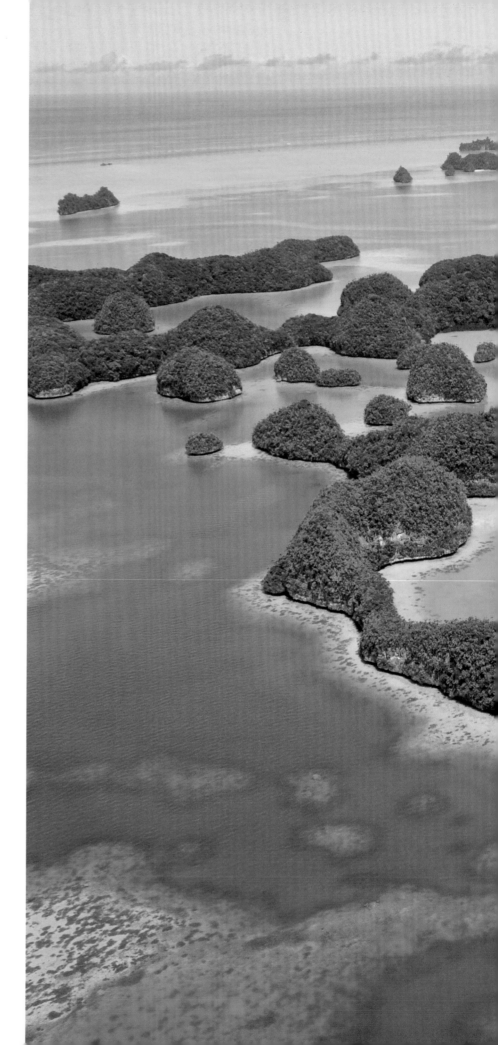

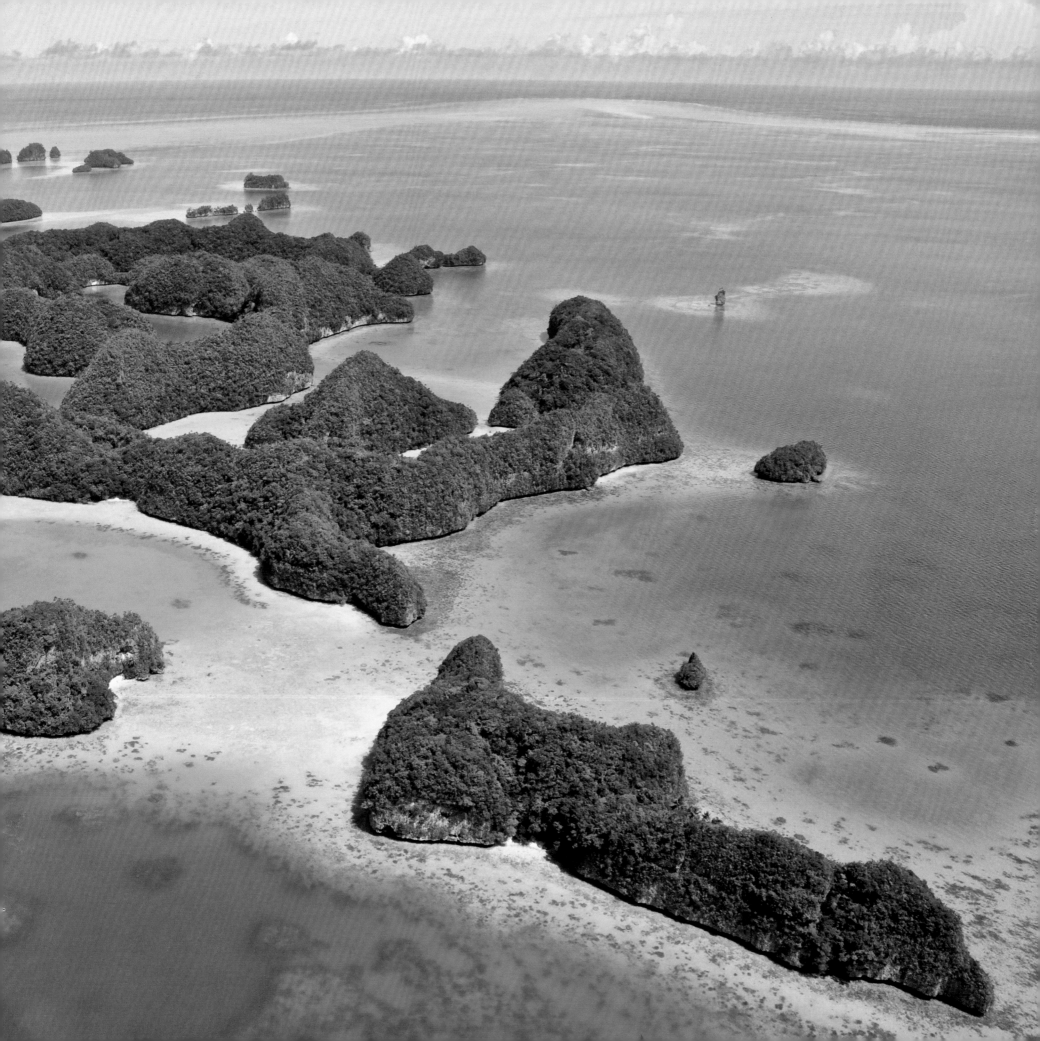

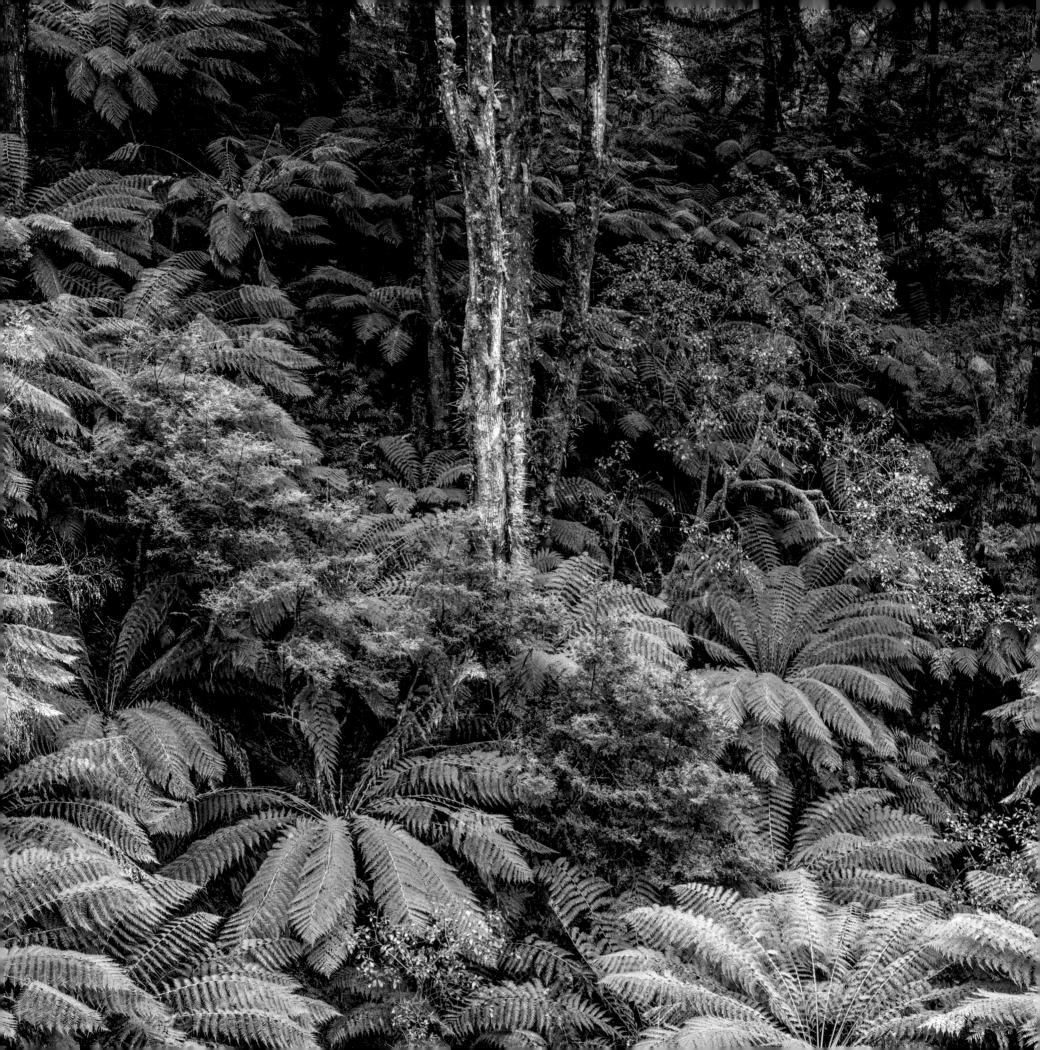

their thick trunks elevating the fronds high above the ground – presumably an evolutionary tactic to get the leaves up high and away from the towering, herbivorous dinosaurs. These ferns are the predecessors to the modern trees of today.

It is not only the trees that are unique, however. These forests also contain the pouched marsupials, wallabies and possums, while the avifauna includes possibly one of the most famous of the tropical birds, the lyrebirds. The mimic maestros of the natural world, these birds copy the sounds they hear around them and then 'play' it back, seeking to have the most diverse and distinctive call with which to attract a mate. Lyrebirds have even been known to mimic the clicks of tourist cameras – and, sadly, the sound of chainsaws.

The forests of this region are an evolutionary wonderland. They offer a unique and fascinating insight into the history of life on Earth, an echo back into our ancient past.

Left: A valley of giant tree ferns in Great Otway National Park, Australia.
Below: A male lyrebird in courtship display, Sherbrooke Forest Park, Australia.

Rainforests of the Americas

Central America and Mexico

The **isthmus of land** between North and South America has a rich and diverse cultural heritage. Many religious beliefs were linked to the rainforests that blanket much of this part of the world. For the war-loving Aztecs, animals indicated different gods and deities, while the knowledge-seeking Mayans had an animal companion that they believed shared their soul. From deep limestone sinkholes or *cenotes*, filled with crystal-clear water in the depths of the Mexican forests, to cloud forest high in the Costa Rican highlands, this is a rainforest wonderland.

Poison, Parrots and Pirates

Like rainforests all over the world, life abounds in these jungles. Bright dots of poison dart frogs are splashed throughout the green foliage – fire orange, golden yellow, purple, ultramarine and aquamarine. Resplendent as they are deadly, the colour of these frogs warns would-be predators of the toxins they are armed with, sequestered into their skin from their toxin-rich diet of centipedes, ants and beetles. High up in the trees, slowly and quietly munching on the freshest of the green leaves, hangs an animal covered in fur and lichen. This is a three-toed sloth: probably the brown-throated sloth, unless you are off the coast of Panama on the small 'Isla Escudo de Veraguas', the only place in which the critically endangered pygmy three-toed sloth can be found.

Previous page: Volcan Arenal is a towering presence over the highlands of central Costa Rica. It is seen here from the lush cloud forest of the Monteverde area, one of the country's early and successful adopters of ecotourism.
Right: *Incredibly beautiful turquoise natural pools make the rainforests of Semuc Champey, Guatemala, resemble a place out of a fairytale.*

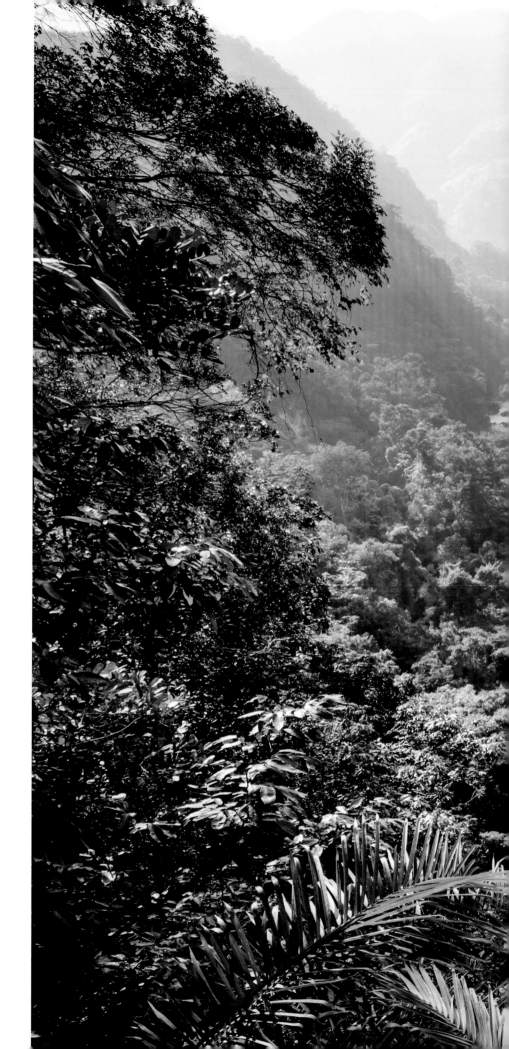

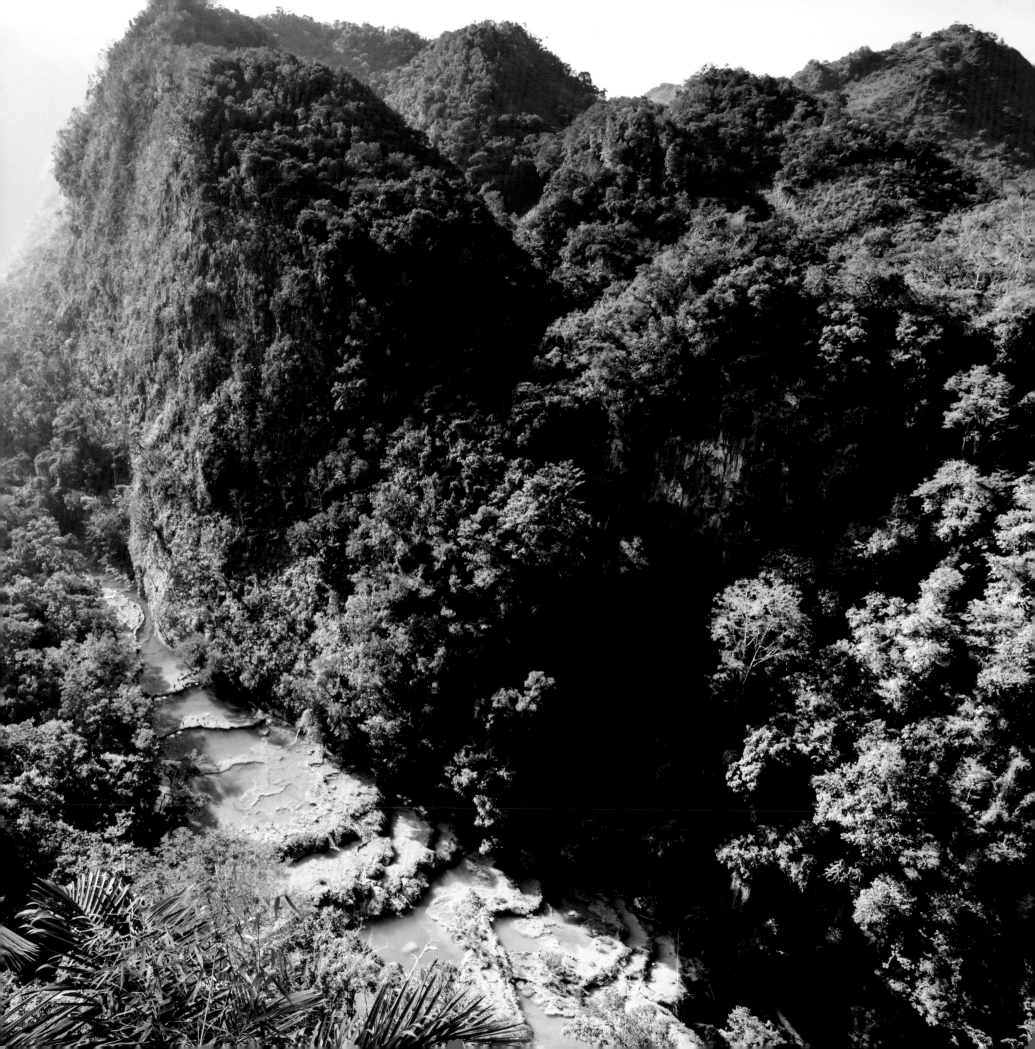

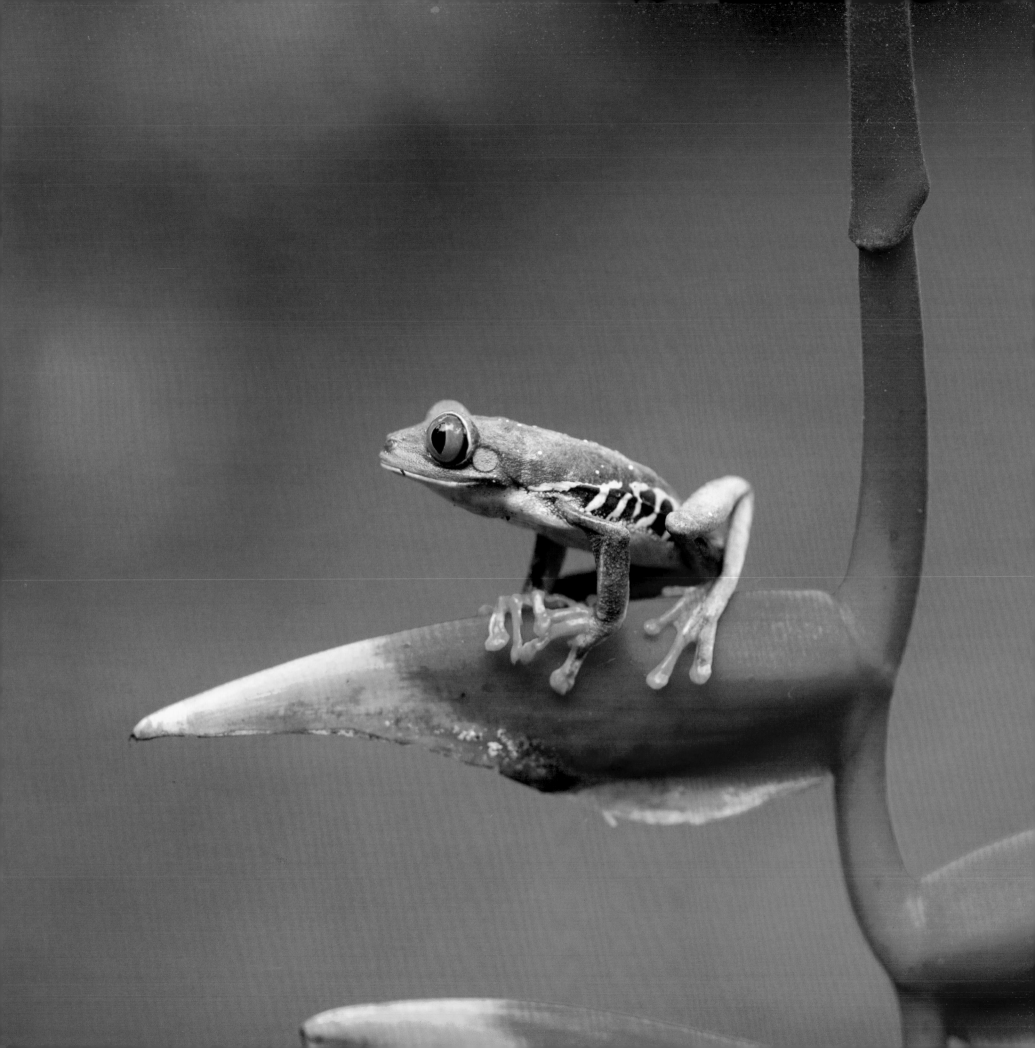

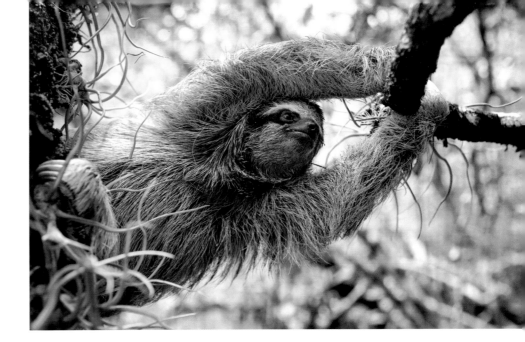

The slowness of these arboreal mammals ensures they also have a slow metabolism, enabling them to survive on a low-energy diet. Grooved hair encourages symbiotic green algae to grow throughout their coat, and the camouflage thus conferred on them, along with their slow, lazy movements, helps sloths evade aerial predators such as the powerful harpy eagle. The sloths rarely descend to ground level, but when they do they face other, more terrestrial predators. Of all the predators of these forests, the jaguar has probably the most diverse array of prey – from the largest land mammals of the region, the tapirs, to the pig-like peccaries and the indolent sloths. Jaguars will also hunt more aquatic animals; they have been filmed patiently hunting caimans that lurk in the muddy rivers, as well as fish that make their way up the forest streams. Where the rainforests roll down the steep coastal hillsides to kiss the warm Caribbean waters, jaguars have been seen patrolling the golden beaches. Here they are on the lookout for huge leatherback seaturtles that heave themselves up the beaches to nest.

The birds of the Central American rainforests come in all shapes and sizes and in a spectacular array of colours. Of course the macaw, famous

Above: The hair of sloths, such as this pygmy three-toed sloth, grows in the opposite direction to most mammals. By growing 'up' to the top of its back, it allows rainwater to run off as it hangs below tree branches.
Left: A red-eyed tree frog perches on a lobster claw heliconia to survey the biological riches of the Costa Rican rainforest.

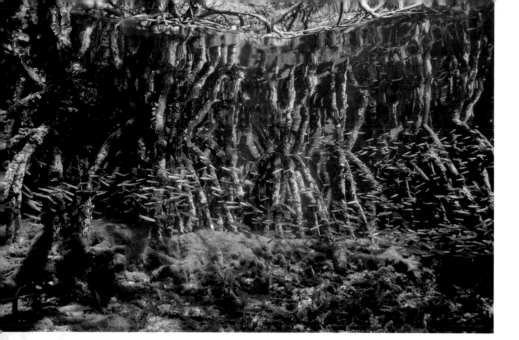

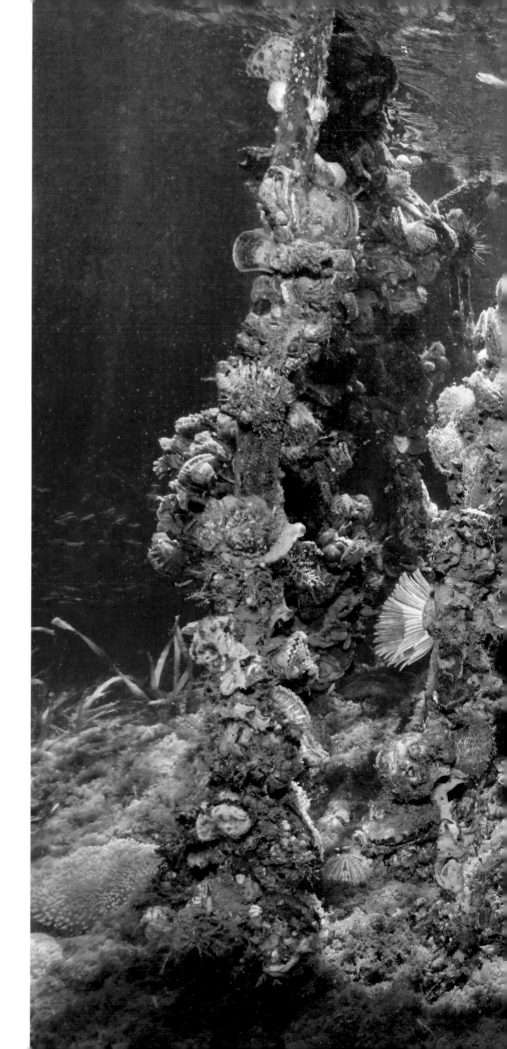

for sitting on the shoulders of Caribbean pirates such as Robert Louis Stevenson's fictional Long John Silver, sports its vibrant reds, blues, yellows and greens. Yet for an even more regal-looking bird travel into the highlands, anywhere from Mexico down to Panama. Up here, in the misty cloud forests, you may be lucky enough to spot the iridescent green of a resplendent quetzal. Its green feathers almost shimmer with golden greens, cobalt blues and sunset yellows, the hues changing depending on the light; all contrast with the blood-red feathers of its breast. As if these dazzling colours were not enough, the feathers of the quetzal's tail extend one-and-a-half times the length of its body. The resplendent quetzal is such a stunning creature that the people of the pre-Colombian empires, such as the Maya and the Aztec, considered it a divine being, making it a crime to kill these birds.

Feeding the World

The rich and diverse plant life of these rainforests results in a quite dizzying array of edible fruits, nuts and vegetables. There is one tree in particular, native to the Mexican rainforests, that makes the world a better

Above: Where rainforests meet the azure seas of the Caribbean, the plants diversify into mangroves, their roots rising above the saline water to 'breathe' and excrete salt. These swamps provide sheltered breeding grounds for a multitude of fish, including many commercially valuable species.
Right: Mangrove swamps, such as this one off the Caribbean coast of Panama with its roots entangled with colourful marine life, also protect the coast from the ravages of extreme weather, absorbing the sea's energy and preventing damage and flooding further inland.

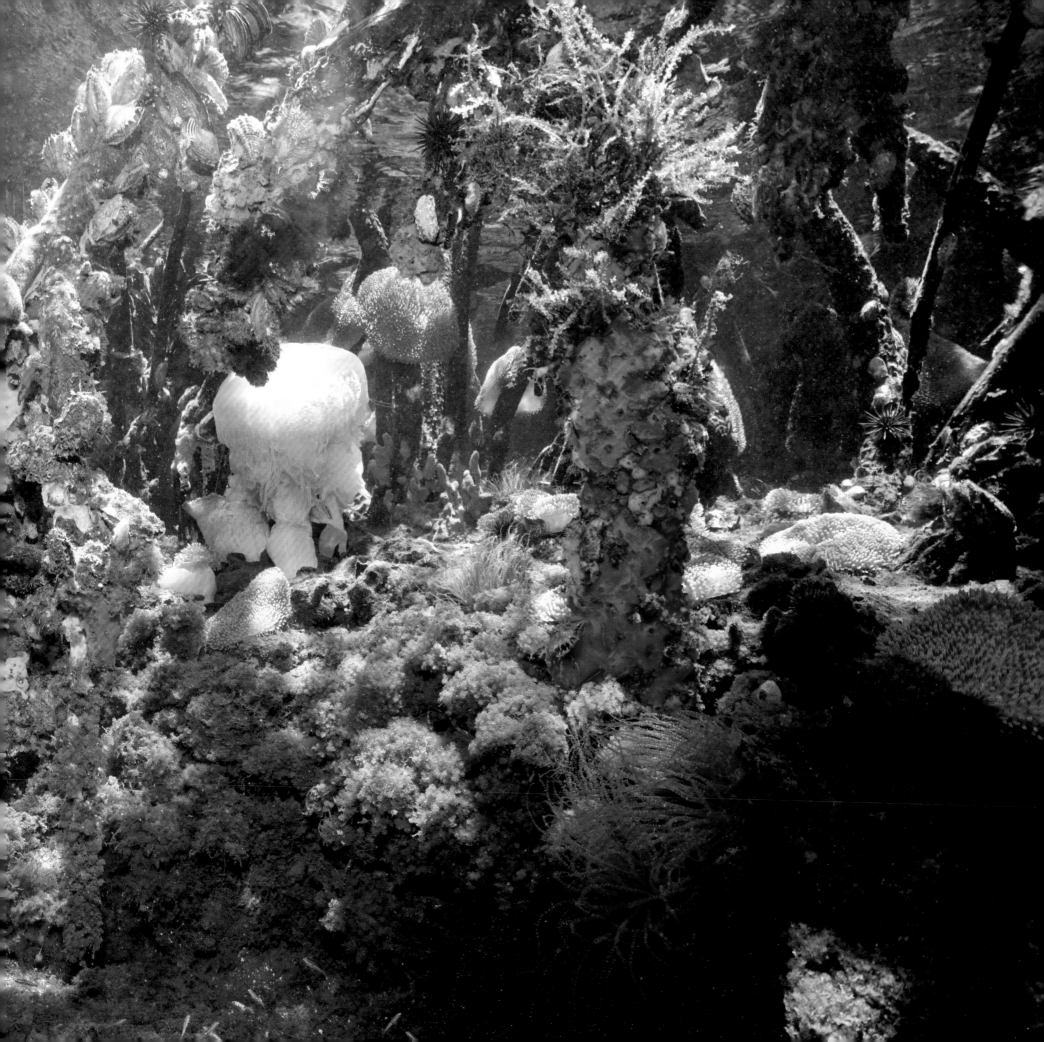

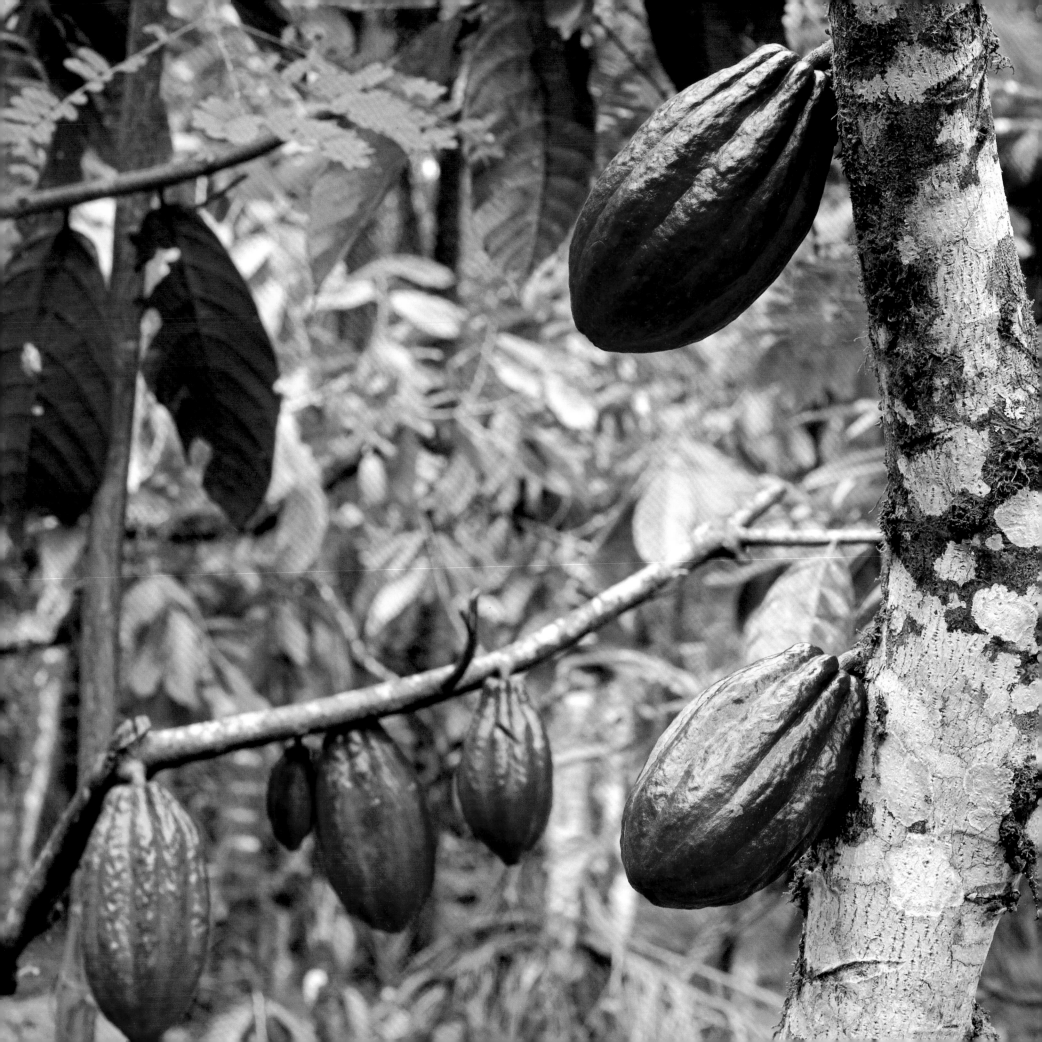

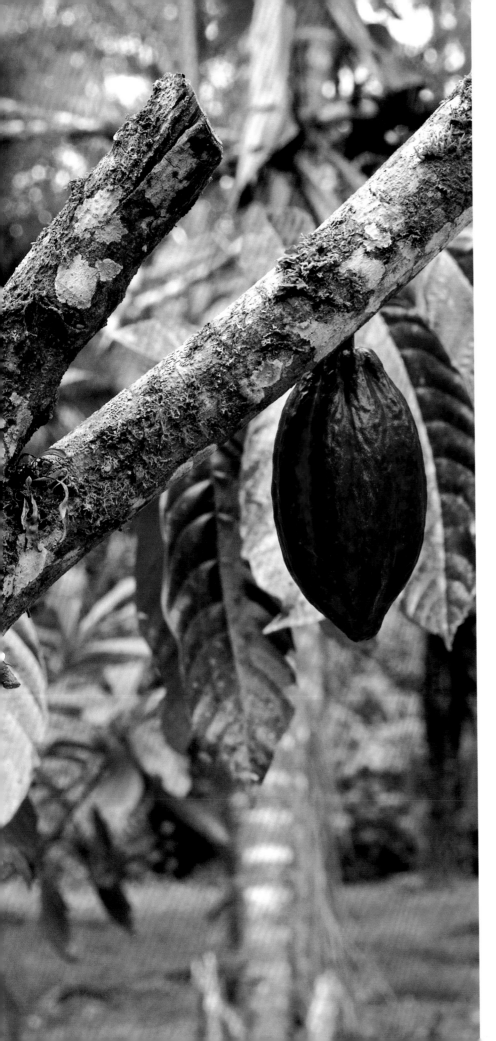

place. In the native Nahuatl the plant is called xocolatl: according to the Maya, it was a gift from the gods. Large seedpods grow from the trunk of this otherwise inconspicuous evergreen tree. Split open one of these pods and it will be full of large, creamy white beans. These are laid out on top of banana leaves, then covered with more of the same leaves and left to ferment; in the process they turn brown. The fermented beans are dried in the sun before being roasted, allowing the now brittle shells to be removed. The meat of the beans is then ground finer and finer, all the while adding sugar; slowly the rough, roasted beans form a thick, dark brown paste. Leave this paste to set and in the morning you will have a wonderful, silky, rich bar of dark chocolate.

Nor is chocolate the only confectionary to have its origins in these forests. Chewing gum, now more commonly made from a synthetic, butadiene-based rubber, used to be tapped from several species of rubber tree. This produced a sticky gum called chicle; it was chewed by the native American population to stave off hunger, freshen breath and keep teeth clean. Walk into any supermarket and you will find the fruit and vegetable isles are also full of foods native to the Mexican and Central American rainforest – avocado, papaya, chili pepper, vanilla and tomato – even if they may now be more associated with other parts of the world. As well as a variety of different food types,

Above: A farm worker grinding cocoa beans at the Hacienda Cacaotera Jesús Maria, Comacalco, Mexico.
Left: Ripe cocoa pods on a tree, Costa Rica.

each of these foods comes in a cornucopia of varieties. In Mexico, there are thought to be over 200 different types of beans and over 100 different chili peppers used in cuisine – and this is just from one country.

Of course, food is not the only product that these rainforests provide. The palms of the forest understorey have been used as roofing material, folded to make drinking vessels or wrapped around food, in the same way that we might use foil. While many of these uses have been superseded by more industrial products, the diversity of forest products, many still unknown, remains quite astounding. It is well acknowledged that rainforests are a treasure trove of untapped resources, just waiting to be discovered. As if to emphasize just how important these resources can be to people, a discovery from the Mexican rainforest just this year has found a new antibiotic, phazolicin. It is already helping in the fight against the ever-growing danger of resistance to our most widely used drugs. Just imagine what advances humanity might make if we keep such an astounding natural heritage and use its treasures as a library of untapped knowledge, rather than plundering its wealth for material gain.

Above: A highly venomous eyelash pit viper rests on a wild ginger flower in a Costa Rican rainforest. An arboreal species, the pit viper lives largely in the rainforest canopy, although here it is shown in the understorey.
Right: A juvenile green iguana gulps down a hibiscus flower in Costa Rica. These ancient-looking reptiles are primarily herbivorous. Their bright green colouration helps them blend in with the lush forests, camouflaging them against predators.

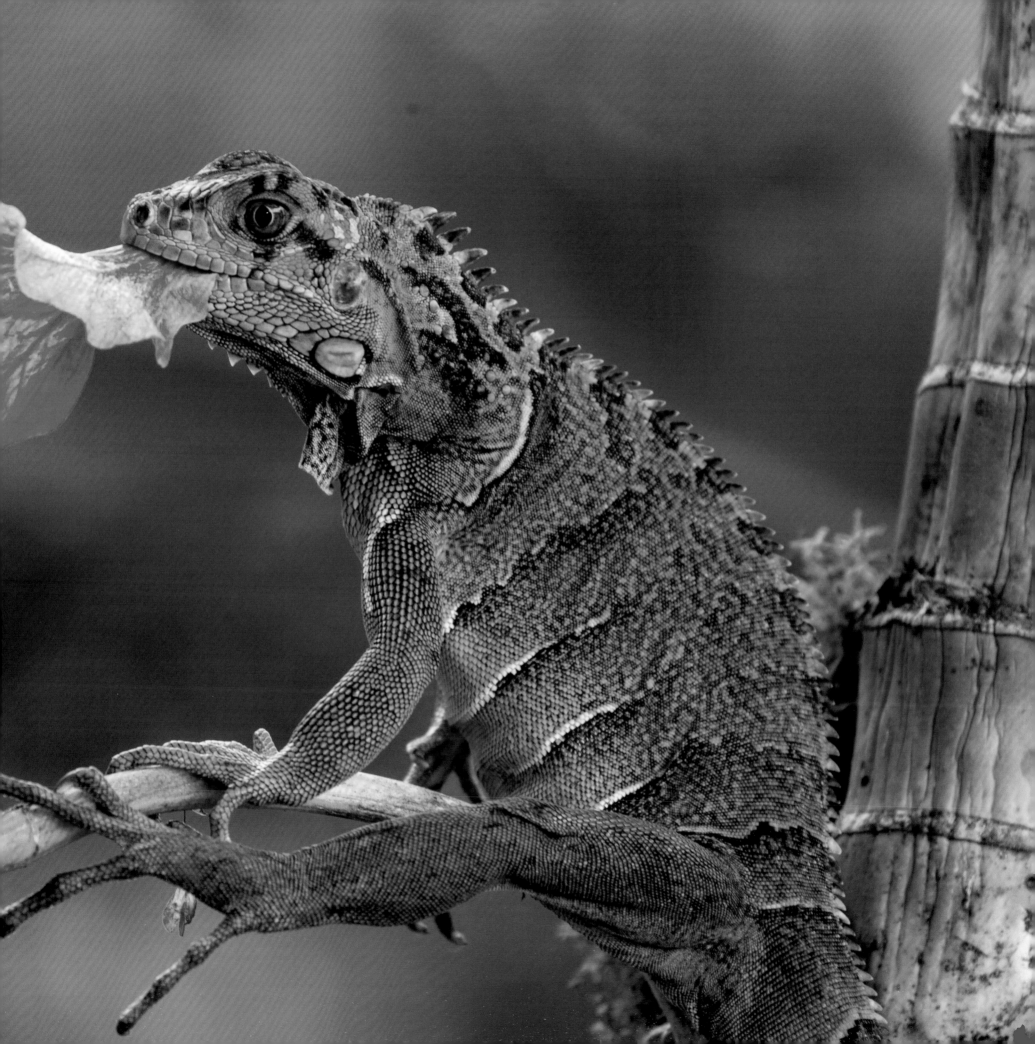

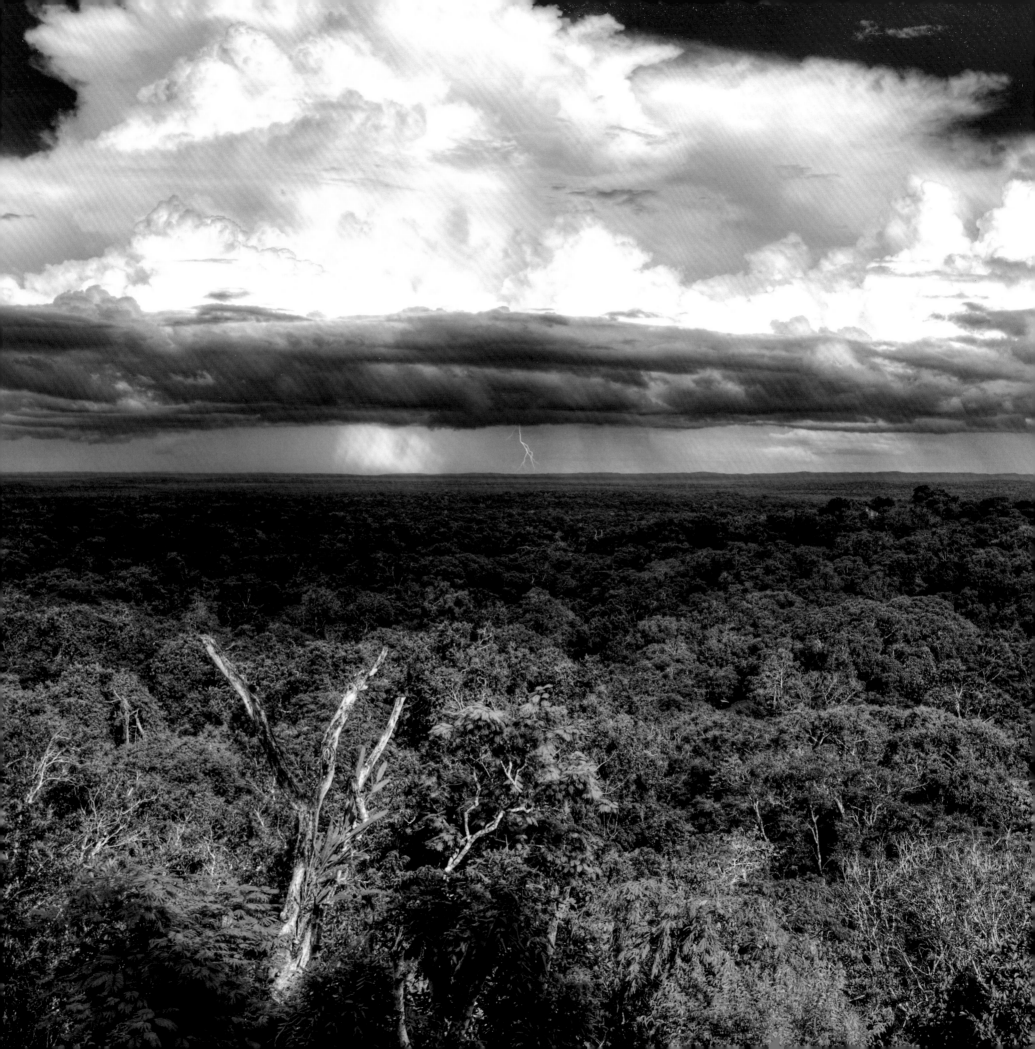

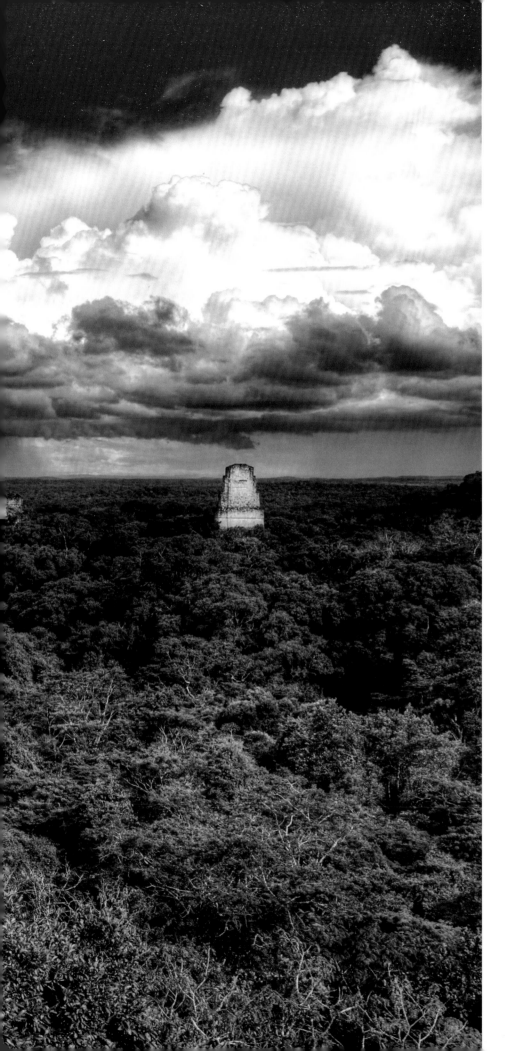

Deforestation and Reforestation

From Mexico down to Panama, the rainforests of this part of the world are diverse, species-rich environments. Yet ever since the first people arrived in the Americas some 16,000 years ago, the forests have been utilized for human gain. The harm their actions inflicted on the rainforest is a question of degree. While the native Mesoamerican inhabitants, such as the Mayans, consumed large quantities of wood and thinned yet more for agriculture, rainforest is still believed to have covered approximately 90 per cent of the region when Europeans first arrived in 1492. On average, forest cover today is lower than 50 per cent; El Salvador has just 21 per cent of forest cover, and less than 2 per cent of that is old, primary rainforest.

The deforestation was initially driven by European demand for cash crops such as sugar and cutting wood to fuel the refining process. Much of the eighteenth to the twentieth centuries saw the felling of the giant mahogany

Left: The ruins of Tikal in Guatemala, one of the many Mayan temples, rise up above the rainforest.
Below: A white-nosed coatimundi skitters up the stairs of one of the many Mayan temples scattered across the Mesoamerican forests – once home to an advanced, highly educated civilization.

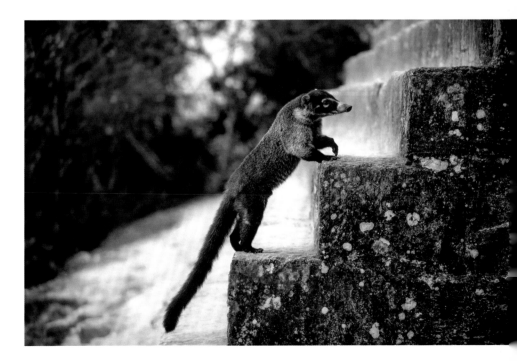

trees, sent to cabinet makers in Europe. This shifted in the 1960s to clearcutting, the complete removal of all trees of any size, in order to open up grasslands for cattle ranching – often linked with the fast-food burger industry, but more generally linked to an increasing global demand for beef. Meanwhile an even less savoury business is also having a devastating impact on these tropical rainforests. The narcotics industry has complex links to deforestation through practices such as road-building, ranch-land creation to facilitate money laundering and the conversion of land within protected forest areas.

It is not all bad news, however. Up until the 1970s, the most heavily deforested country in the region was Costa Rica, named for the 'rich coast' that Columbus observed. However, since the 1980s, this forward-thinking country has increased its forest cover from 21 per cent to 52 per cent today. This increase in forest cover was linked to economic ideas that prioritized long-term prosperity over short-term economic gain. The simple logic was built in part around the country's ability to generate its own power supply. Being such a water-rich nation, the logic was that if people increased rainforest cover then they would increase the amount of water in their rivers; this in turn could be used to generate more hydroelectric power. The concept worked, and today 92 per cent of Costa Rica's domestic power comes from renewable sources.

In addition, the increase in transnational travel for pleasure was opening the world up to tourism. Recognizing the beauty of their rainforests, Costa Rica strove to increase their ecotourism offering. Again the country was successful: tourism today is a bigger contributor to its national GDP than the three main cash crops of bananas, pineapples and coffee combined. It is not just the tourism and hydro-power industries that have benefited, however. The clean air generated by the expanded forest cover is attracting

Right: Emberá, an indigenous people of Panama and Colombia.

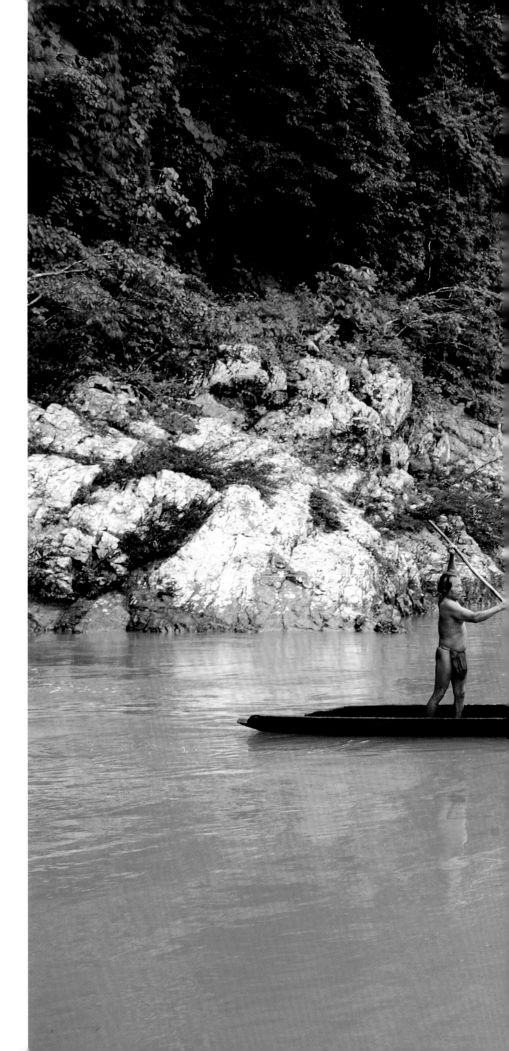

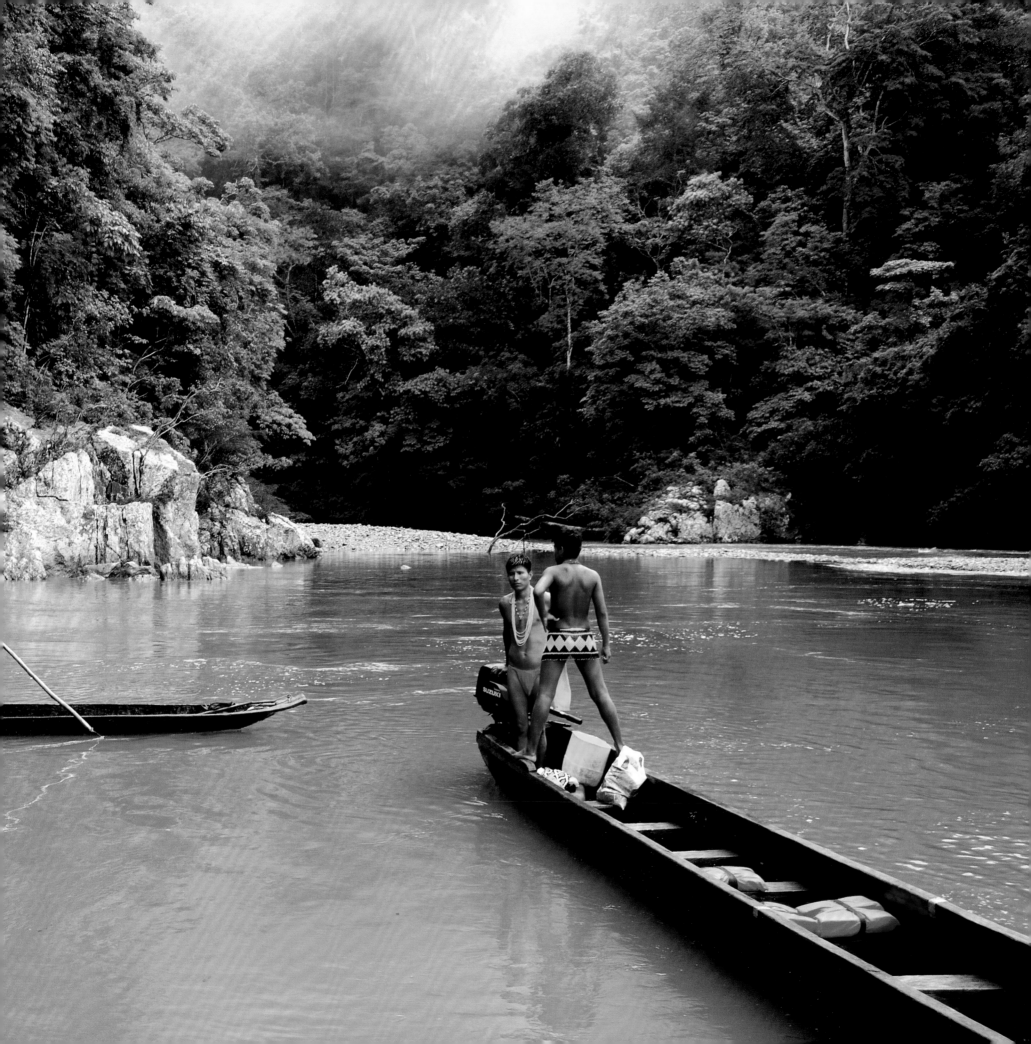

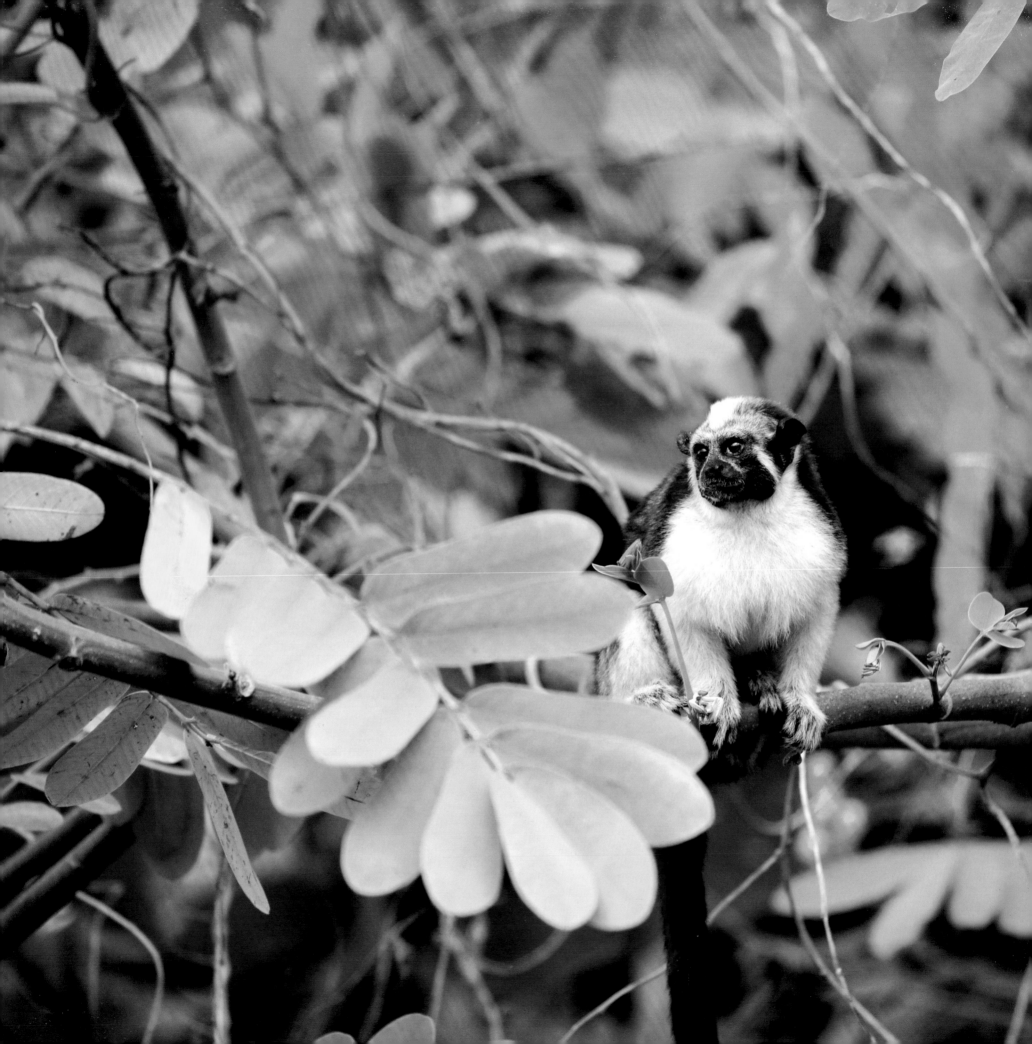

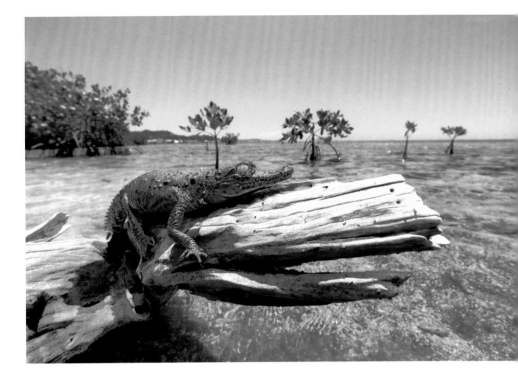

international investment from high-tech businesses that require clean air in which to produce their delicate, electronic components.

All in all, there has been a marked improvement in Costa Rica's economy. The per capita GDP has increased dramatically and the population is ranked as having the greatest wellbeing in the world, with a longer life expectancy than the people of the USA. Such forward thinking should encourage us to be positive about the conservation of these forests, as it has certainly encouraged some ambitious projects. One such project, 'Paseo Pantera' or the 'Path of the Panther', aims to connect all the rainforests and core jaguar populations of Mesoamerica, from Mexico right down to Panama; some even have ambitions for this to extend to the southernmost range of the panther in Argentina. The ambition of such a multinational project surely provides motivation for continued optimism regarding the future of what remains of the world's rainforests.

Above: An American crocodile basks in the early morning sun on the edge of a Honduran mangrove swamp. She is waiting for sunlight to warm her blood sufficiently to go hunting for fish.
Left: The world's rainforests contain many species of primate, including the small tamarin monkey. This one pauses in its foraging of the Panamanian forest.

South America

'So tomorrow we disappear into the unknown… we are really on the eve of some most remarkable experiences.'

Sir Arthur Conan Doyle, *The Lost World*

The word 'rainforest' immediately evokes the Amazon, mightiest of all the forests and rivers in the world. This forest dominates South America and countless explorers have ventured into its depths; even today, many people still look to these great forests for adventure and discovery. The Amazon forests were home to people long before Columbus first came to the shores of the Americas. It has been estimated that before his arrival as many as 8 million people lived in the Amazon forests.

The Mighty Jungle

Named after the mythical *Amazónes* tribe of warrior women from Greek legend, it is not without good reason that the Amazon is considered the mightiest of all the jungles. As may already be apparent, describing the Amazon in terms of the world's other rainforests is an exercise in superlatives. This rainforest covers nine countries, well over 6 million sq km

Right: A jaguar rests on a branch in the Peruvian rainforests. It is waiting for darkness to fall, when it will blend into the forests to stalk its prey.

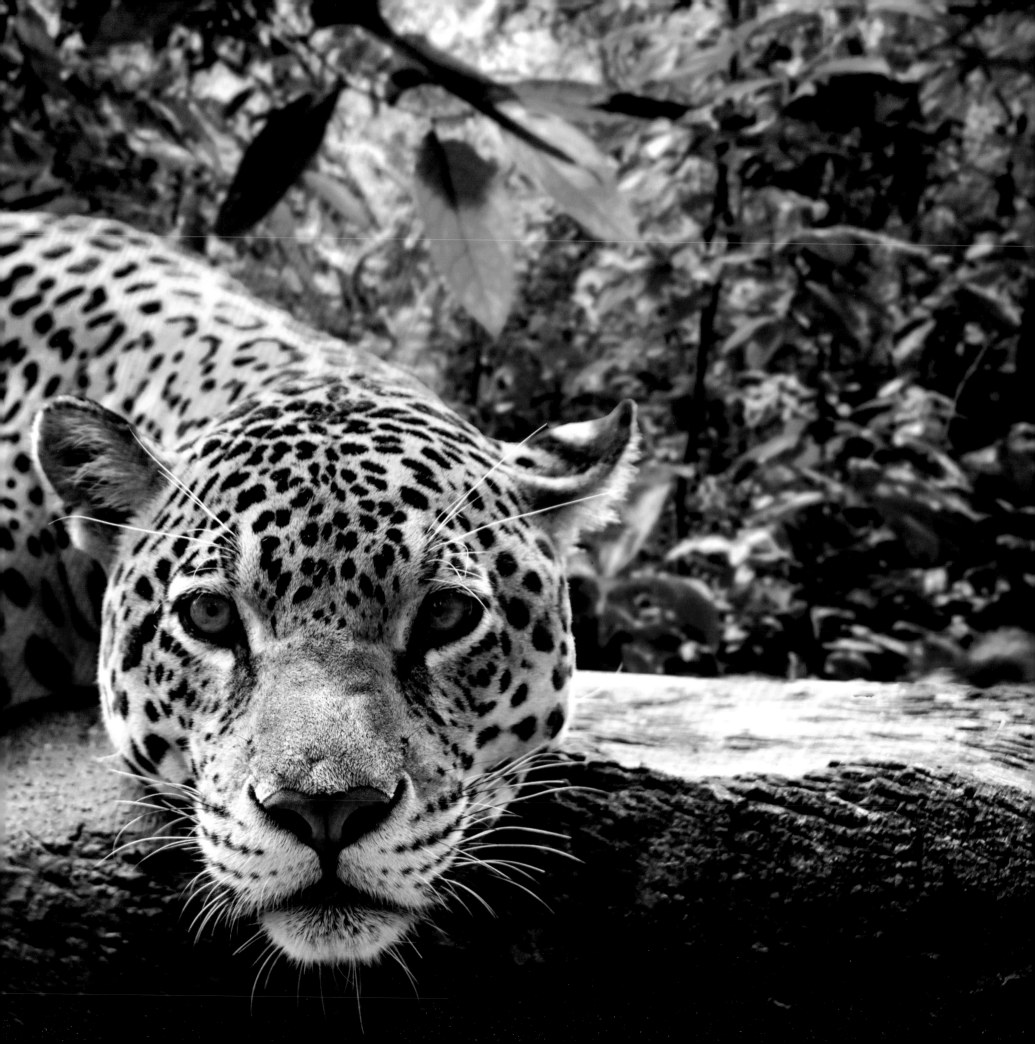

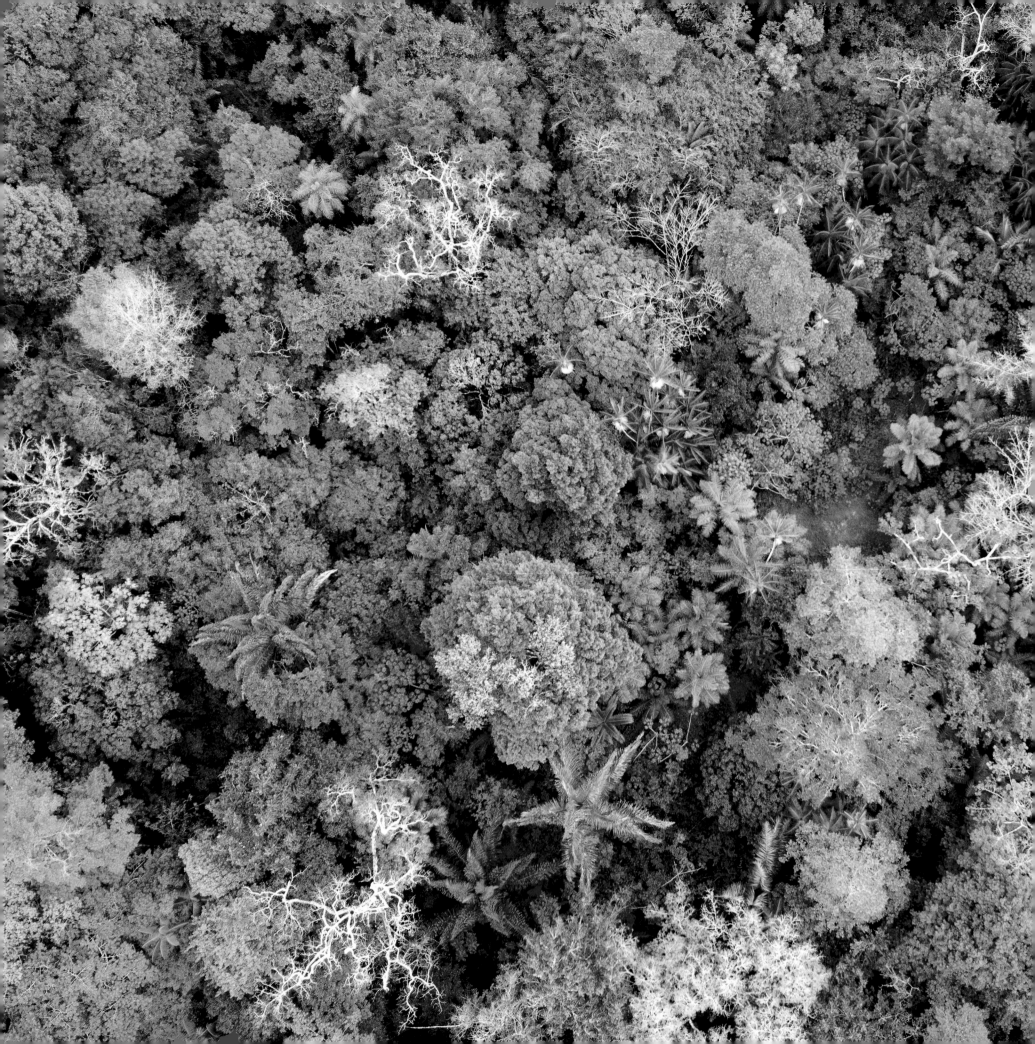

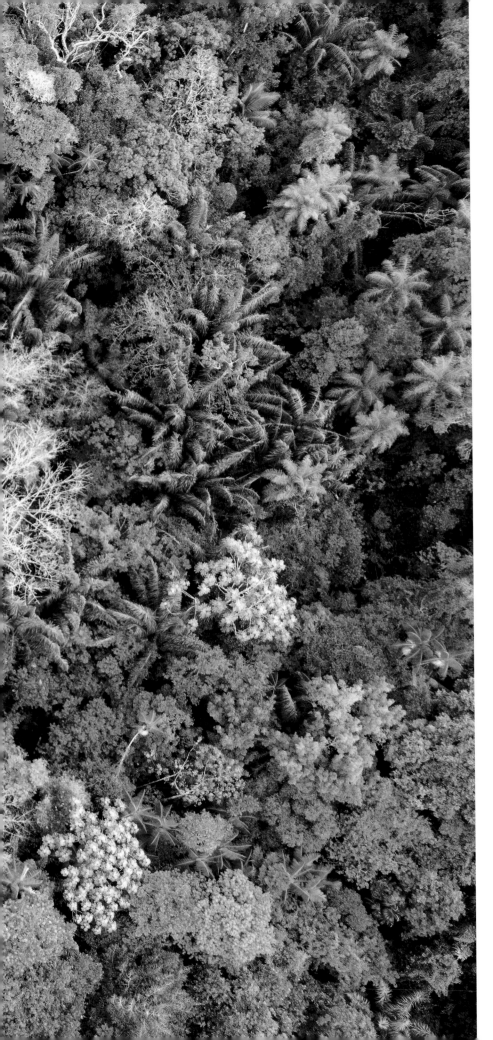

(2.3 million sq miles), 60 per cent of which is in Brazil; it is the largest rainforest in the world, accounting for over half of all rainforest still remaining on Earth. Being the largest rainforest on the planet also means that its biodiversity is unparalleled: an estimated 10 per cent of all species on Earth live in the Amazon rainforest.

The forest of the Amazon consists of an estimated 390 billion individual trees, thought to include up to 16,000 species (although this is only an estimate, as so far just under 7,000 have been scientifically verified). A single square patch of Ecuadorian rainforest, measuring just 250 m (820 ft), was found to contain a staggering 1,100 tree species. Trees, of course, are nowhere close to being the most abundant form of life in these forests; this title is held by the insects. Somewhere in the region of 30 per cent of the Amazon's biomass is attributable to insects, only a tiny fraction of which, around 100,000, have been described by science. It is likely that over 2.5 million insect species occupy these immense forests.

The huge species diversity of these forests is partly due to their tropical location, but largely to periodic climatic fluctuations and the ever-changing path that rivers and tributaries forge through the forest landscape. In fact, the rivers of the Amazon are integral to this forest – so much so that 14 per cent of the Amazon could be classified as wetland, making it the most extensive area of freshwater wetlands in the world. Much of this water comes from the Amazon river itself. However, the rainforest of this region also covers the Orinoco and Paraná watershed complexes, which are themselves connected to the Amazon by a natural canal called the Casiquiare. Altogether they form a massive rainforest complex.

Left: *The Amazon rainforest from above, Curuçá, Pará State, Brazil.*

The Amazon rainforest remains deeply connected with humanity. Of course, with such abundant natural resources, the region is under sustained and increasing pressure from human activities. These come in a range of guises, including damming the rivers to provide hydroelectric power, extracting timber for furniture and mining for the valuable oil and gas reserves beneath the forest. Each of these results in deforestation. Yet the single biggest driver of forest loss is the conversion of the land for cattle grazing. Remarkably, the primary aim of this cattle grazing is not necessarily to produce food or leather; rather it is to establish land claims which can then be sold for profit to businesses that do not wish to be implicated in deforestation activities.

In addition to cattle, large tracts of the forest are cleared for soy plantations. The soy is then exported for human consumption, either

Right: The Amazon rainforest in Manu National Park, Peru.
Below: Meaning 'big water' in the native Guarani and Tupi languages, the Iguazu Falls are the largest waterfall system in the world. They extend over 2.7 km (1.7 miles).

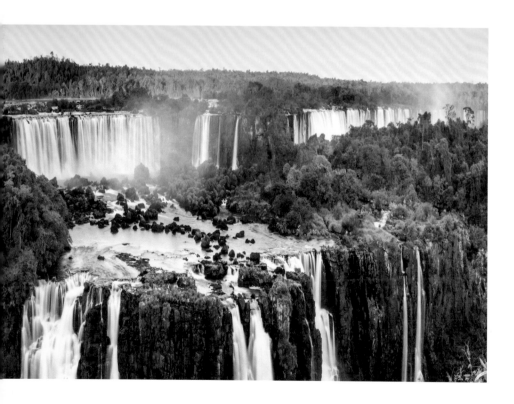

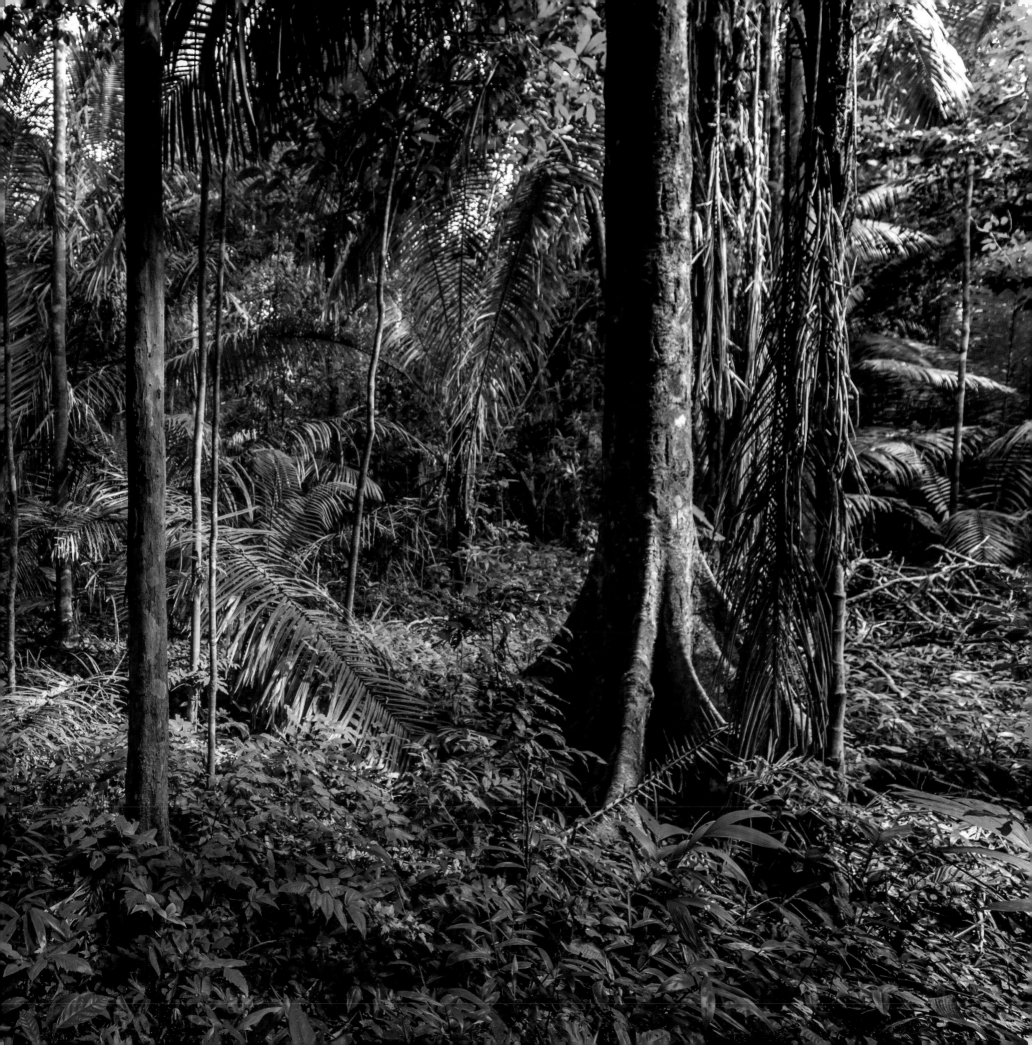

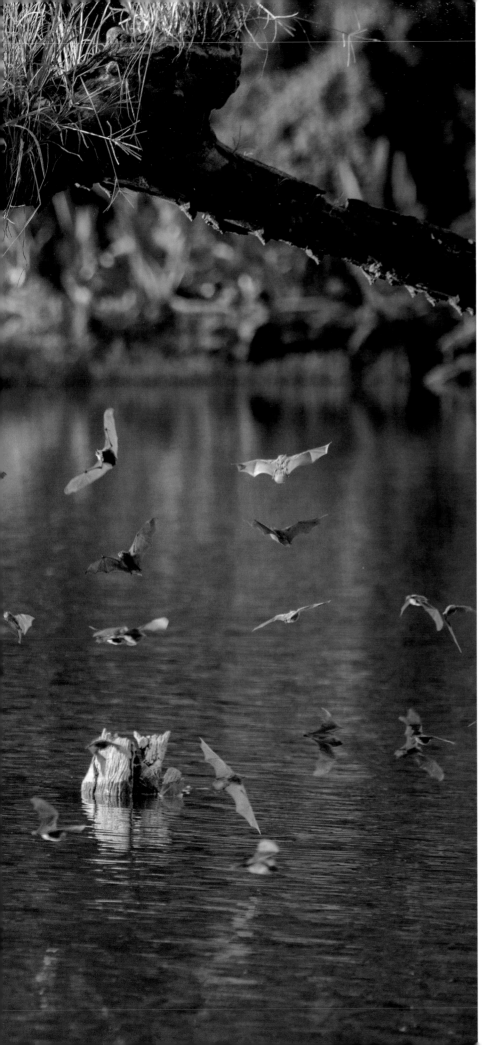

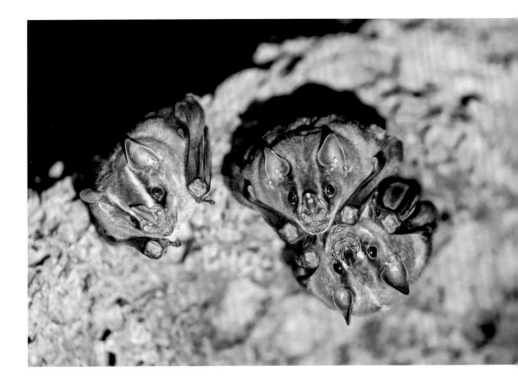

directly, or indirectly as feed for beef cattle. In the UK, for example, much of the winter feed for cattle is comprised of soy. Ultimately, it is the global demand for meat that drives most of the deforestation in the Amazon, both of which are increasing year on year.

Massive Biodiversity

The scale of biodiversity in the Amazon rainforest is difficult to comprehend. The ecologist Professor Edward O. Wilson has made a useful comparison; a single bush in the Amazon may contain more species of ants than the entire British Isles; leafcutter ants, army ants, bullet ants, acrobat ants, carpenter ants and countless more. While mammals are probably the least abundant group, they are still very diverse; over 430 species have been identified so far, and more are being discovered every year. Over one-third of these mammals are bats, helping to keep the millions of insect species in check. Many bats do not rely on insects for their food, however. Instead they

Above: *Vampire bats, Manu National Park, Peru.*
Left: *Bats foraging for insects, Manu National Park, Peru.*

prefer fruits, the seeds of which they disperse, or even nectar, the foraging of which leads to flower pollination for many species of plant. In fact, these winged mammals are crucial in the life cycle of many plants, and thus play a prodigious role in the health of the rainforest.

Unfortunately, the reputation of bats has perhaps been sullied by three particular bat species, collectively known as the vampire bats – named after the European folklore which they have influenced. While these bats have been known to feed on human blood, they are rarely dangerous, except in vary rare cases when they transmit rabies. Certainly vampire bats can be credited with saving more lives than they are responsible for ending. Scientists have synthesized the anticoagulant in the vampire bat's saliva, which allows blood to flow freely from the site of a bite; it is now used as a drug to treat heart attack victims. If you still doubt the importance of bats you only have to look to bananas, cashew nuts, avocados and many other common forest foods, all of which have a life cycle that depends on bats.

Of course, while bats are largely harmless and the warrior women of the *Amazónes* are no more a threat than the dinosaurs of *The Lost World*, there are still plenty of things in this deep wilderness that can bite, sting, poison, crush or shock. The most charismatic is probably the jaguar, distant cousin to Africa's leopard. This powerful predator, its ochre-yellow coat camouflaged with black rosettes, is a key species in regulating the populations of many of the forest's large herbivores. But it is not just mammals that pose a threat. Lazily winding its way across swampland or sunning itself on low-hanging branches over water can be found the anaconda. This enormous behemoth of a snake has been known to grow up to 5 m (16 ft) and to weigh almost 100 kg (15½ stone). What distinguishes these snakes is their massive girth. This is all muscle, and the snakes use this enormous strength to squeeze their prey until it is asphyxiated. There

Right: A rare black panther in Ecuador's Yasuni National Park. These melanistic individuals still have the same markings as their lighter littermates, but it is disguised in the blackness of their coats.

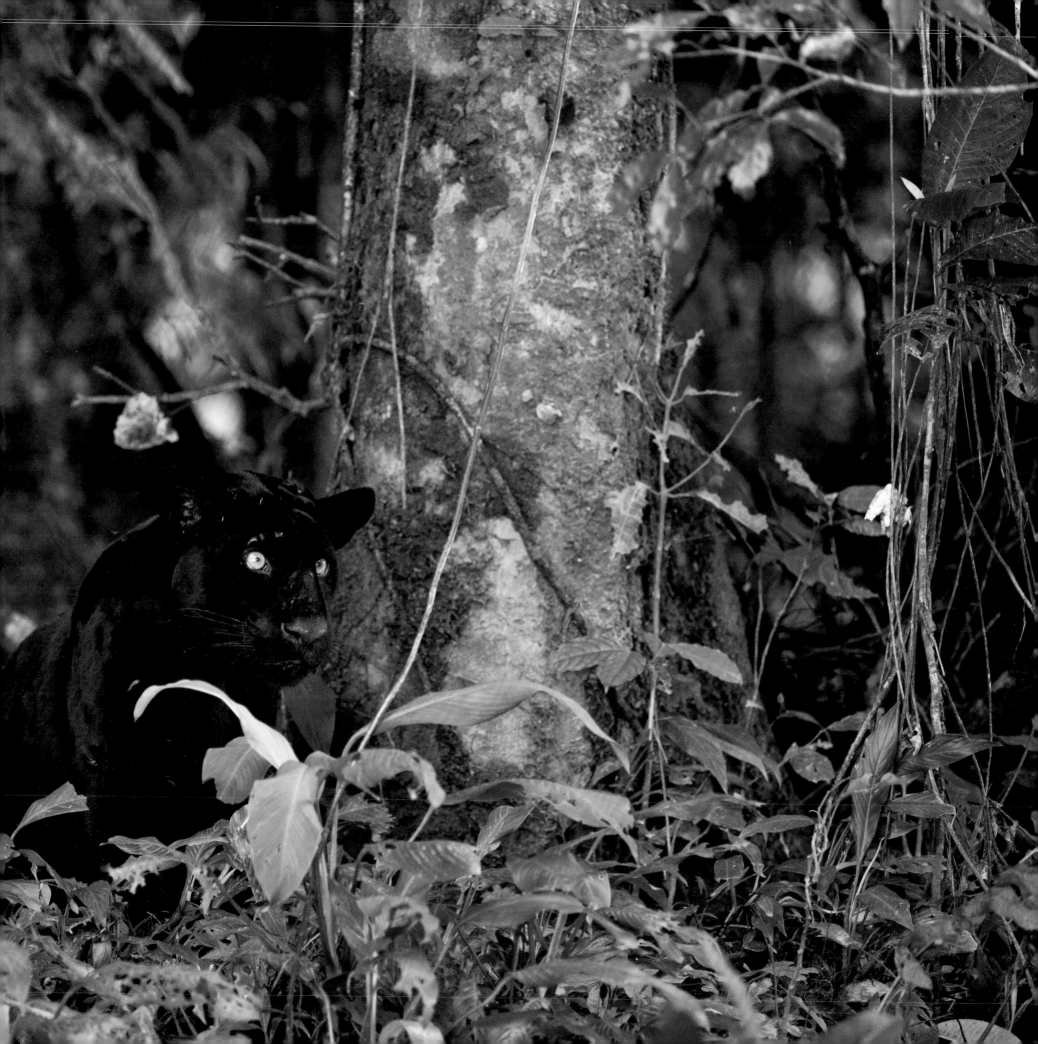

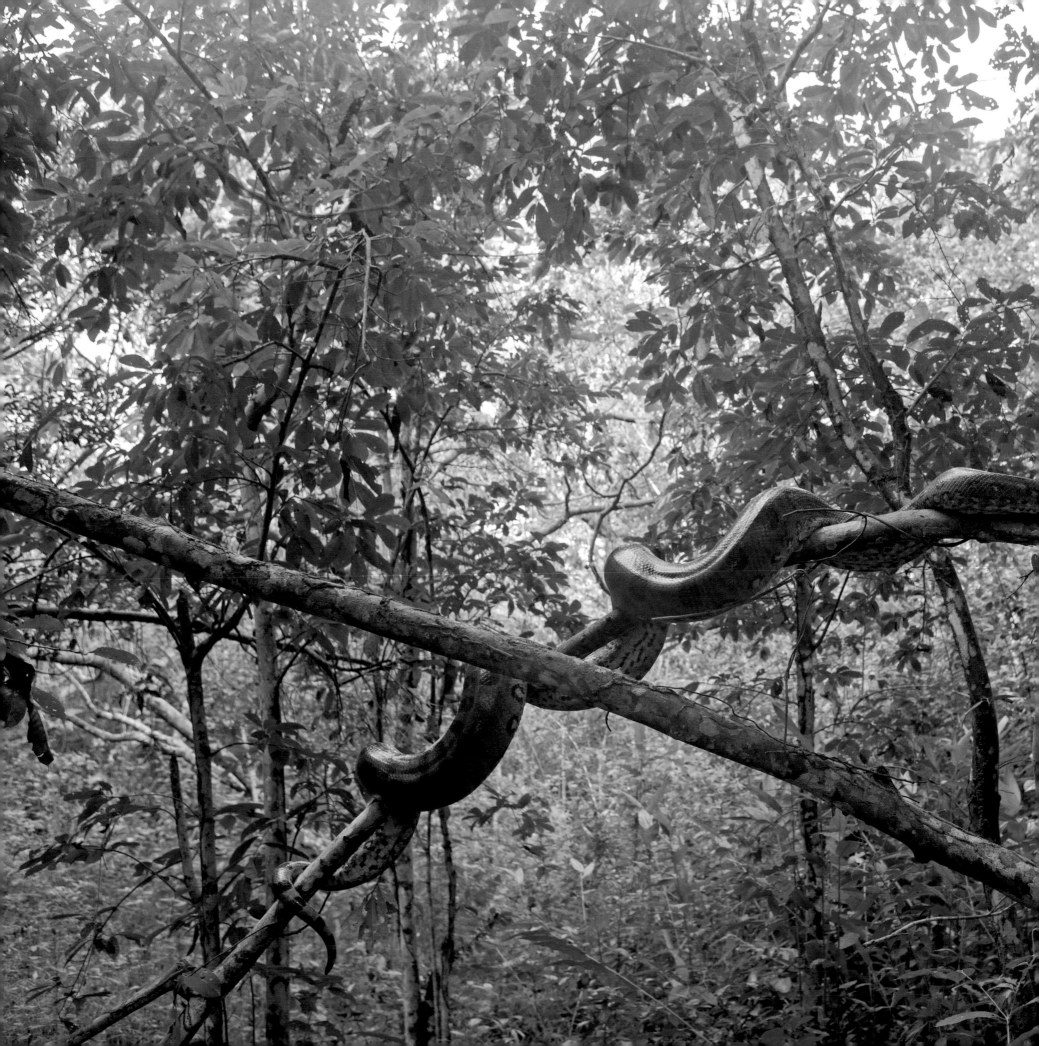

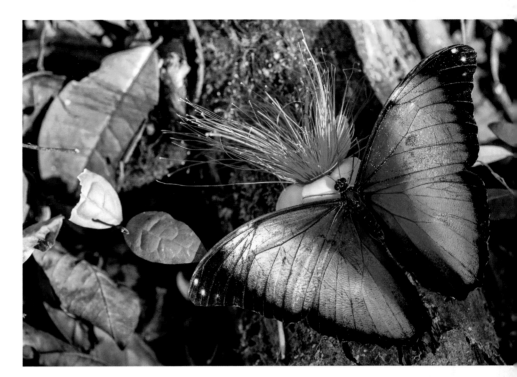

is nothing in these forests that they cannot tackle, although there has never been a record of an anaconda eating a human.

For the arachnophobes out there, the Amazon is perhaps somewhere to stay clear of, with an estimated 8,000 species of spider scuttling through these forests. But before the spiders or snakes put you off the Amazon, consider this: you will miss out on the jewels of the rainforest, the simply stunning spectacle of thousands of wondrous butterflies. There is no combined estimate of how many species of butterflies can be found across the region, but it has been suggested that this rainforest may contain 25 per cent of the world's species. As an example, one small reserve in southern Peru, Tambopata, has an estimated 4,000 butterfly species. Of all these butterflies, the striking blue morpho is hard to miss, its males having a wingspan of up to 20 cm (8 in) and flash iridescent ultramarine in the sunlight.

Above: A blue morpho perched on a flower, Mount Itoupe, Table Mountains, French Guyana.
Left: A green anaconda rests in the dappled morning light of the Brazilian Amazon. It absorbs the heat of the sun's rays that slowly warm its cool blood.

It is not just the butterflies that astound. Wake up with the first glow of dawn breaking across the canopy and you will be greeted with an orchestral cacophony of bird song from the estimated 1,300 species of birds. Three hundred species of humming birds in all colours of the spectrum, their wings beating at more than a thousand beats a minute, feed on the nectar from the flowers of the forest; toucans, their oversized bills gulping down fruit, will also feed on insects, snakes and the eggs of other birds. Above it all, giant harpy eagles glide through the canopy, looking out for the monkeys or sloths that are its prey.

Amazon River

As well as being home to the largest area of rainforest in the world, the mighty Amazon drainage basin is the largest river system on Earth. Every second an astonishing 175,000 cubic m (6,180,067 cubic ft) of water flood out of the mouth of this enormous river into the Atlantic Ocean. That is around one-fifth of all river outputs from the world's continents combined. In a single day, the Amazon river produces the equivalent amount of water to that consumed by New York over a nine-year period.

The waters are classified into three types: whitewater, blackwater and clearwater. This nomenclature, based on water colour, was first described by one of the fathers of evolutionary theory, Alfred Russel Wallace. Whitewater actually tends to be milky brown in colour, carrying a large amount of sediment and supporting high levels of biodiversity. These whitewaters tend to be found in the major channels and the seasonally flooded forest or *várzea*. The whitewater of the main Amazon channels is loaded with so much silt that its deposition at the mouth of the river has resulted in an island, Marajó. The world's largest river island, Marajó is comparable in size to Switzerland; it has a population whose daily life

Right: *A lettered aracari toucan, Yasuni National Park, Ecuador.*

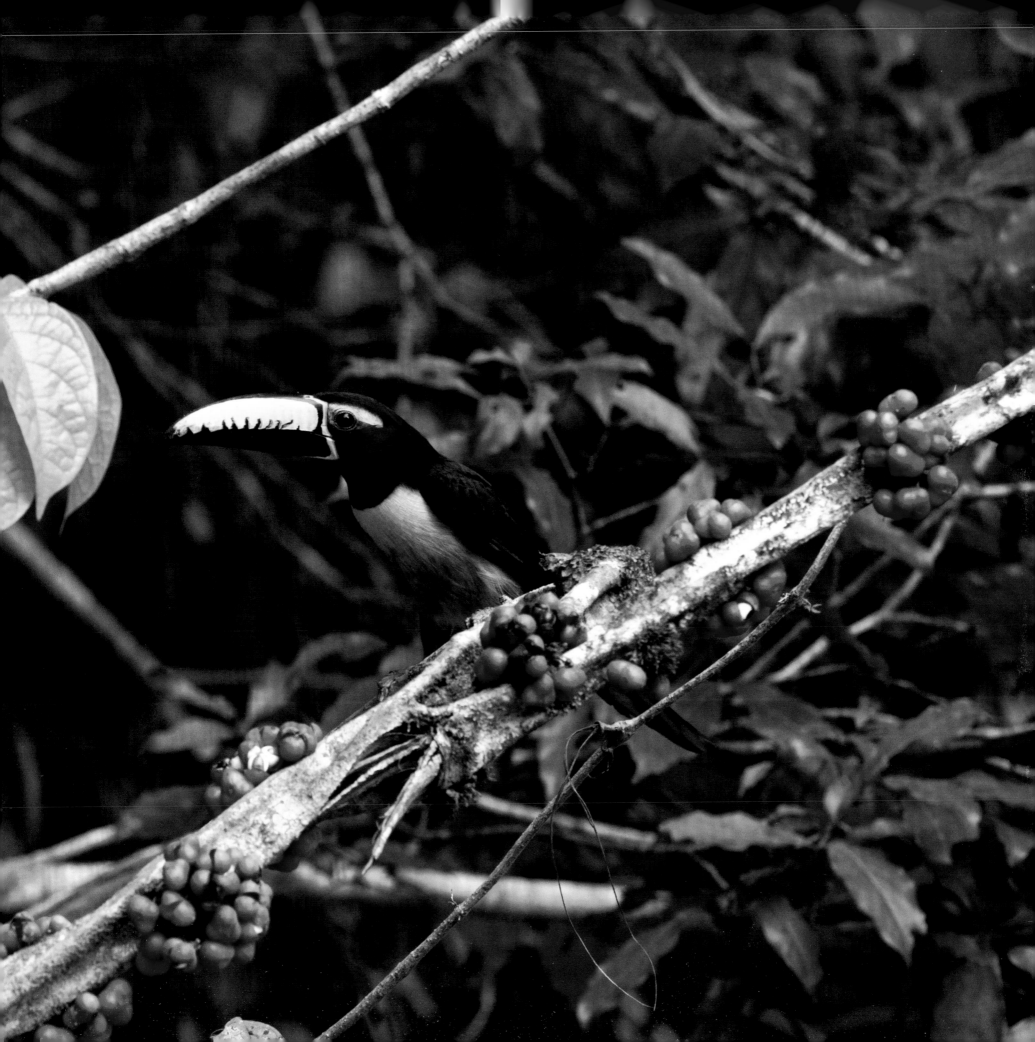

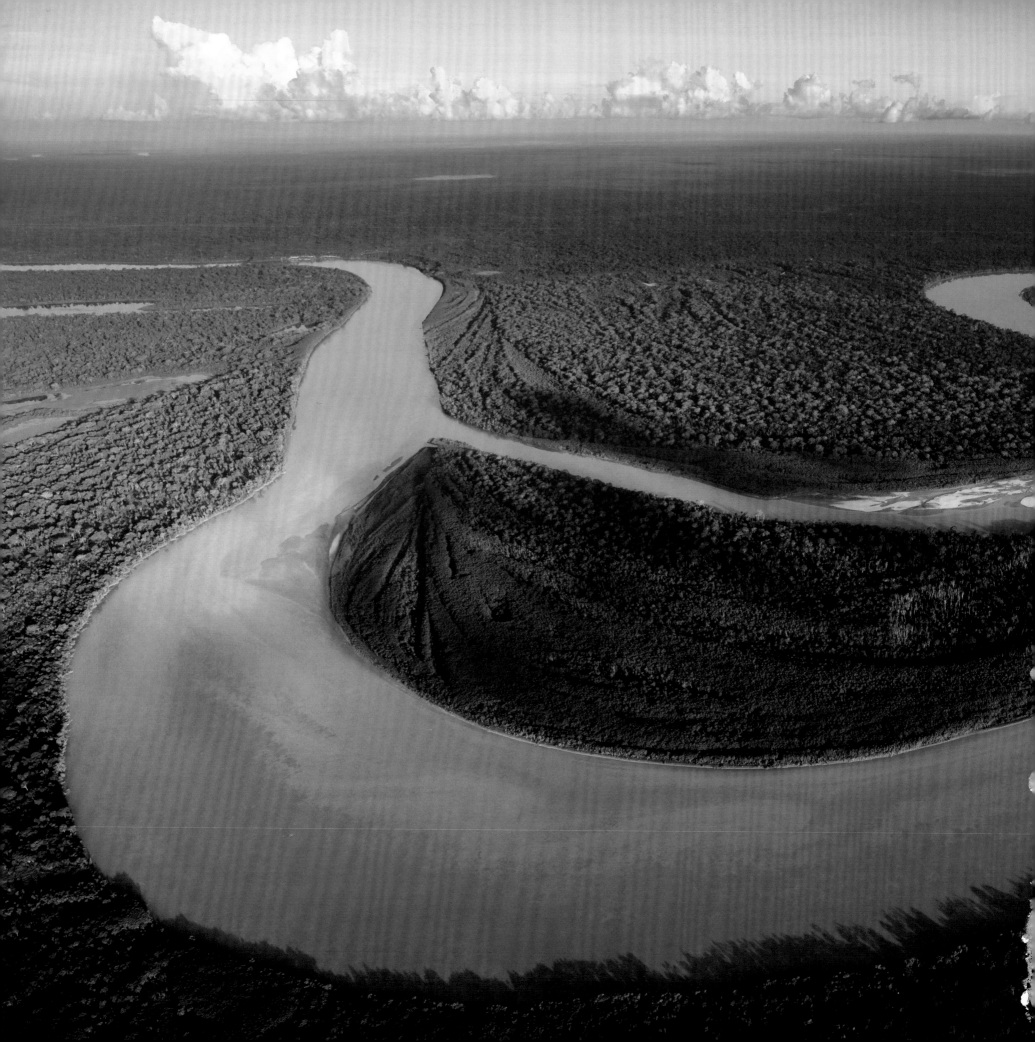

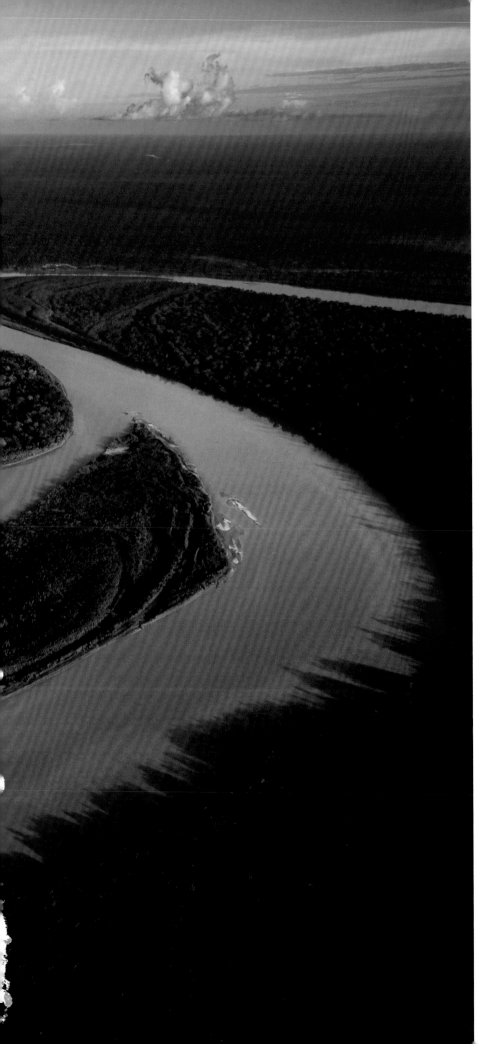

revolves largely around the 450,000 strong population of Asian water buffalo. The origin of these buffalo is unknown, but the population has adapted to their presence so well that their police force even uses them as mounts instead of horses.

Away from the whitewater of the Amazon's main rivers can be found the blackwater of the slower-flowing channels. These meander through the thick forested areas and swampland, leaching tannins into the water as they pass. These tannins make the water a dark whisky or tea-stained colour, hence blackwater, and also increase their acidity, which dramatically changes what species can thrive in such waters. The final type of water is clearwater. As its name suggests, these waters are very clear, perhaps with a slight greenish tint; they have very low levels of sediment and low nutrient loads.

While different types of water often share species, especially where they meet, in most instances blackwater and clearwater are separated by

Above: Cowboys herd some of the many thousands of buffalo that have become the lifeblood of Marajó, at the mouth of the Amazon river.
Left: The river winding through pristine Amazonian rainforest, Bolivia.

whitewater, and so the species found within the former two do not mix. Over millennia, this division has resulted in significant speciation within the different river types, resulting in the richest freshwater fauna in the world. The Amazon basin is estimated to support 9,000 fish species or 30 per cent of all freshwater fish. Of these 9,000 species, only 3,000 have so far been described by science.

The best-known of the Amazon's fish species is probably the piranha, a fish with a reputation for skeletonizing a human in seconds. Fortunately, this reputation is unfounded. Although occasional attacks on people are reported, they are rare and tend to occur when the fish are stressed, due to drought or lack of food. In contrast the electric eel, which is in fact a type of knifefish, does deserve its reputation; it is capable of delivering an 860-volt shock, similar to that of a stun gun. The electric eel has four-fifths of its body dedicated to three unique types of organ that, combined, can produce either a mild or strong electric current. The eel uses the mild current to 'feel' for its prey in the murky water. It can also use quick bursts of high-voltage pulses to cause prey to twitch

Right: The boto, otherwise known as the Amazonian or pink river dolphin, is widespread throughout the larger tributaries of the Amazon and Orinoco rivers, but is rarely seen by humans.
Below: A caiman gulps down its evening catch, a large piranha – one of the many fish that form the majority of its diet.

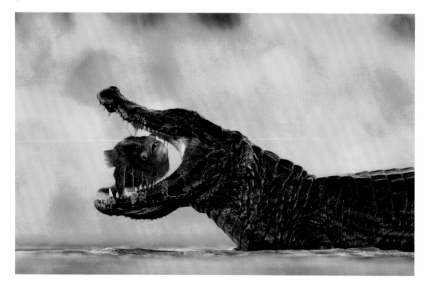

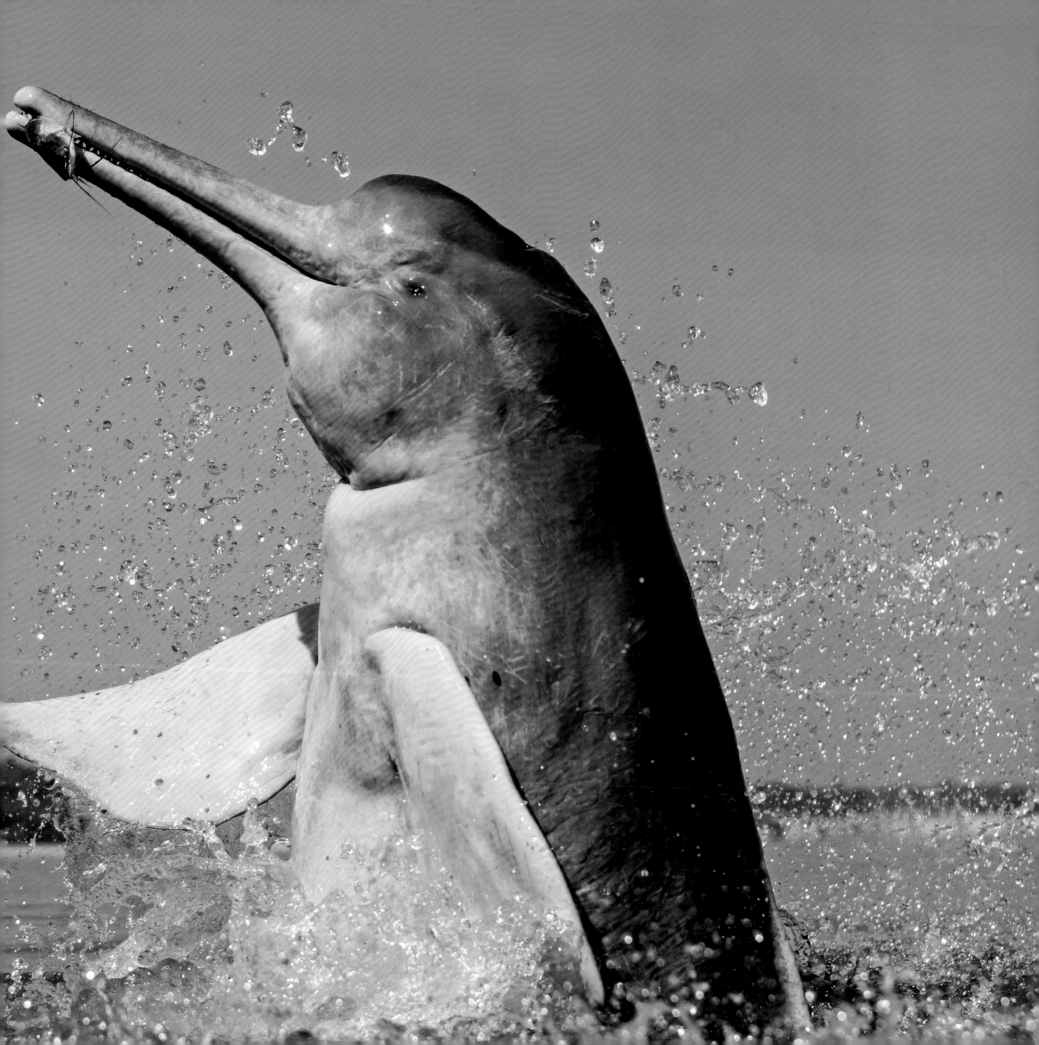

involuntarily, so giving away their location. Once detected, the eel fires multiple high-voltage pulses, approximately 400 a second, to stun or paralyse its victim.

The largest fish in these waters, by a large margin, is the arapaima. These living fossils are among the oldest fish on the globe, having gone almost unchanged for over 23 million years; they can measure up to 3 m (10 ft) in length. Due to the relatively low oxygen levels in the Amazon, this fish has evolved to surface for air every 10 to 20 minutes. They are also armoured with scales to prevent piranhas from being able to eat them. In fact their scales are so tough that engineers are studying them to improve modern materials.

If you find yourself on a boat on the Amazon and see a pink dolphin jumping out of the water, do not worry – you have not drunk too many Caipirinha cocktails. This is the elusive Amazonian pink river dolphin; it has pinkish-grey skin to camouflage itself in the murky waters and is a freshwater cousin of the more common oceanic dolphins. In Amazonian folklore the dolphins are enchanted shapeshifters, living in magical underwater kingdoms. In the evening they are believed to transform themselves into handsome men, attending parties to seduce young girls. However, they cannot fully transform from their true dolphin selves so, to disguise their blowhole, they must always wear a white hat.

While these dolphins are a freshwater species, a number of normally marine species have adapted to live in the rich Amazon waters. It is not uncommon to find bull sharks in some of the main channels; they have indeed been found as far as 4,000 km (2,485 miles) from the sea. Females will often seek out freshwater areas to give birth to their young, which are born fully formed measuring around 60 cm (24 in). While still vulnerable,

Left: *Phallale mushroom, French Guyana.*

there are fewer predators in the shallower rivers than out at sea, giving the young pups a greater chance of survival.

All in all the Amazon river, and its collection of inhabitants, form a quite remarkable aquatic world that supports the most impressive tropical forest on Earth.

A Living Wonderland

The tropical forest that is the Amazon supports an astounding mass of life – a fact that is all the more astounding given its thin, nutrient-poor soils. Like all rainforests, the high diversity of life extends to the detritivores, fungi and bacteria that decompose anything dead that falls to the canopy floor, from branches and leaves to sentient life. This decomposition would normally produce rich soils, but in these forests the subsequent uptake by trees and plants is so rapid that the soils themselves remain thin. Many of the additional nutrients that the Amazon forest requires to maintain its rich plant life actually arrive in the form of dust, blown across the Atlantic Ocean from the Sahara Desert. For example, the Amazon acquires approximately 20,000 tonnes of phosphorous each year from Saharan dust. This is just another example of connectivity between the Earth's great ecosystems; even ones as different as the desert and the rainforest rely upon and support each other.

No matter the source, the Amazon rainforest is hugely rich in plant life, which in turn supports a huge diversity of animal life. Take the bromeliads: this family of flowering plants has around 3,500 species, most of which are found in the American tropics. They are usually characterized by fleshy,

Right: Hoatzins surrounded by bromeliads, Napo Basin, Ecuador.
Inset: Pineapple plant, Sao Paulo, Brazil.

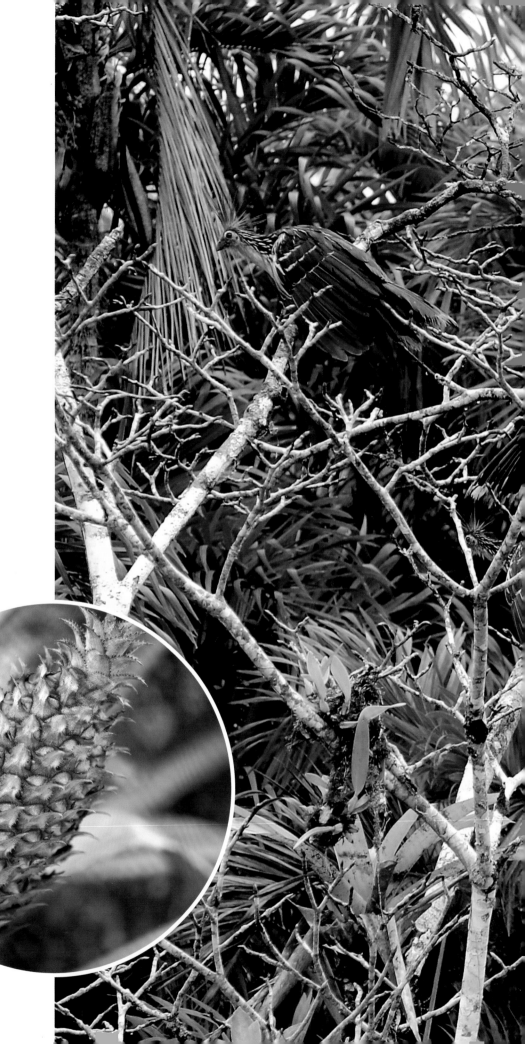

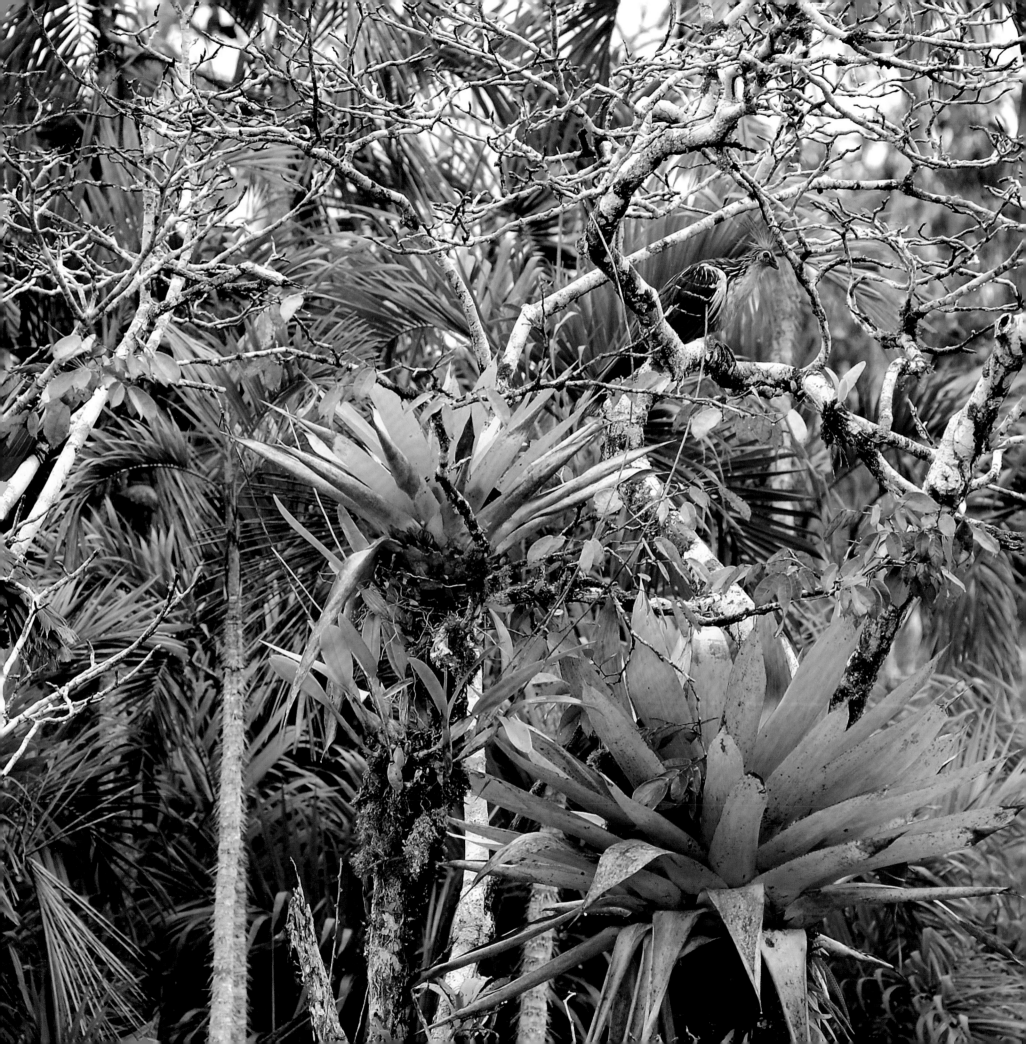

sword-shaped leaves that grow in a rosette, the flowers appearing to be colourful versions of these leaves at the top of the plant. The pattern of the leaves results in water being trapped between them. This creates an aquatic habitat that supports a diversity of insects and, in all likelihood, tiny amphibians. In return the plant receives nitrogen that these insects release into the water. One such bromeliad has been domesticated over thousands of years, first by the native Amazonians and then by more modern agriculture, to produce an ever larger and ever sweeter fruit. It is used in drinks, puddings and even, controversially, as a pizza topping: the pineapple.

Gardeners of the Forest

It is not only in modern times that humans have been utilizing the South American rainforests. Before Europeans arrived in South America, it is estimated that the Amazon rainforests supported as many as 8 million people, descendants of the first arrivals on the American continent around 16,000 years ago. This population did not simply use the forest, but was integral to its natural systems. Not only were these native populations the first to domesticate many of the foods we take for granted today, but they did so on an almost industrial scale, supporting substantial cities such as those of the Inca. This is all the more impressive given what we know about rainforest soils, their poor fertility and the scale of fertilizer and soil enhancement needed to sustain crops on these poor soils, even with modern technology.

It turns out that these ancient forest people were perhaps more forward thinking than we are today. Over periods that must have stretched many centuries, they enhanced the soil on a massive scale using composting techniques. *Terra preta*, or dark earth, is a rich soil found across 150,000 sq km (57,915 sq miles) of the Amazon rainforest. Most of it was created

Left: *Perched on a Peruvian mountain ridge 2,430 m (7,972 ft) in height, and surrounded by mountainous rainforest, Machu Picchu is probably the most familiar remnant of the Inca civilization. A UNESCO World Heritage Site, it is considered one of the New Seven Wonders of the World.*

141

by these ancient but sophisticated gardening techniques, enhancing the soil with waste food, ash, bones and excrement. These soils were so well constructed that they remain hugely fertile 2,000 years later.

In addition to careful management of the soils, the ancient 'farms' mimicked the forest itself with tall fruit and nut trees creating a canopy over the shrub layer of plants such as tomatoes, and finally the three staples of beans, maize and squashes were grown on the ground layer. Mimicking the forest in this way maintained humidity levels, reduced the likelihood of pest invasions so prolific in monoculture and encouraged natural insect control through a diversity of birds and bats. In contrast, modern agriculture in this region results in erosion and loss of soil fertility; it also has massive problems with pests. The first monoculture plantations in this part of the world were rubber trees, intended to supply the burgeoning Detroit factories with car tyres. Unfortunately, this million-hectare (2,471,054 acre) plantation was decimated by disease that swept through such tightly packed trees, all of a single species. This single example highlights the benefits of using a more harmonious approach to forest-based agriculture, as was employed by the native Amazonian people, to facilitate a more productive utilization of these bountiful forests.

Sadly, the fate of the native Amazonian population was sealed from the moment Columbus landed on the coast of Venezuela on 1 August 1498. Having never been exposed to several diseases common in Europe, many of which were carried by the livestock with which they were unfamiliar, as many as 90 per cent of the native populations lost their lives to pathogens such as flu, smallpox, measles, tuberculosis – even the common cold. Those who did survive met other fates. Columbus, while trying to convert the population to Christianity, noted their vulnerability, in particular their lack of knowledge of guns or swords; he observed that, 'with fifty men we could

Right: Agroforestry in the Amazon: this Brazilian farm is growing a variety of crops, including bananas, Brazil nuts, copoazu, papaya, pineapple and cassava.

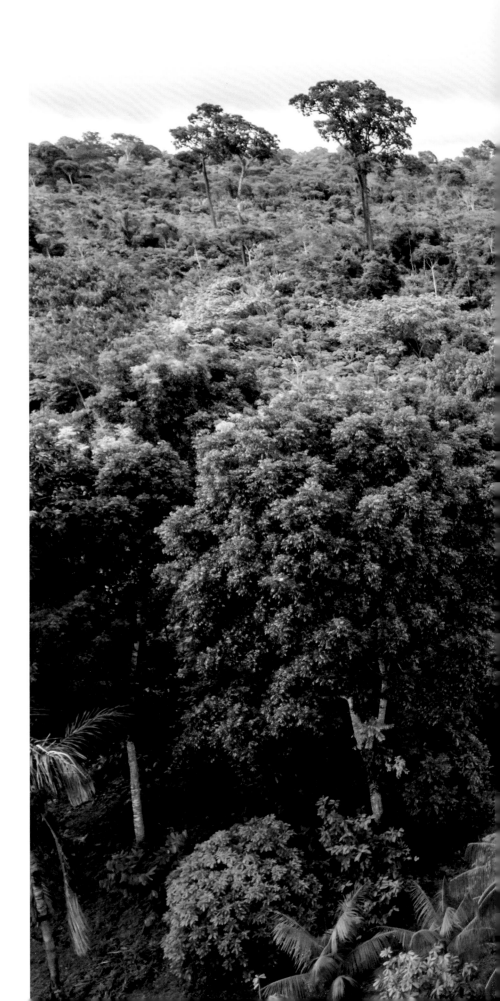

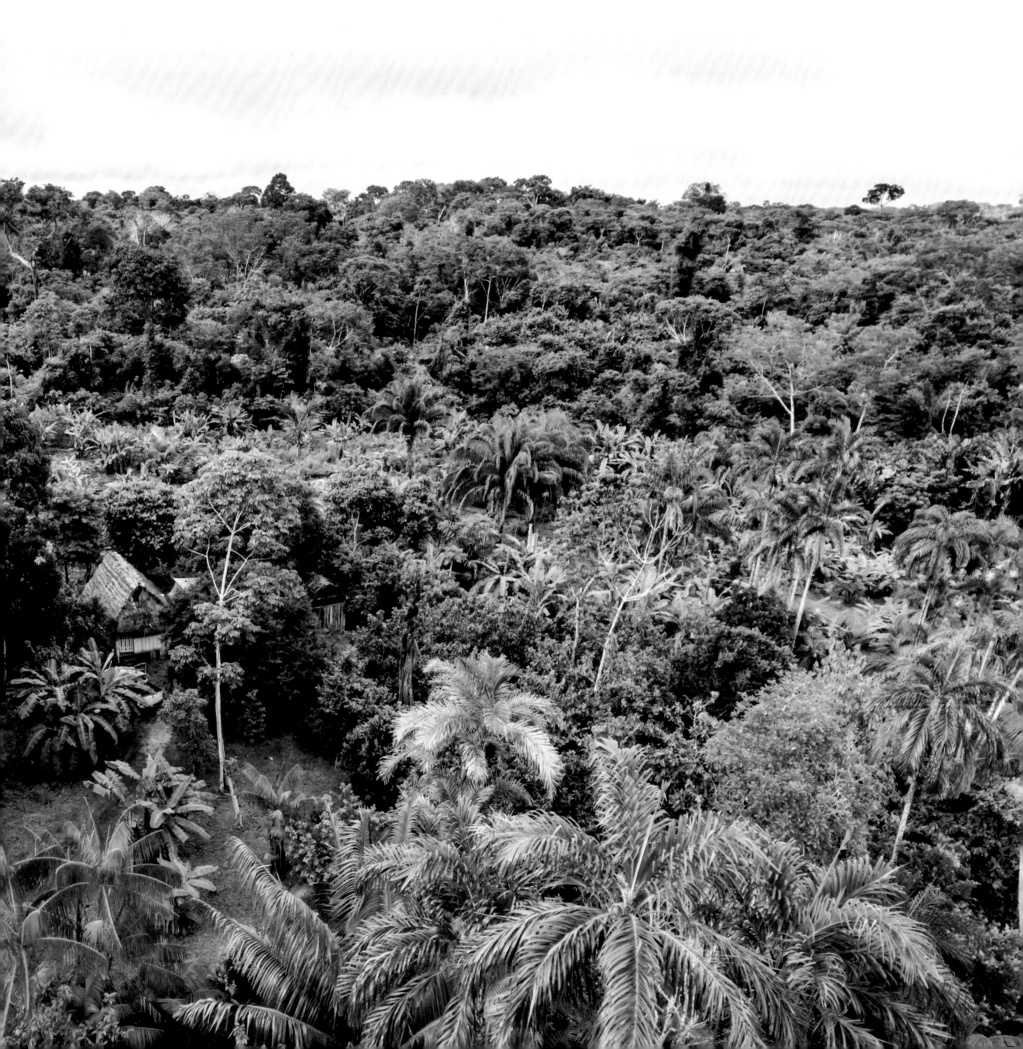

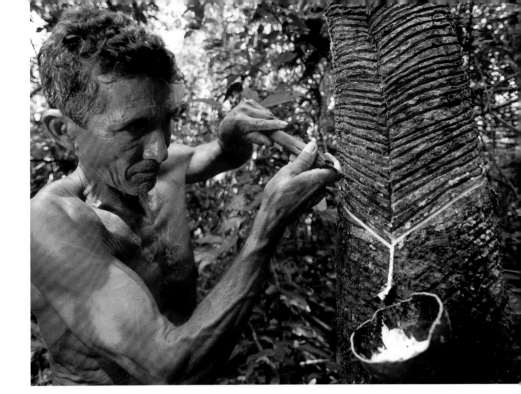

subjugate them all and make them do whatever we want.' What followed was mass enslavement or worse. Today, only around 0.4 per cent of the Amazon population is of native Amazonian descent. Many 'uncontacted' tribes are thought to be ancestors of people who fled into the forests to escape slavery and who, likely through their oral history, have a deep-seated and understandable aversion to the 'outside world'.

The people who now live alongside the forests often practise slash-and-burn agriculture, extracting quick economic gain at the cost of long-term stability, both for the forest and their investments. Fortunately, this is slowly changing, as many are realizing the short-sightedness of chopping down the forest and exhausting the soil. Today more sustainable harvesting of forest products is increasingly adopted, and crops are cultivated with more awareness of the benefits of the forest. This ranges from extracting oils from trees and planting cocoa under the canopy to harvesting Brazil nuts. Sadly, the knowledge of the native Amazonian people has been lost, but there is hope that these gentler uses of the forest will help secure its future. Life on Earth in its current form relies on it.

Above: A rubber tapper extracting latex, Tapajos Arapiuns Reserve, Brazil.
Left: Sunrise over the foothills of the Andes and the rainforest below, Cordillera Escalera Conservation Area, Peru.

Rainforests of the Americas

145

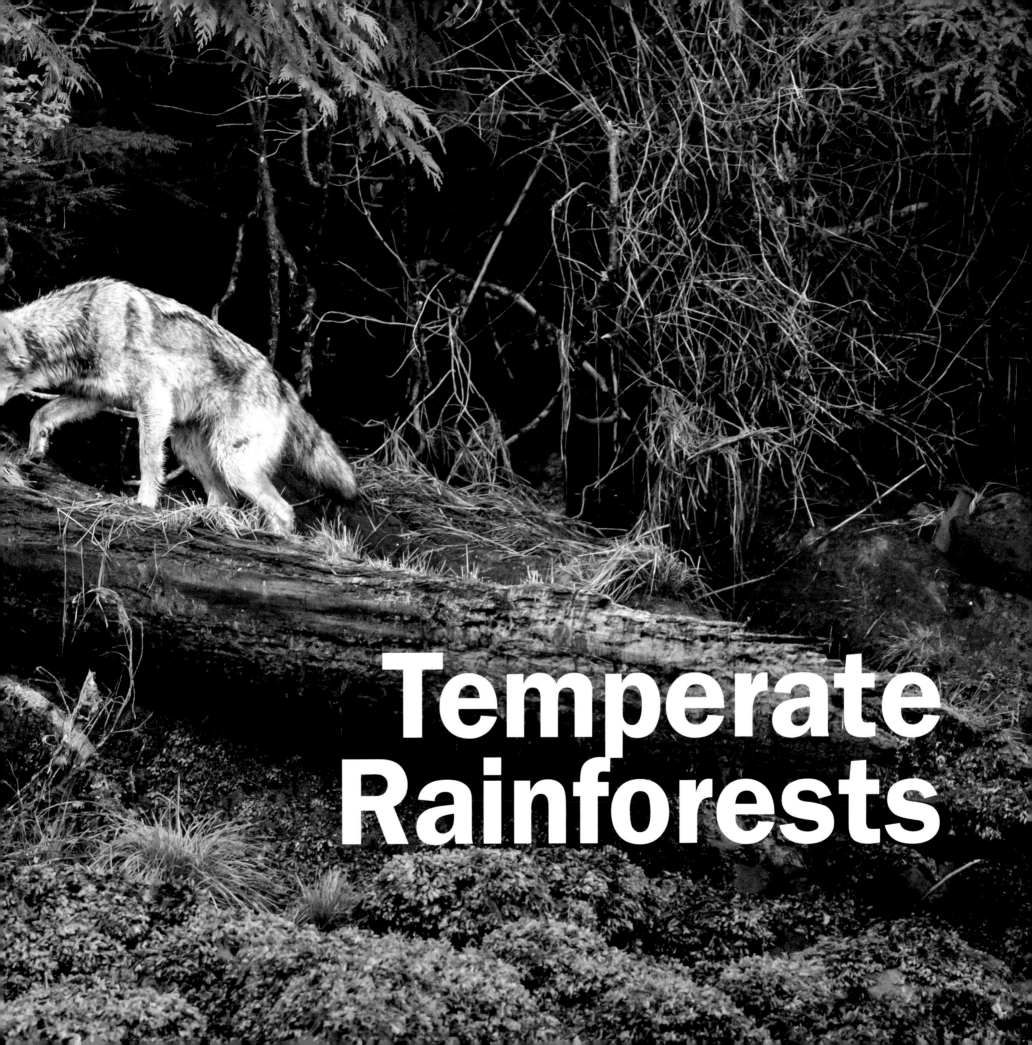

Temperate
Rainforests

Cooler Cousins

While the word *rainforest* conjures to mind images of hot, steamy, tropical forest, it is not only within the tropics that they can be found. Travel north or south to the cooler latitudes of the planet and you will find the temperate rainforests. While not supporting quite the same diversity of life as their tropical cousins, these temperate forests are similarly spectacular. Their trees tower high into the sky, dwarfing even those of the tropical forests.

Forests for all Seasons

There are many differences between the temperate rainforests and their tropical cousins. One thing remains the same, however: both are wet. While the amount of rainfall is slightly less in the temperate forests it is still high, averaging around 200 cm (79 in) per year. Not all the water in these temperate rainforests comes from rain; much of it falls as snow. This signifies one of the major differences between tropical and temperate rainforests. The temperate forests are heavily seasonal, often with a longer winter than summer, and are milder, rarely dropping below freezing or exceeding 27°C (80°F).

This seasonal climate forces organisms that live in these rainforests either to migrate or to adapt to the contrast of summer and winter. For the plants, this means many of them are deciduous. At the end of the growing season, when the ground becomes cold and absorbing water becomes more difficult, the plants stop replenishing their leaves' store of chlorophyll – the

Previous page: Wild wolf in Great Bear Rainforest, Canada.
Right: Pumalín Park, Palena, Chile.

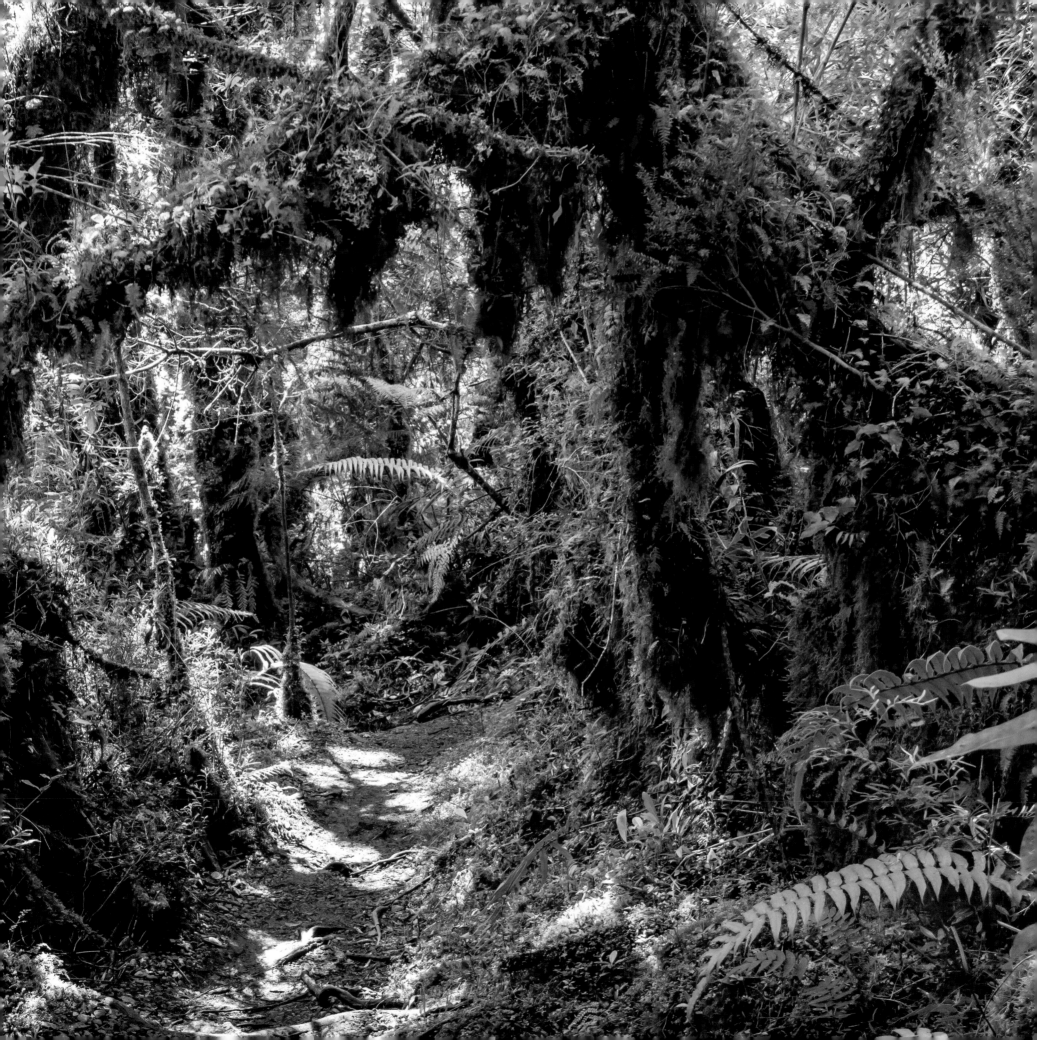

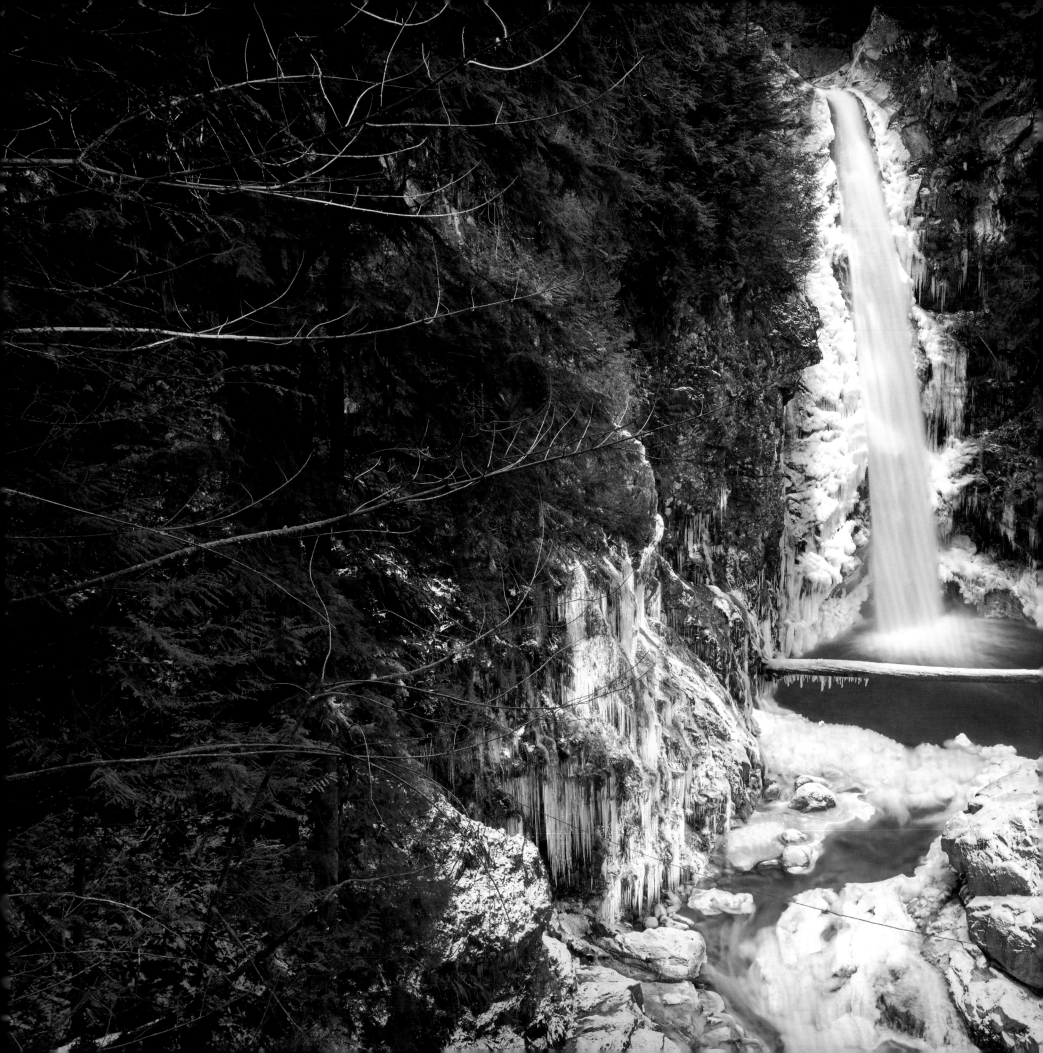

compound that facilitates the conversion of water and carbon dioxide into energy-giving sugar. Slowly the leaves lose the green-pigmented chlorophyll and turn yellow, red and golden-brown before finally falling to the ground. The trees then stay dormant over winter, when there is not enough sunlight to support them in full leaf.

Seasonal change also prompts another difference: the lower levels of the temperate rainforest tend to have more pronounced green growth. In the early spring, when the trees are waking up from their winter dormancy, the amount of light falling on the forest understorey is significantly higher, allowing a flush of green and the growth of thick groundcover. This jungle-like lower storey is thick with mosses, ferns, lichens and shrubby plants growing in the rich, dark soil. Unlike the tropical rainforests, the seasonality of the temperate climate allows soils to develop before their energy is depleted by nutrient-hungry trees.

Left: Cascade Falls Regional Park, British Columbia, Canada.
Below: Black-tailed deer fawn lying on the mossy forest floor, Montague Island, Alaska.

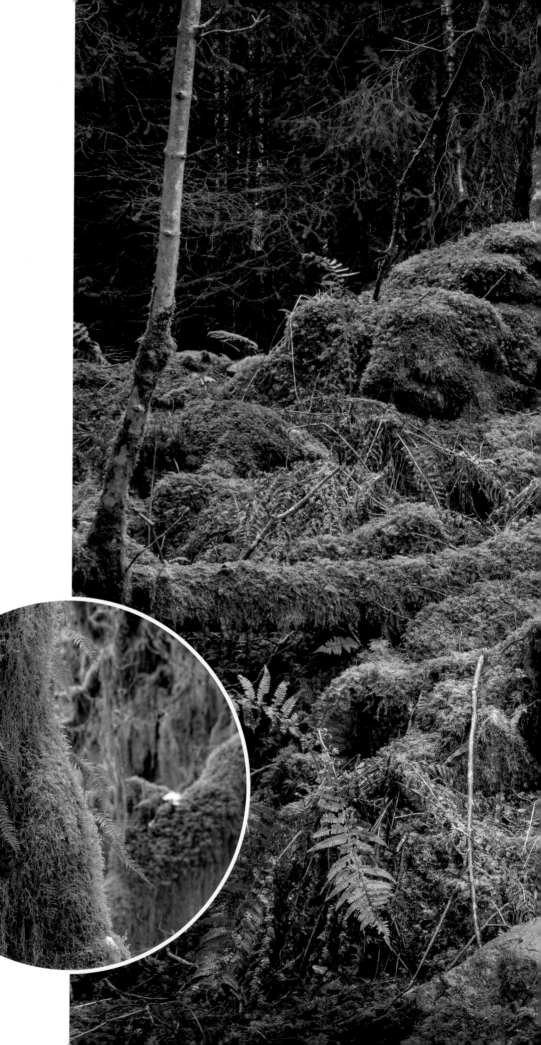

When a tree falls it often creates a wide clearing, knocking away the smaller trees growing beside it. Unlike most tropical forests (apart from those of central Africa), the bountiful populations of herbivores will often keep the forest floor open; they browse and graze any lush new vegetation, prevent regeneration and facilitate open forest glades. A cooler climate results in slower decomposition so, when a tree falls, it remains solid for a far longer period of time than it would in the tropics. This prolonged period of decay allows the large fallen trees to act as nurseries for seedlings that germinate on top of the fallen tree, as its wood softens with decay. This gives the young trees a head start as they race to reach the light penetrating the canopy above, and raises them above the reach of browsing herbivores.

The rainforests of the world's temperate regions have always had a more limited extent than those of the tropics. This has been exacerbated as much of what does exist is logged for the huge timbers that can be obtained there. However, fine examples of this type of rainforest are still found all across the globe: the far north and southwestern coasts of the Americas, southern Australia and most of New Zealand, Japan and far eastern Russia; the foothills of the Himalayas, the coasts of the Black Sea and the Caspian Sea and the northern coast of Europe and Scandinavia. Even the heavily populated shores of the British Isles still retain fine examples of this damp, cool wonderland.

Inset: Ferns growing out of a moss-covered spruce in Olympic National Park, Washington, USA.
Right: *Glean a Gealbhan forest, Argyll, Scotland.*

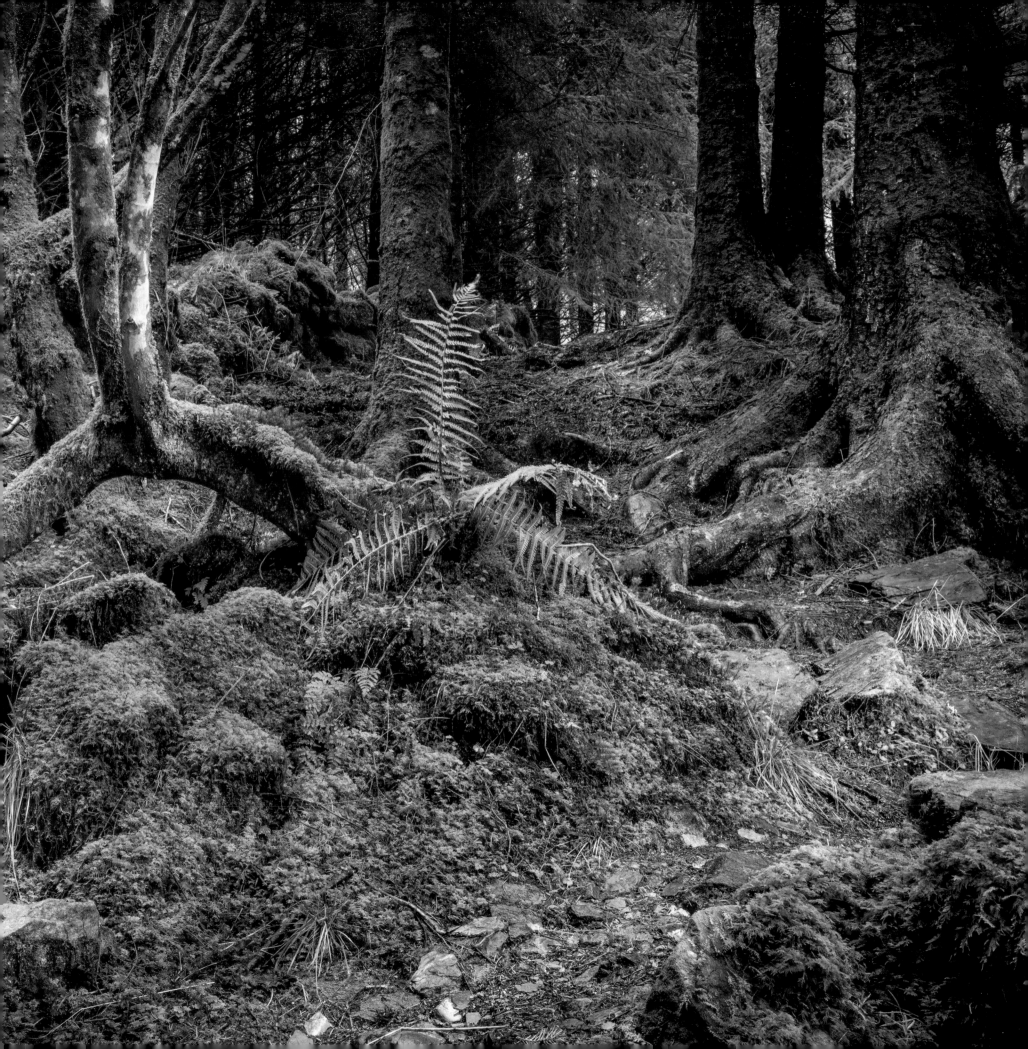

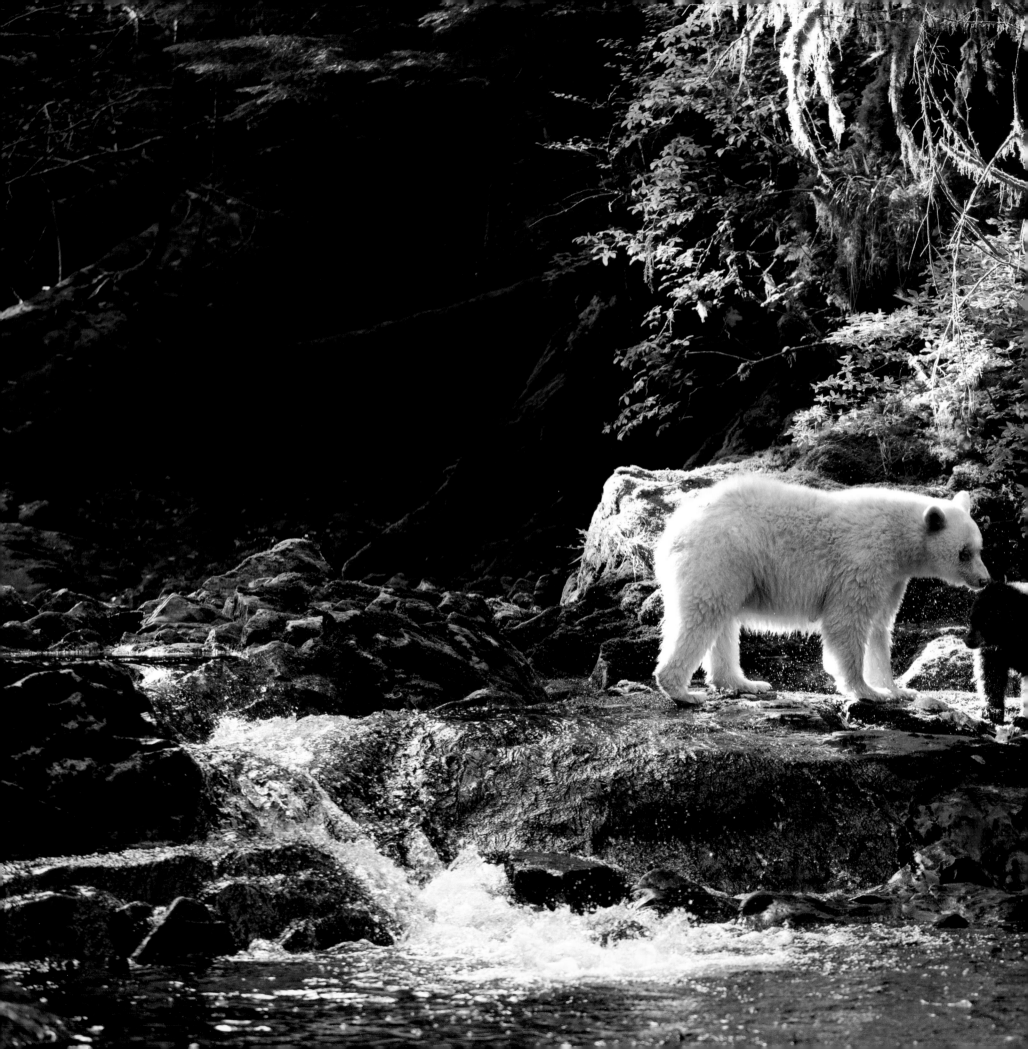

The Americas

The largest areas of temperate rainforest are found in the Americas – mostly on the Pacific coast of North America, from Alaska down to northern California. There are also smaller tracts of temperate rainforest in South America, along the coast of Chile. Although dwarfed by the vast expanse of the Amazon, the American temperate rainforests harbour some of the planet's largest trees. In fact, they are the largest single organisms to be found anywhere on Earth.

North America

The North American Pacific coast is home to the largest expanse of temperate rainforest on Earth, from Alaska's Kodiak Island to the coastal redwood forests of northern California. These vast, sodden forests are home to the world's tallest species of tree, the coastal or California redwood. They also contain the largest bears on the planet, the Kodiak bear; known to exceed 600 kg (over 94 stone) in weight, they are equalled in size only by the mighty polar bear. More elusive are the Kermode or 'spirit bears'. These celebrated, cream-coloured bears are considered sacred by the native T'simshian tribe. Today they draw people from around the world who hope to see one of the 400 spirit bears that live in these forests.

Bears are also the namesake of the world's last great expanse of temperate rainforest, the Great Bear Rainforest of British Columbia. The wildlife here is abundant and, unlike many of the tropical rainforests, can largely be seen from ground level. Bears are not the only attraction: wolves' eerie howls echo through the valleys, mountain goats prance like ballet dancers

Left: A white 'spirit bear' tends to its black cub in Canada's Great Bear rainforest. Only 10 to 20 per cent of these bears are white, their rarity giving rise to their central role in many traditions of the area's indigenous people.

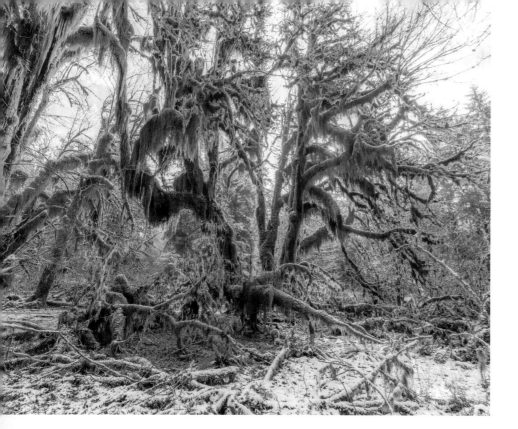

on seemingly sheer cliff faces and skittish deer hide in the undergrowth as they try to avoid the stealthy approach of a cougar. The dams of beavers control the flow of the mountain streams and create huge, shallow lakes, the perfect spawning grounds for trout. The remaining faster-flowing rivers and their crashing waterfalls form obstacles for salmon. Here these extraordinary fish display their graceful leaps as they pursue a relentless course towards the headwaters, avoiding the hungry teeth of bears and otters.

All this wildlife is watched over by the oldest and tallest organisms on Earth. One coastal redwood, known as the Hyperion tree, measures almost 9 m (30 ft) in diameter and a fraction over a staggering 115 m (377 ft) in height, making it the tallest organism on the planet. The species regularly reaches well over 100 m (328 ft). Not only are they tall, but they are also ancient. Many hyperion trees are estimated to be at least 2,000 years old.

Above: The Hoh Rainforest in winter, Olympic National Park, Washington, USA.
Right: The redwoods found in the temperate rainforests of America's Pacific Northwest are some of the largest organisms on the planet. They tower above even the giants found in the Amazon forests.

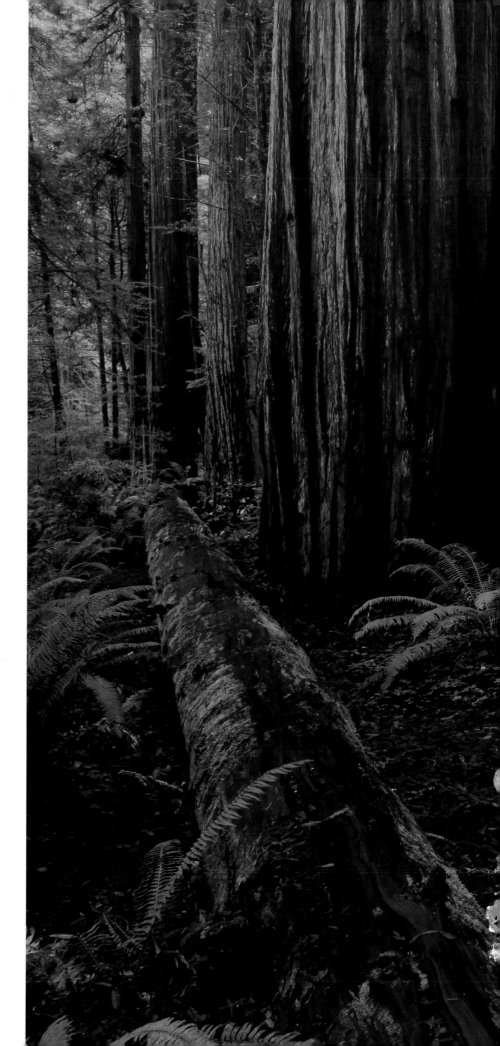

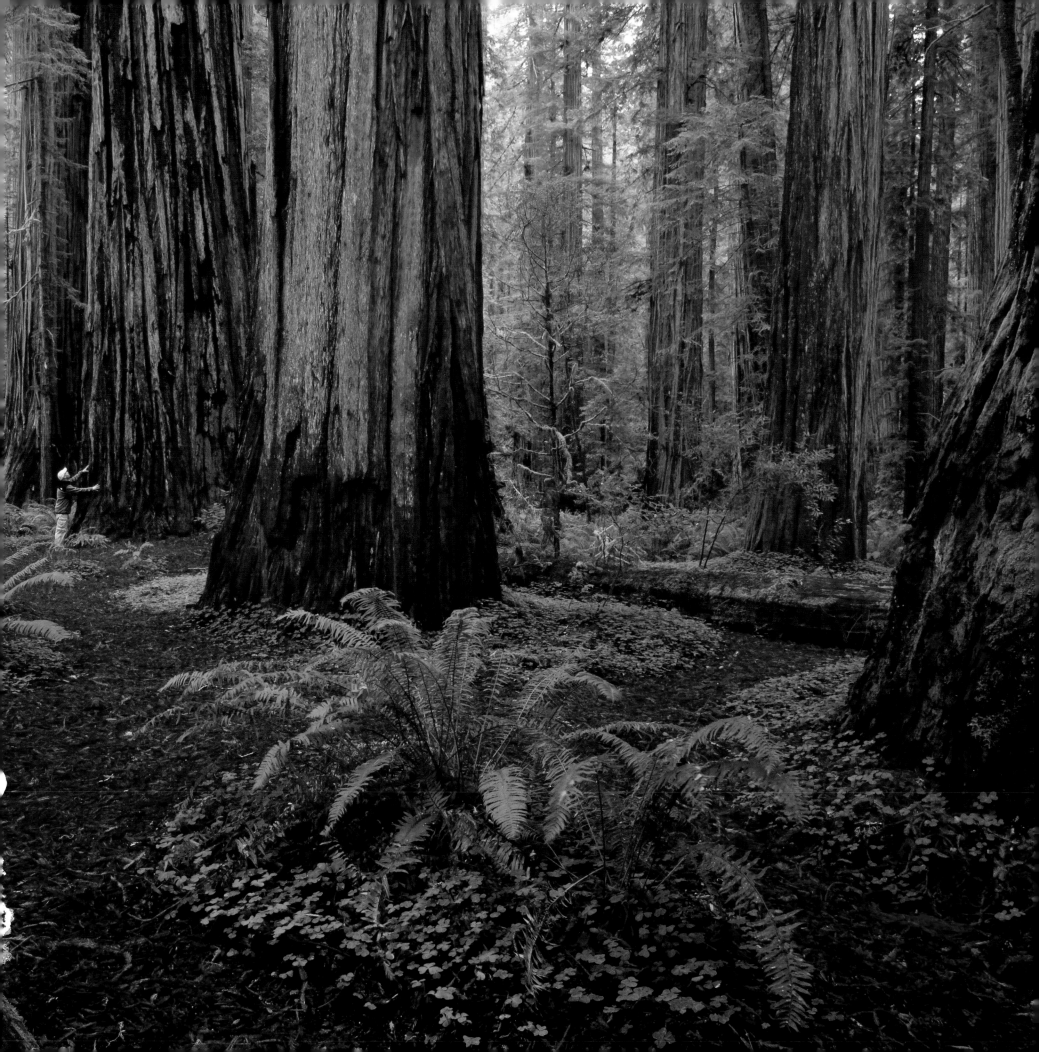

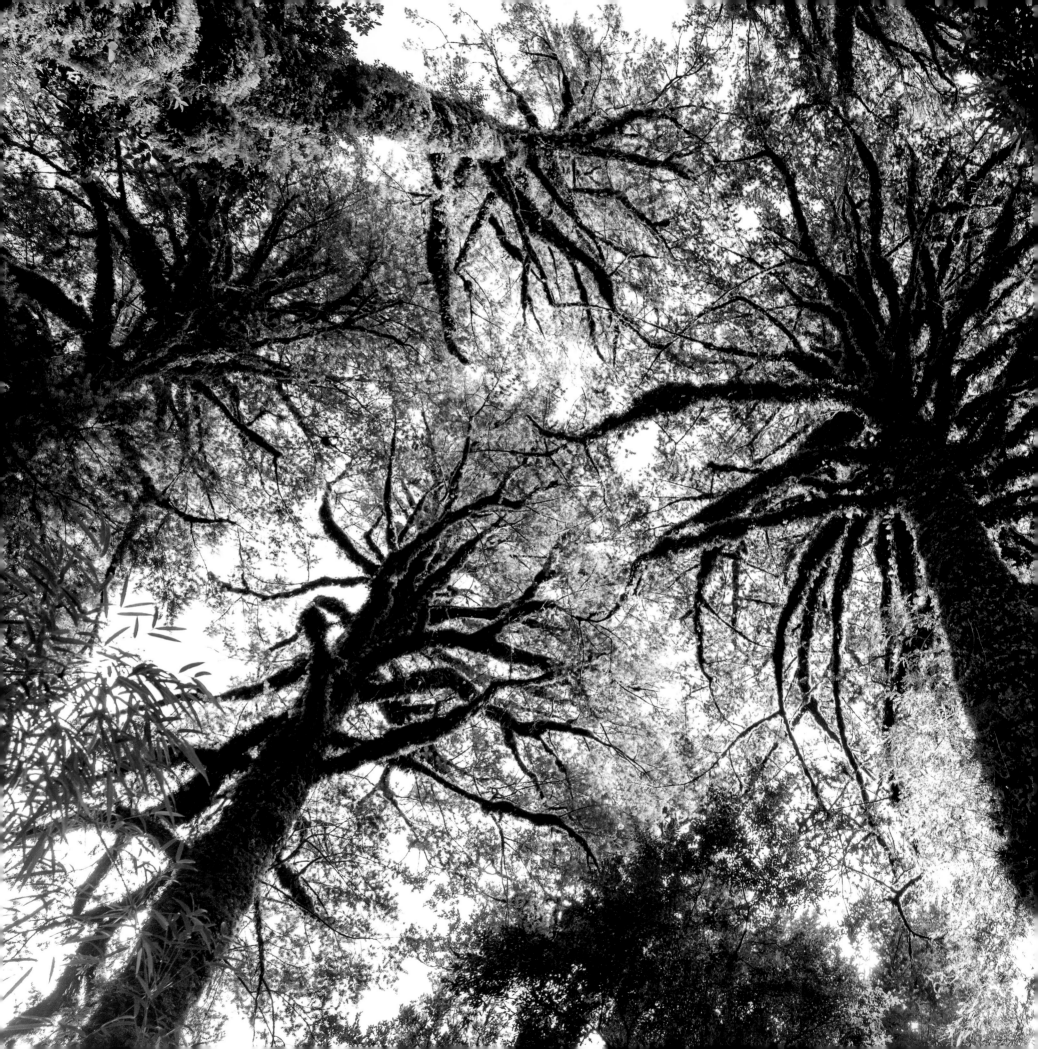

South America

Second in extent only to the North American Pacific rainforests, the rainforest of South America exists along the southwestern coast of Chile. The range of these forests is so extensive that they are divided into two distinct ecoregions: the lush, evergreen Valdivian rainforests and the mixed deciduous and coniferous forests of the Magellanic subpolar rainforests. The latter are the world's southernmost rainforests. These South American forests mirror their northern counterparts in being home to vast, towering conifers with a rich understorey of ferns and, unlike the northern continent, bamboo. The tallest trees in South America also live here. The alerce or fitzroya can reach heights of 70 m (230 ft) and the incredible age of 3,500 years. A single specimen measured by Charles Darwin (1809–82) was recorded at over 12 m (39 ft) in diameter. Unfortunately, many of

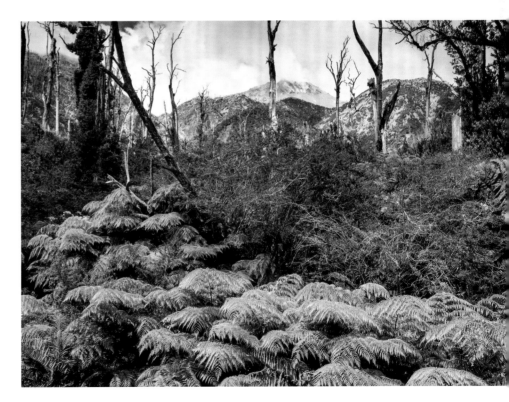

Left: Fitzroya are the largest trees in South America. They are known to grow over 70 m (230 ft) tall, and are the second oldest trees on Earth. One specimen has been calculated to be 3,622 years old.
Above: Lush green ferns and forest understorey grow around the charred remains of dead trees – evidence of the 2008 eruption of the volcano Chaitén that looms in the background.

these grand old trees no longer survive, having been felled and shipped to England during the rapid expansion of London in the nineteenth century.

However, what makes these forests most remarkable is not the size or age of the individual trees, but something far less obvious. In these coastal rainforests can be found plants that hark back to the ancient continent of Gondwanaland – and, more precisely, plants that would have grown in what is now Antarctica, long before it was covered in thousands of metres of ice. Many close relatives of these plants exist far away in parts of the world also once connected to Antarctica, namely New Zealand and southern Australia. Such living fossils include the strange monkey puzzle tree and various conifers that hark back millions of years. They offer us glimpses of a time before Antarctica became too cold and dry to support virtually any substantial plant life beyond a few lichens, mosses, liverworts and algae.

Above: The Magellanic woodpecker, which can range from 36 to 45 cm (14 to 18 in) in length, native to southern Chile and southwestern Argentina.
Right: Monkey puzzle trees in Conguillio National Park, Chile.

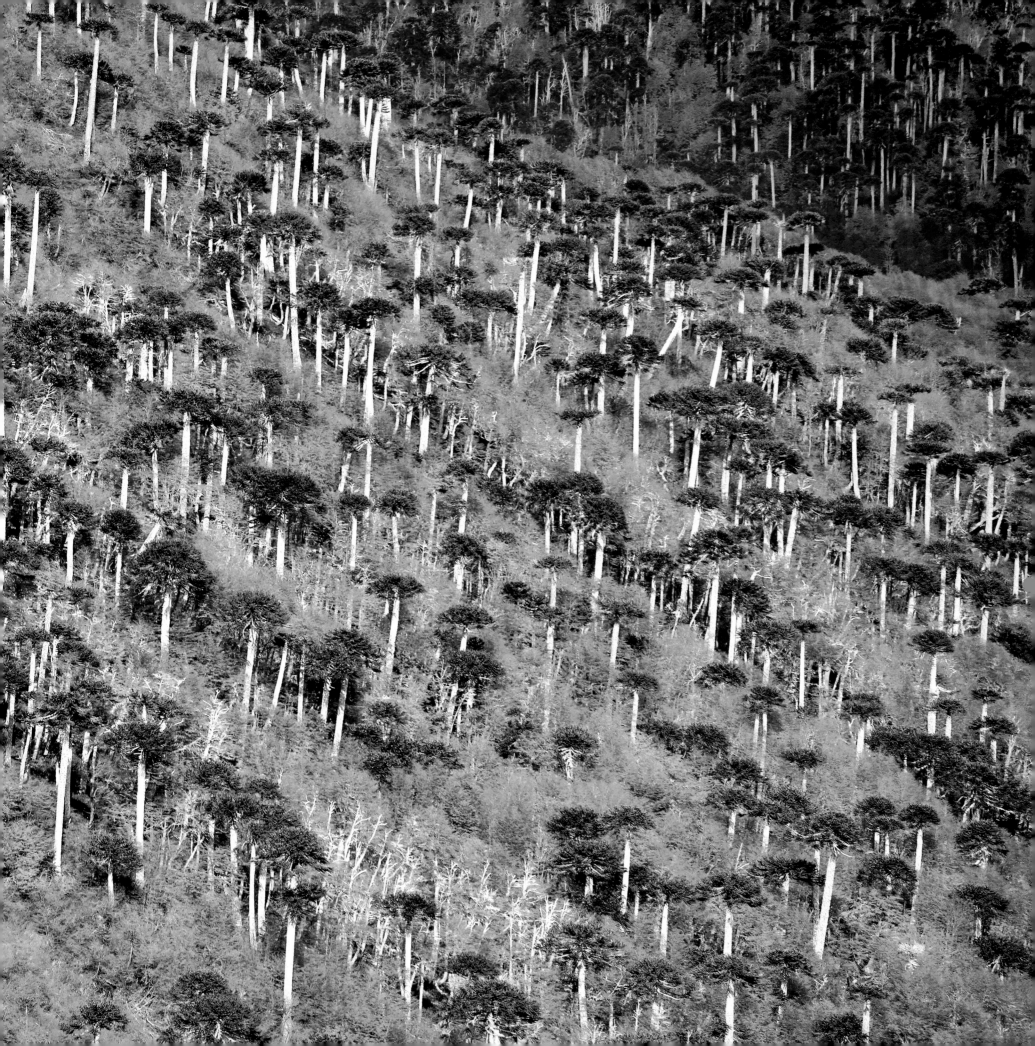

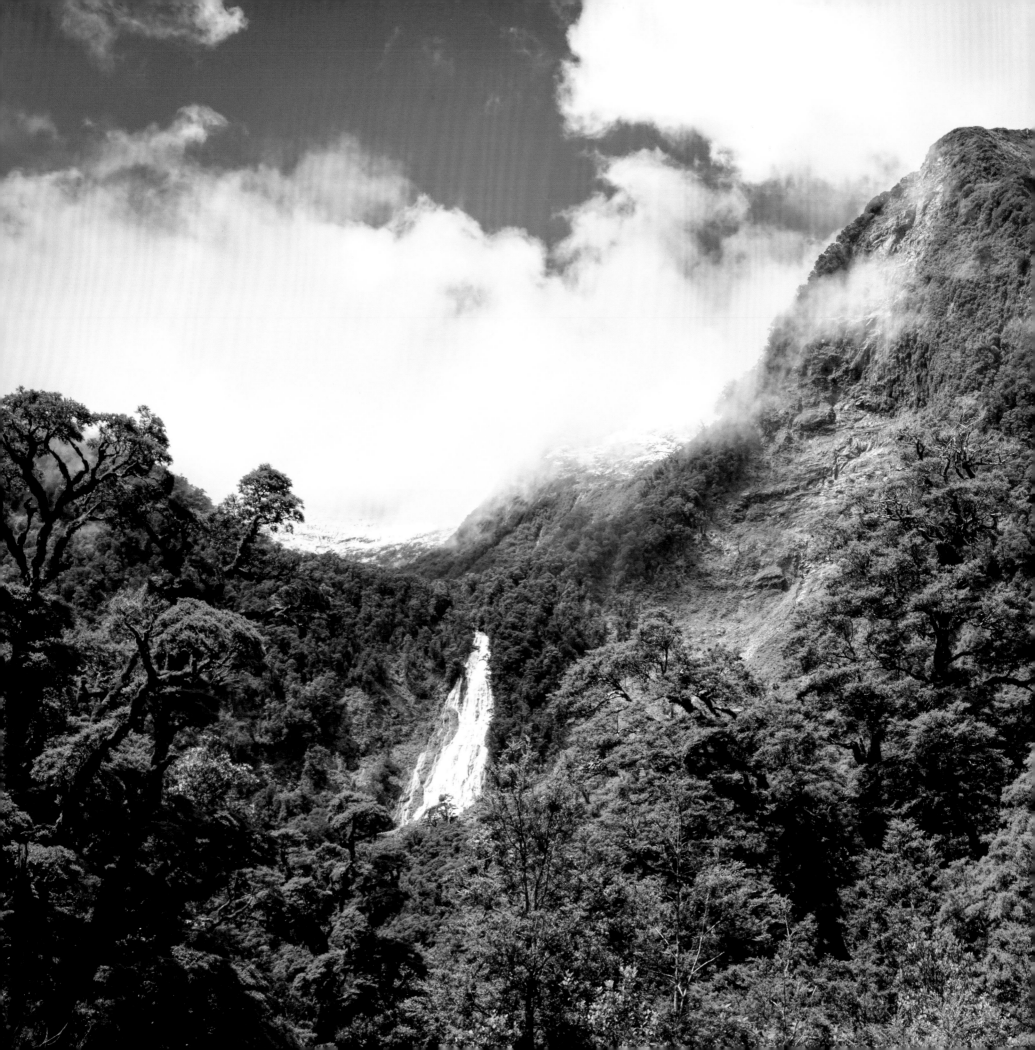

Oceania & Asia

The lands of Oceania acted as another refugium for ancient Antarctic flora, as did those of South America. Flora of the Japanese islands was similarly protected from ice sheets and drifting icebergs during the last ice age. Further inland, temperate rainforests support huge swathes of bamboo, the giant grass on which pandas thrive. The temperate rainforests of New Zealand and southern Australia share their history with those of South America, but have also developed differences over millions of years.

Oceania

These misty rainforests still have plenty of unique plants, many of them splashes of colour in a sea of green. Deep blue spheres with red, flower-like arils or seed coverings dot the branches of the coniferous kahikatea trees. The bright flowers of the southern rata tree look like clusters of red pins, their yellow heads pointing skywards. These antipodean forests also have many unusual fauna, probably the most charismatic of which is the Tasmanian devil – a small, stocky, dog-sized predator, made famous by Taz from the *Looney Tunes* cartoons.

The Tasmanian devil is the largest carnivorous marsupial still in existence. It has the strongest bite force quotient of any land mammal, being able to bite even through thick metal wire. It is probably named after its call: a loud, growling scream that could certainly be considered unholy. Sadly, the population of this unusual animal has declined by around 80 per

Left: *New Zealand's Fiordland National Park, on the South Island, contains the country's largest area of unmodified vegetation. It acts as a refuge for many threatened native animals, including the world's only species of flightless parrot, the kakapo.*

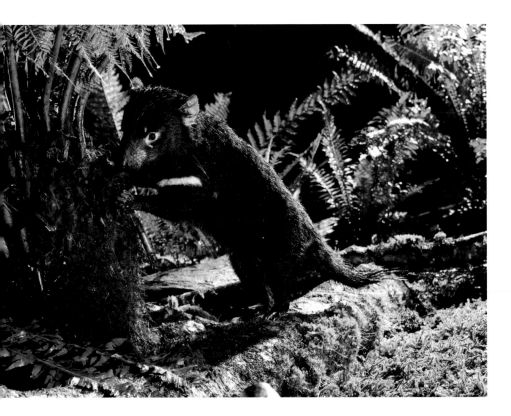

cent in the last 20 years. This is largely because of a unique facial cancer, transmitted by the biting that is part of the creature's social interaction. Fortunately, a recent advance in the treatment of this cancer is looking promising, giving rise to optimism that this charismatic animal can be saved from what appeared to be certain extinction.

Asia

The temperate rainforests of mainland Asia comprise the only forests of this type to be found away from coastal regions. These forests are higher up, in the foothills of the Himalayan and Karakorum mountain ranges. Unsurprisingly, given their highland position, a large amount of the water received by these forests falls as snow, releasing its water to the plants only when it melts. This is also the land of an iconic Chinese animal, the giant

Above: *A Tasmanian devil joey forages through the base of a fern looking for insects. While competent hunters, Tasmanian devils are opportunistic feeders with an eclectic diet, including kangaroos, frogs, fruit and even roadkill.*
Right: *A kakapo in the forest, Codfish Island, New Zealand.*

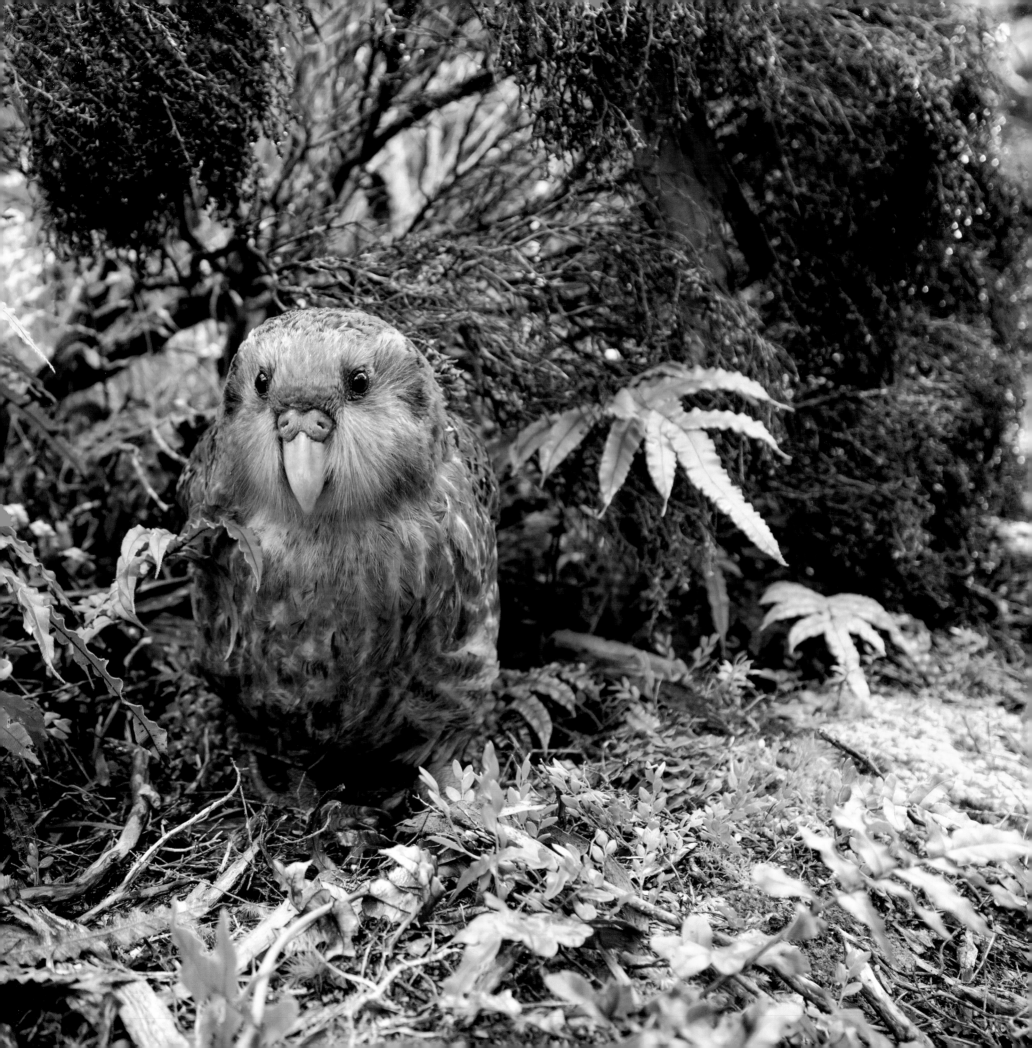

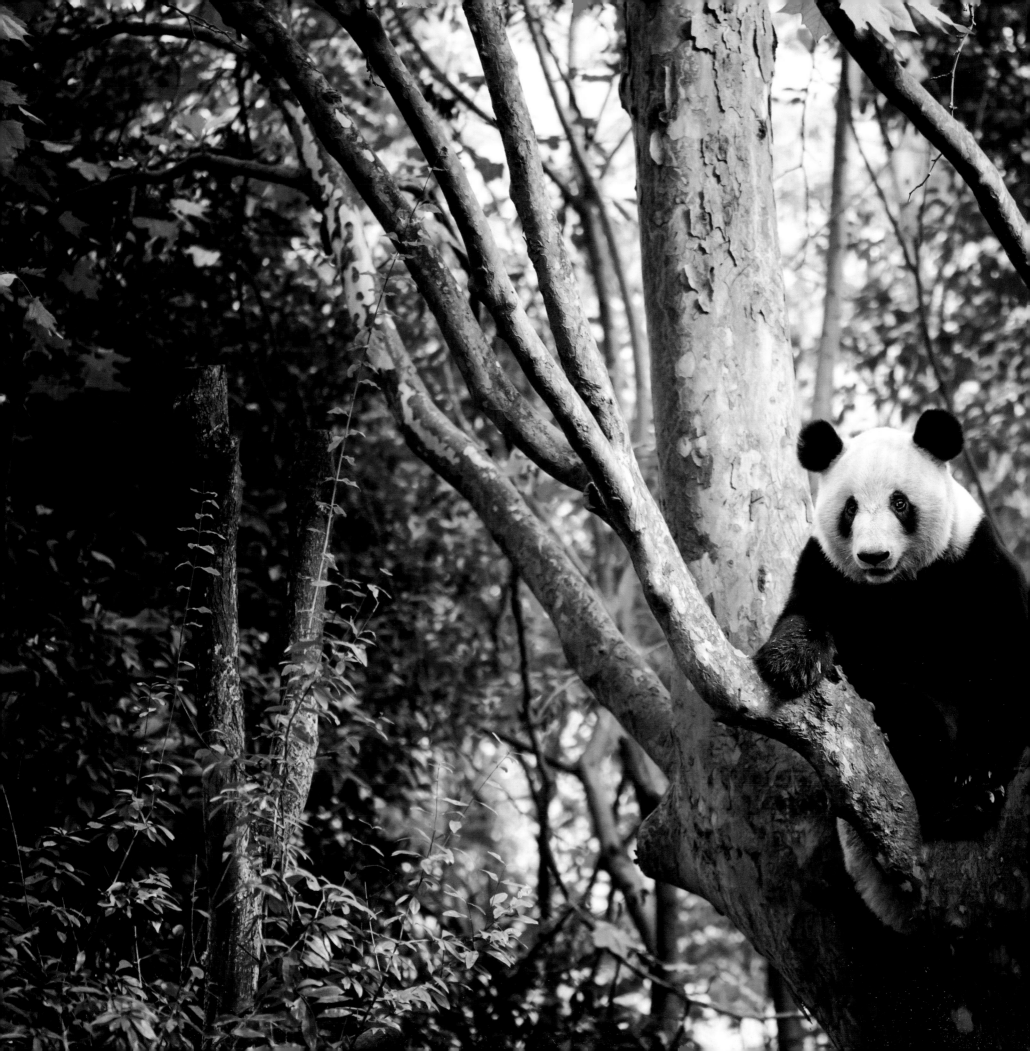

panda. This cuddly looking black and white giant can be found searching the forests for juicy new bamboo shoots; the plant covers large tracts of the rainforest and grows up to 30 m (98 ft) in height. The bamboo, which is in fact a giant grass, makes up 99 per cent of the panda's diet. Unfortunately, this very specific requirement has resulted in a situation where its habitat has significantly declined, largely due to human encroachment and harvesting of its principal food for construction. Without continual conservation intervention, the panda would undoubtedly disappear.

Away from mainland Asia is an archipelago of islands that collectively make up Japan. These islands are home to temperate rainforest of impressive diversity. The forests are spread in fragments from Kyushu, the southernmost of the main islands, to Hokkaido, the northernmost. Many grow on the impossibly steep sides of Japan's towering rocky landscape, with majestic golden eagles soaring above.

The diversity of these forests is largely due to their situation as a refuge from the last ice age. Being coastal in nature and largely oriented in a north–south direction meant that when the ice sheets spread down from the Arctic and across much of Russia and Asia, the flora of Japan could disperse southwards. They thus avoided the cold that would otherwise decimate most of the plant life. Acting as a refuge in this way has meant that a diverse collection of plants could survive and continue to evolve, resulting in well over 5,000 species of plants. Being an island nation, there has been little immigration of plants from the mainland. This has led to the development of many unique species, with as many as 40 per cent being distinct to Japan.

Inset: The Arashiyama Bamboo Forest, Kyoto, Japan.
Left: While population estimates vary widely, it is generally believed that the number of wild giant pandas, such as this one in the forests of China's Sichuan province, are increasing.

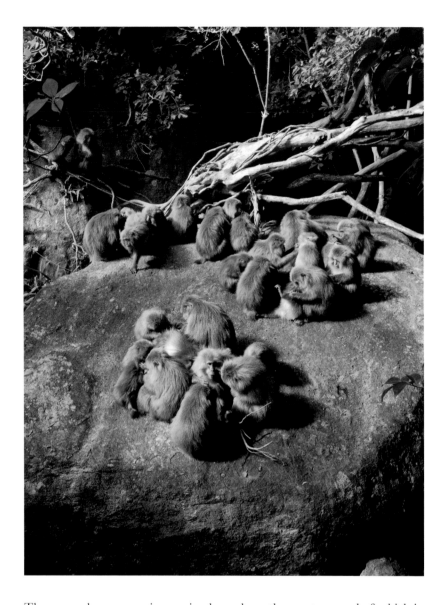

There are also some unique animals, perhaps the most unusual of which is the aquatic Japanese giant salamander. Related to other giant salamanders such as those found in China, these are collectively the largest amphibians in the world, often measuring over 1.5 m (5 ft) in length. They live in the oxygen-rich forest streams. Sadly, like so many rainforests around the world, most of the temperate rainforest of Japan has been logged, posing a threat to many unique species such as this.

Above: For many months of the year the habitat of the Japanese macaque or snow monkey is covered in snow. While not rain, this snow is enough to consider their forest habitat as temperate rainforest.
Right: *Many of the forests of Taiwan support temperate rainforest, despite falling within the Tropic of Cancer, making them an ideal winter habitat for migratory birds travelling south from the Russian Far East.*

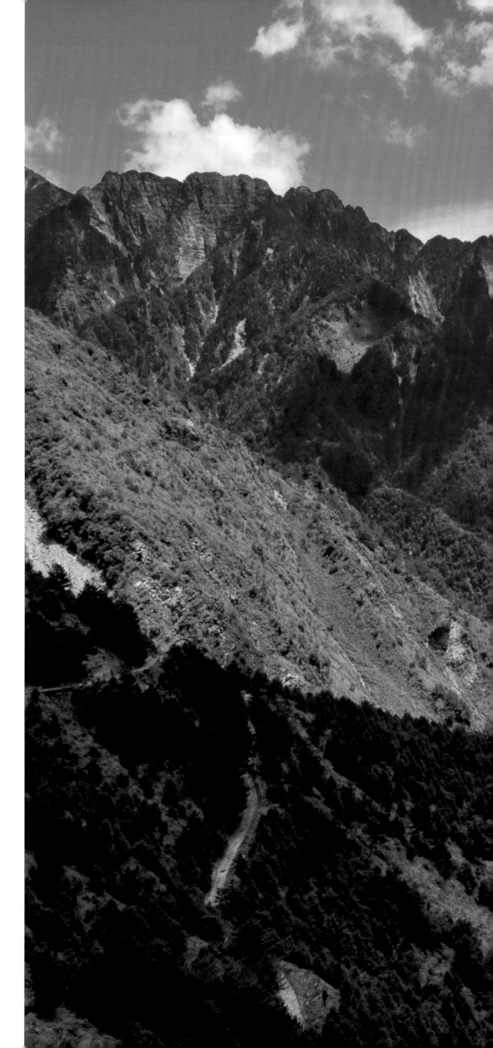

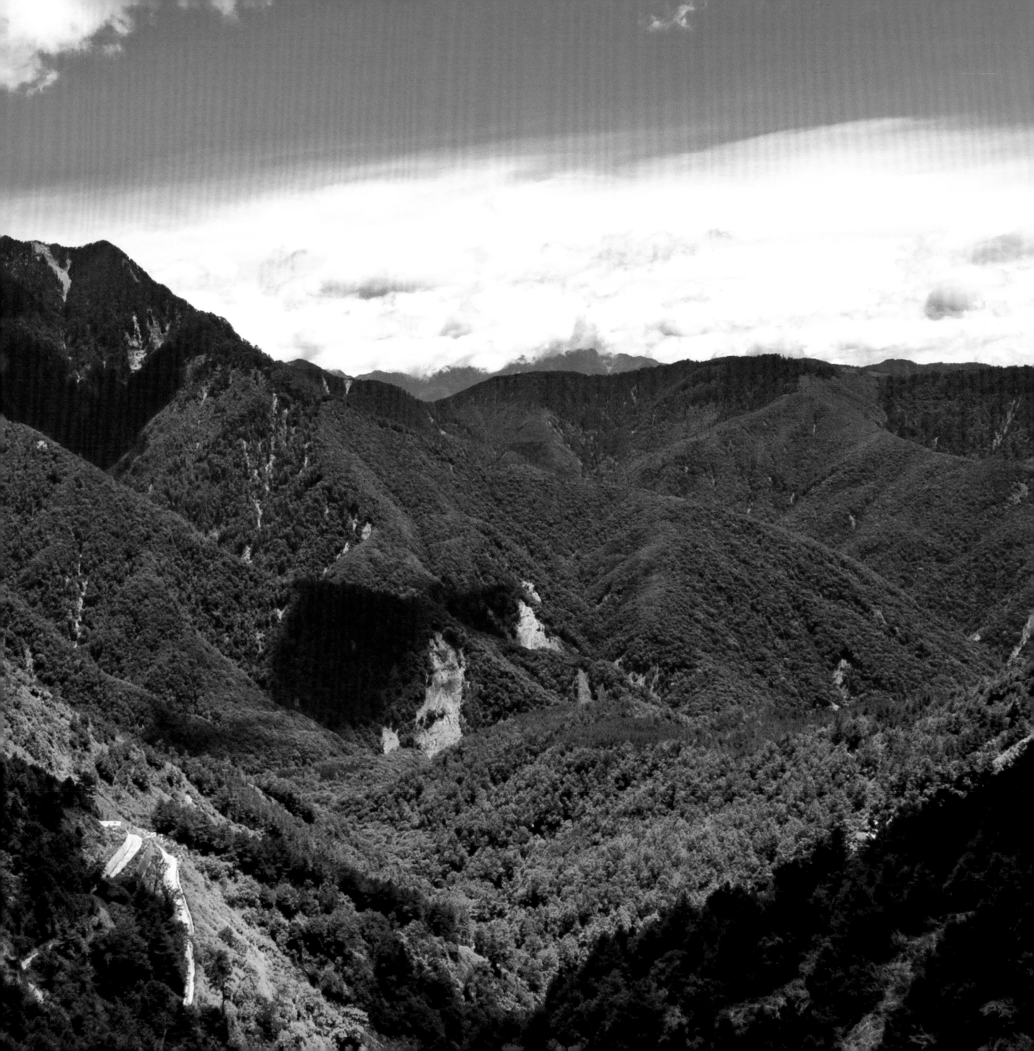

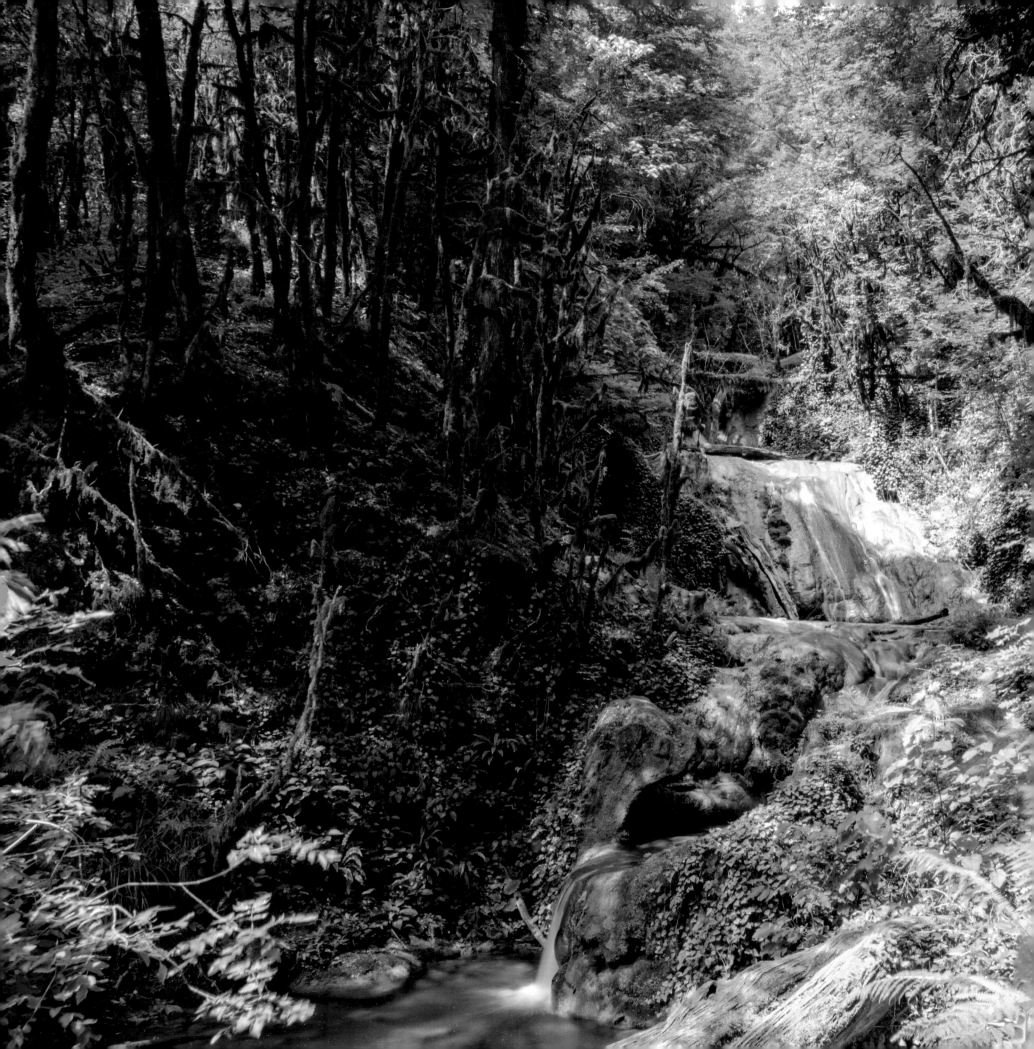

Europe & Russia

While the northern forests of Eurasia and Russia are the largest tracts of forest in the world, the tiny remaining fragments of temperate rainforest hold much of the arboreal diversity of this vast landmass. The rainforests extend from the wilderness of the Russian Far East to the human-dominated shores of the British Isles. They have an ancient link to humans and the old religions of Europe, but unfortunately have been decimated by their proximity to these industrial economies.

Russia

The wild temperate rainforests of the Russian Far East are perhaps the most intact of all the world's rainforests. Where others have been exploited, they have maintained most of their former range and almost all of their historical biodiversity. While they are still very much intact, however, economic pressures on Russia's population following the collapse of the Soviet Union in 1991 led to dramatic increases in illegal logging and poaching. The result is that these same forests are home to one of the highest densities of endangered species on Earth; for this reason they are perhaps some of the most valuable environments in the world. This is the last remaining refuge for the critically endangered Amur leopard and Amur tiger, for example, of which there are fewer than 40 leopards and 600 tigers left in the wild. Alongside these cats can be seen the Asiatic brown bear, with a distinctive white 'V' emblazoned across its chest. These rainforests are the only place in the world where tigers, bears and leopards coexist.

Left: Cascade waterfall in rainforest of Sochi National Park, Russia.

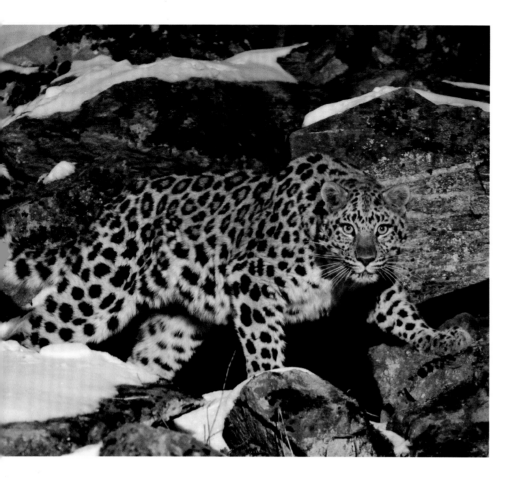

It is not just rare mammals that survive here. You may also be lucky enough to spot the largest owl in the world, Blakiston's fish owl, as it hunts for salmon. The survival of birds such as this is dependent on the preservation of intact old-growth forests, the only habitat in which they will nest and breed. Fortunately, the presence of such iconic and hugely endangered species has focused conservation resources and initiatives, helping to protect the forests in which they live.

Europe

In stark contrast to the wilderness of Russia, the remaining rainforests of Europe are far from intact. Now mere remnants of their former glory, the

Above: Threatened by poaching for its skin, the Amur leopard is one of the rarest cats on Earth, with estimates suggesting fewer than sixty individuals surviving in the region between southeastern Russia and northeastern China.
Right: *The temperate rainforests of the Russian Far East support a wealth of endangered species, such as this majestic Amur tiger, in habitat that remains relatively unspoilt.*

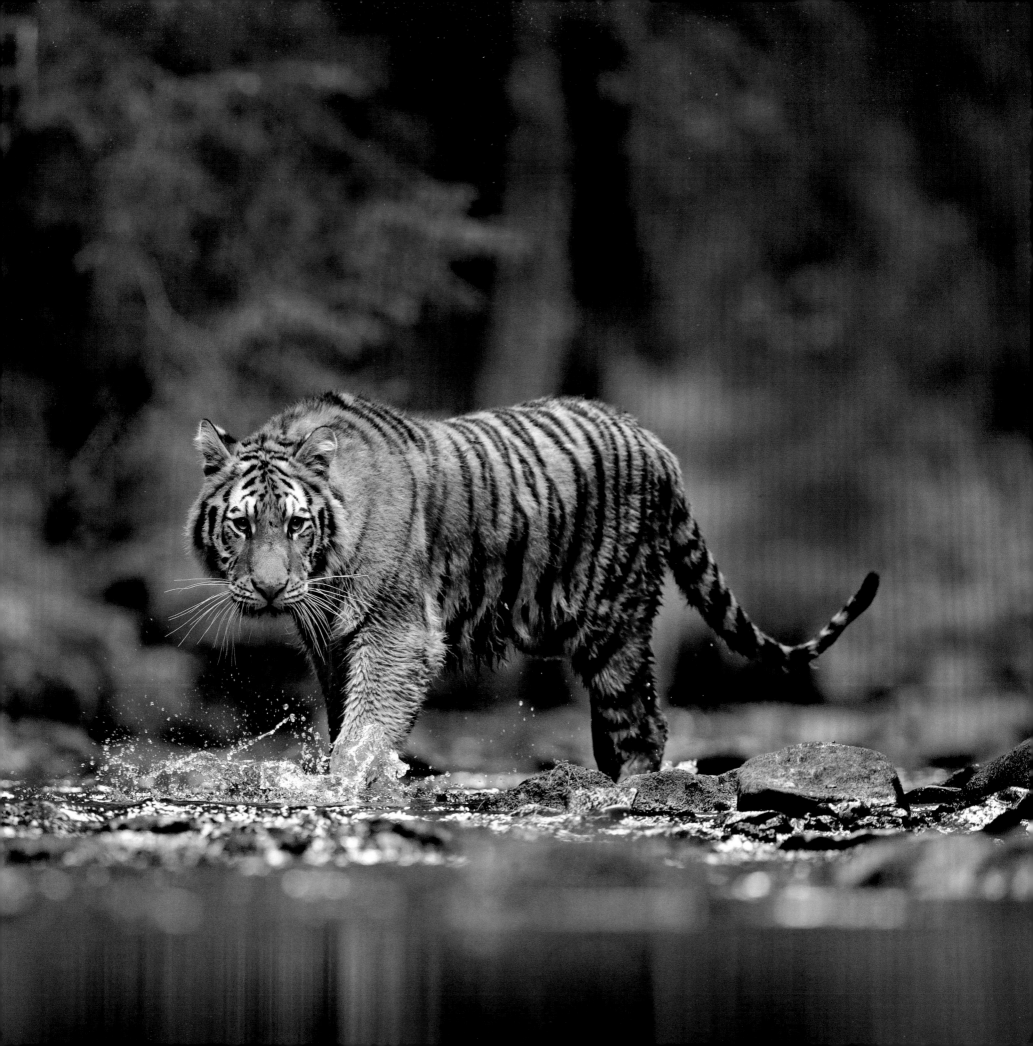

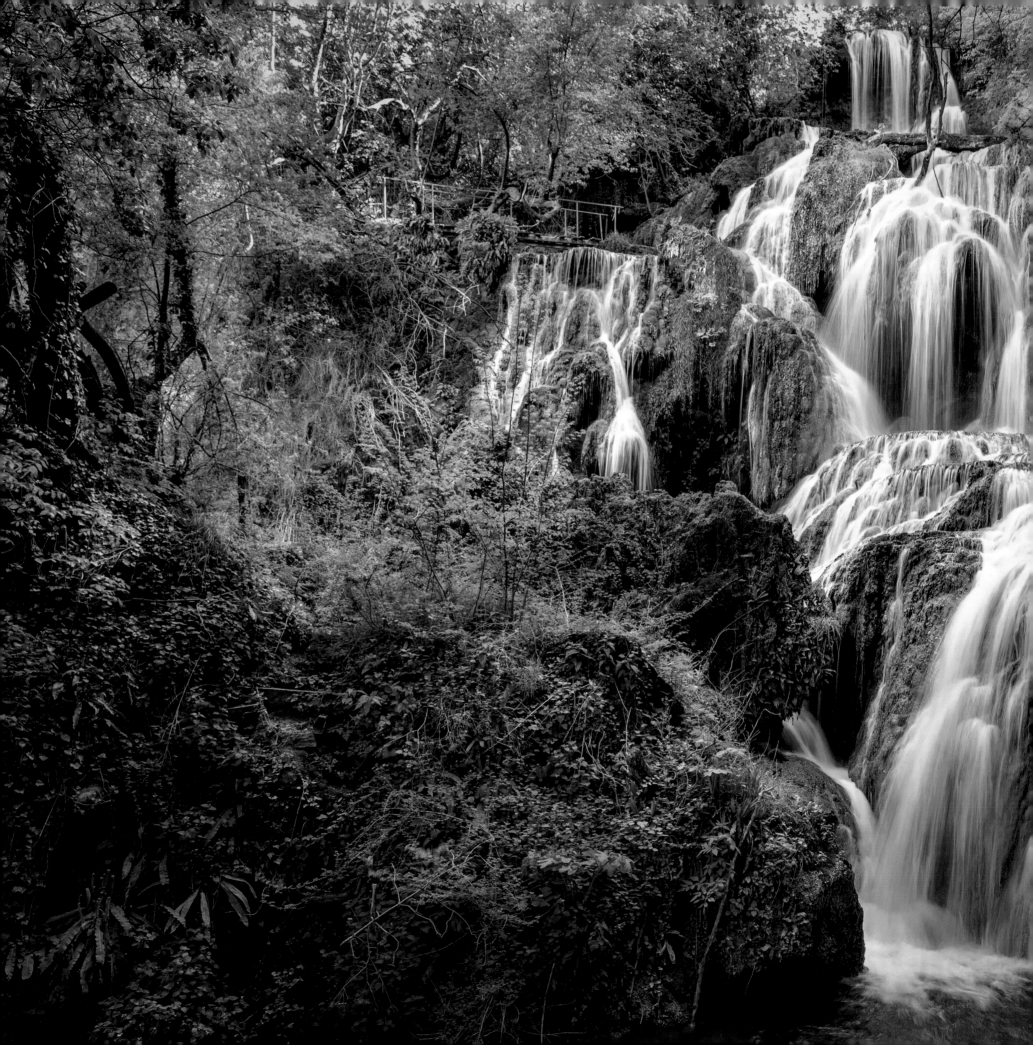

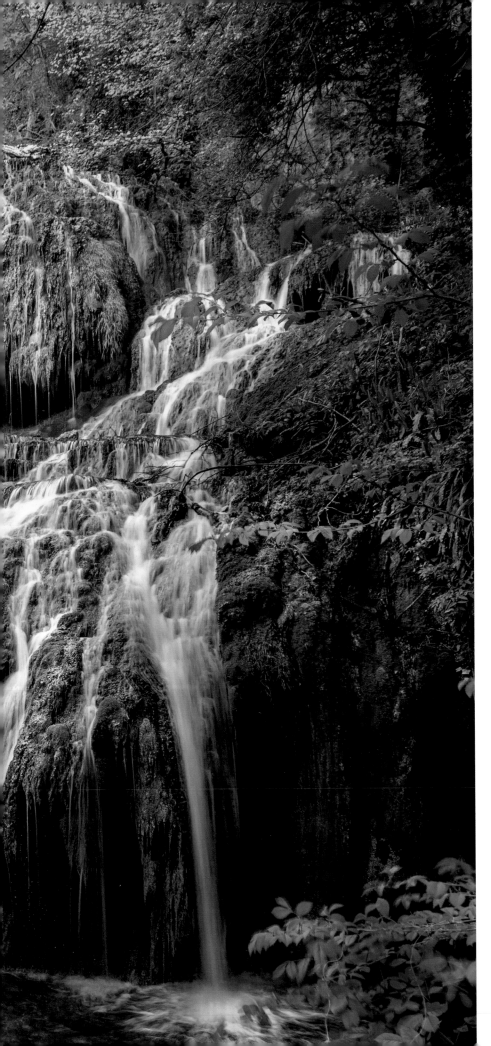

largest fragments can be found in the Colchian rainforests of Bulgaria, Turkey and Georgia. More surprising, perhaps, are the remaining rainforests of Britain. These Celtic rainforests are known by various names, but the most iconic are the once great Caledonian forests of Scotland. These forests are believed to have gained their name from the original Celtic inhabitants of these lands, the thick wooded landscape marking the northern border of the Roman Empire, whose knowledge did not extend up into the *silva Caledonia*, or woods of Caledonia. At this time, almost all of Scotland would have been swathed in these beautiful forests of oak, Scots pine,

Above: *The ancient Caledonian rainforest once covered much of Scotland but now only exists in a few remnants, representing just five per cent of their original extent. However, numerous organizations are pushing the drive to restore these fairytale woodlands.*
Left: *The lush Colchian rainforests are spread across the southern shores of the Black Sea, from southeast Bulgaria across northern Turkey and into Georgia.*

Temperate Rainforests

mountain ash and rowan, with the now common heather uplands being an unusual sight. Some sources estimate the forest would have covered a wilderness of over 10,000 sq km (3,861 sq miles) of the Scottish Highlands, supporting lynx, wolves and bears.

As people continued to fell the trees for fuel and buildings and to create grazing land, the forest diminished to the few fragments that still exist today, covering less than 200 sq km (77 sq miles). The forest's recovery is hindered by the overgrazing of both sheep and deer, as well as the afforestation of non-native coniferous plantations. Despite the loss, intense optimism still remains, largely started by one charity, Trees for Life. Since 1993, this charity has been replanting the forests, one glen at a time. It has to date had great success in returning the Scottish Highlands to the forested glory that they once were.

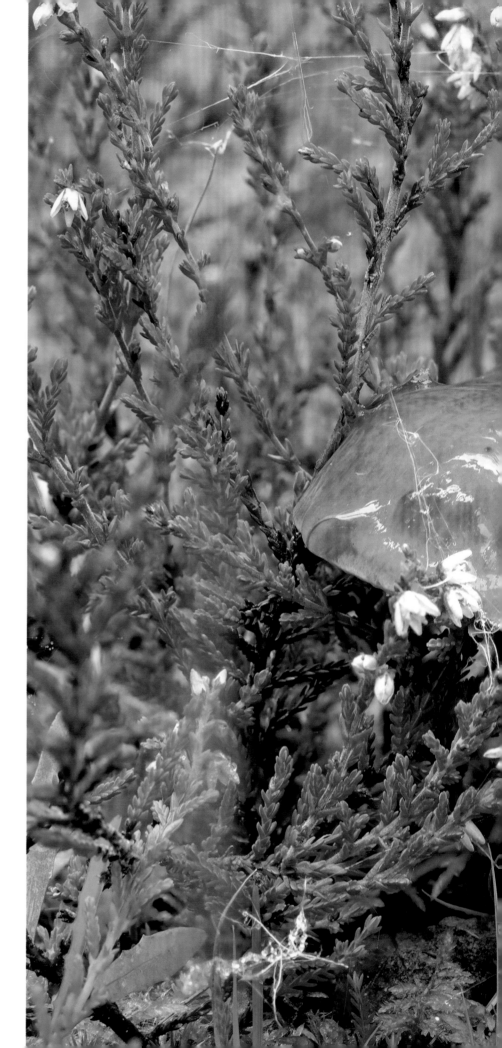

Above: Loch Garten Nature Reserve, Abernethy, Scotland.
Right: European temperate rainforests are home to a wealth of edible fungi for those who know what to look for. This slippery jack is delicious in stews if properly prepared. If not well prepared, expect stomach pains!

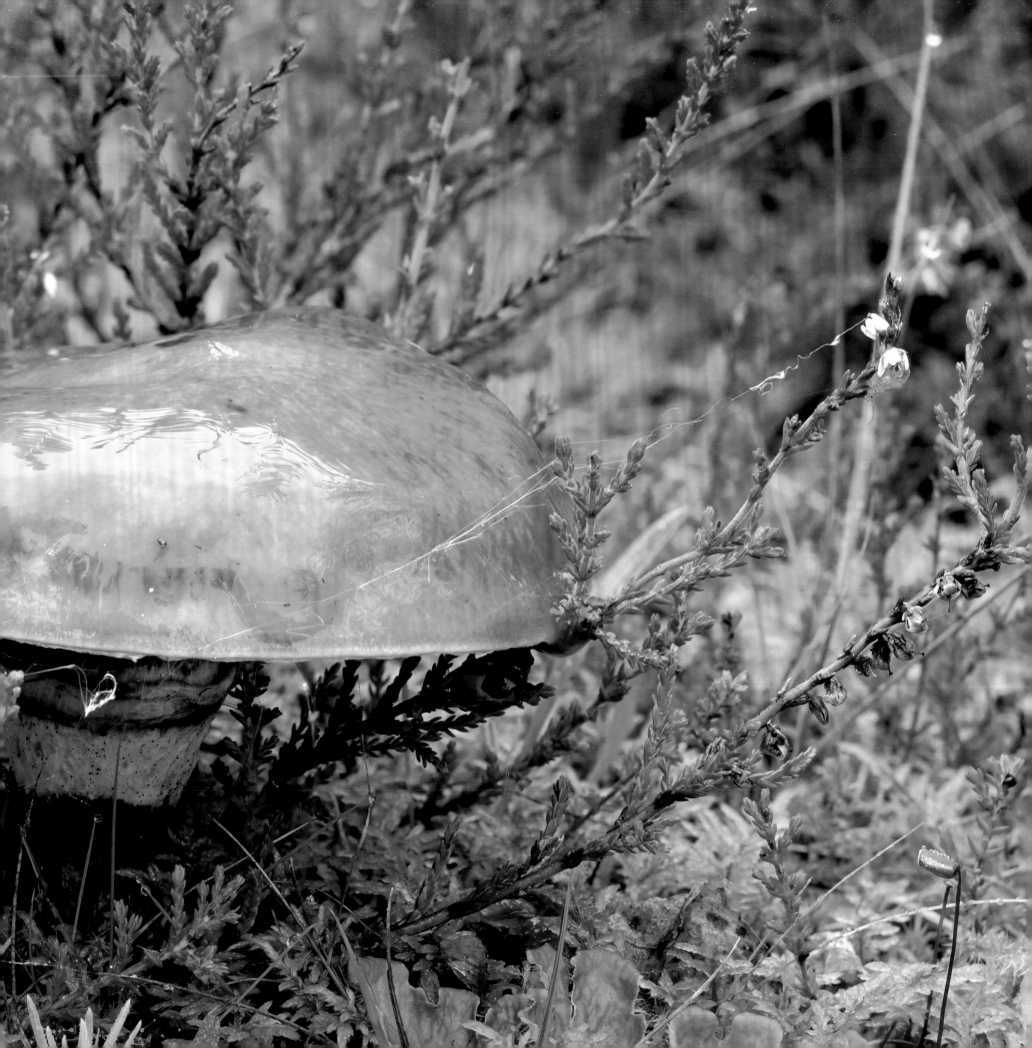

The Future of the Forest

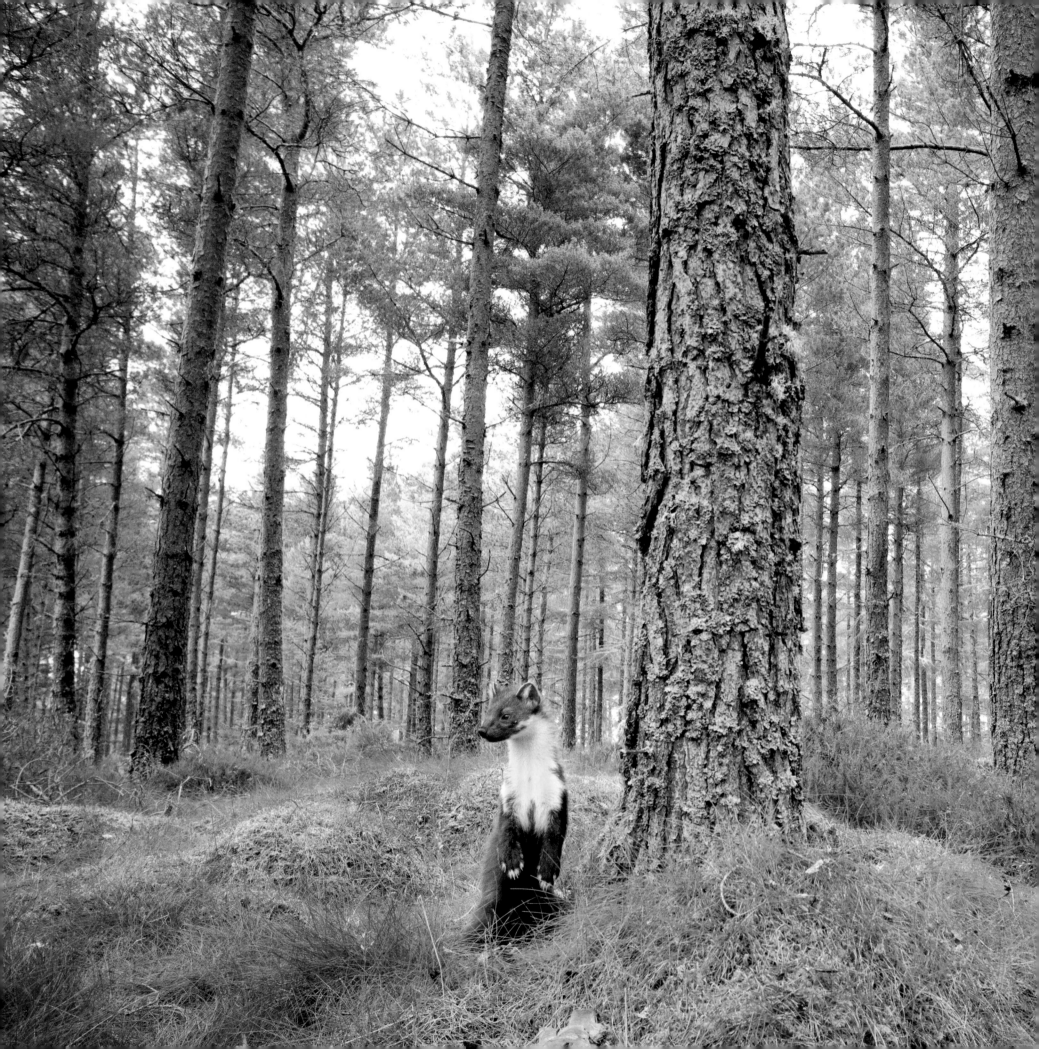

Help for the Rainforests

'The world is changing: I feel it in the water, I feel it in the earth, and I smell it in the air.'

Treebeard, in *The Lord of the Rings*, J. R. R. Tolkien

It is clear that the rainforests of the world have diminished significantly in recent centuries as humans have extracted resources and commandeered the land for alternative use. Every single rainforest has felt the touch of mankind in some way. Now that such delicate and important resources are in precipitous decline, what does their future hold? What would be the consequences of their continued decline for humans – and for the planet itself?

Nowhere to Hide

While the loss of rainforest happens on a specific site, its impact is truly global. For example, climate scientists have estimated that if the Amazon rainforest loses 20–25 per cent of its cover it will no longer be able to generate its own rainfall and the ecosystem will collapse. The scale of loss currently stands at 17 per cent

Previous page: Only through wider understanding and education into the importance of our rainforests can we hope to preserve them. Trails such as this one in Ang Ka Luang, Thailand, help tourists to understand the magnificent sights.
Left: Pine martens, once heavily persecuted, are making a healthy comeback in the forests of Scotland and, following reintroduction, Wales. These nimble predators are helping control the invasive grey squirrels that spread disease amongst the native red squirrels.

deforestation, so this tipping point could occur within the next 20 to 25 years. Should this happen, billions of tonnes of carbon would be released into the atmosphere, rapidly exacerbating global heating. The Earth's patterns of rainfall would be irreversibly altered, probably leading to global drought. The loss of these amazing habitats is thus something that will affect every person, in fact every organism, on the planet.

Action on the Ground

While the loss of these magnificent habitats is disastrous, it is important that we do not give up hope. Much can still be done to stop, and hopefully to reverse, the trend. By educating people on how their actions can affect the future of the forests – both locally and internationally, and from individuals to businesses – we can help them to understand these magnificent cathedrals of our natural world. In so doing, it may be possible to instil a deeper and more pervasive sense of their value in people's minds.

Before we can truly appreciate something, we first need to comprehend it and pass on that knowledge to others. Only then can we hope to rebuild what has been lost.

Above: A technician from the Tropical Forest Institute leading a course on sustainable and low-impact forest management, Pará, Brazil.
Right: The vegetable garden of the El Monte Sustainable Lodge in the cloud forests of Mindo, Ecuador.

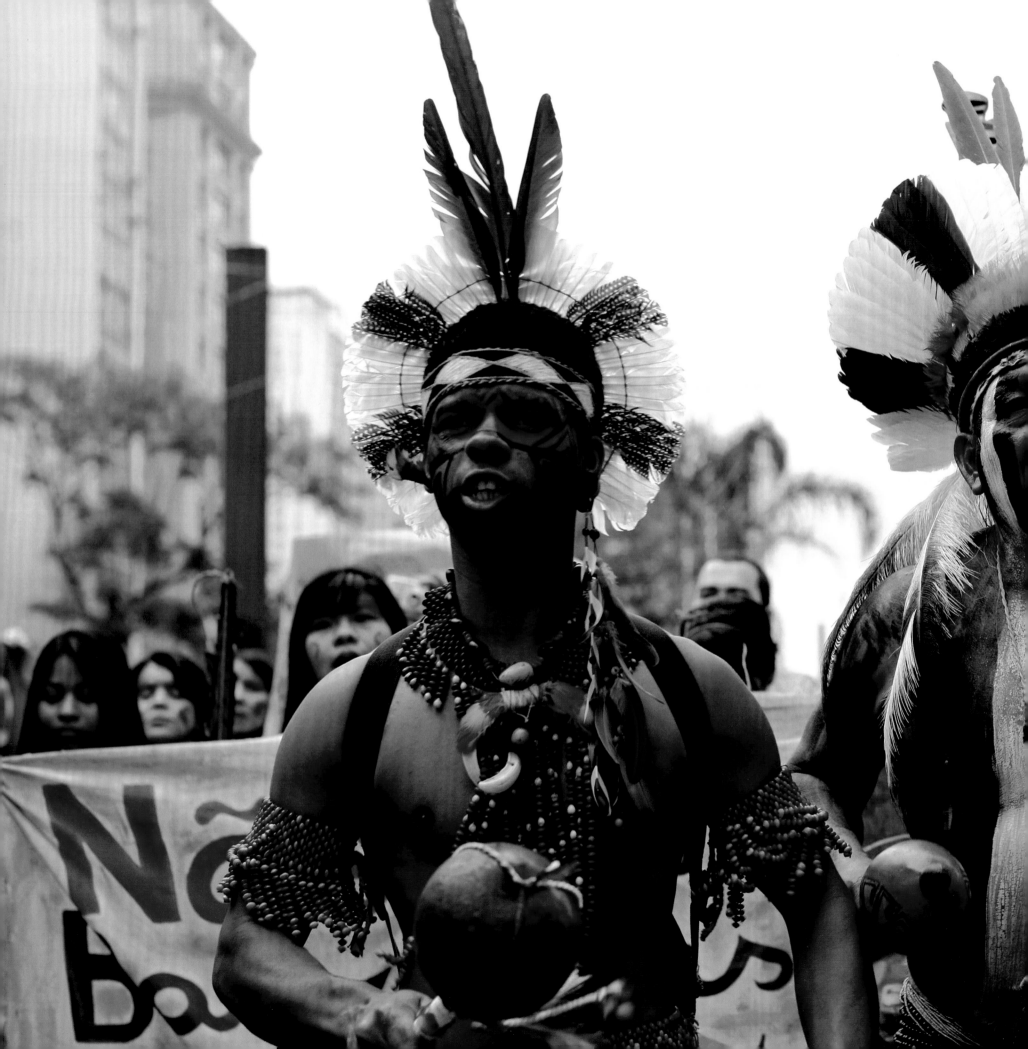

Reduce & Rebuild

There are two stages in ensuring the long-term stability of the world's rainforests. The first is to reduce the rate of loss – a task that involves international co-operation and a reduction of the demands placed on finite forest resources. This will not be easy to achieve, but it is possible: everyone has a part to play. The second is to restore what has been lost. This much more local endeavour will nevertheless require a long-term international commitment of financial resources.

Protecting the Rainforests

Large tracts of the world's rainforest fall under some form of government protection. This is their first line of defence. Even though this protection is often not enforced or the laws may be flouted, it is still a start in the process of stopping deforestation and exploitation. However, governments are only as good as the people who vote for them. This is where people pressure becomes so important: these rainforests will only be protected if people view it as in their own best interests to do so. Fortunately, the amount of forest under protection is slowly increasing, as is global awareness of the importance of conserving these life-giving forests.

Alleviating Poverty

Regardless of the protection these forests have in law, if people living close to them are in dire poverty they will, in desperation, use forest resources for food and to obtain money. As the global population continues

Left: People around the globe are demanding that governments help to preserve the world's rainforests. At stake are indigenous cultures, biological conservation and the regulation of the Earth's biotic systems.

to expand, and demand for high-impact 'Western' lifestyles increases, it is crucial that people who live in and around the rainforests have opportunities to better their lives. Ideally, we need to empower those people who may wish to improve their lot in life to be able to do so in as sustainable a way as is feasible.

One way to do this is through tourism, now a huge global employer. You only have to look to a country like Costa Rica to see how people's desire to experience the rainforests can be used to help a country's economy. Similarly, with a rising ecological awareness, new methods of farming that work in closer harmony with the forest are providing sustainable products, such as shade-grown coffee and chocolate. These can be sold at higher prices to more discerning and ecologically aware consumers. If these products can be encouraged and preferred, it will not only empower people living close to a particular forest, but also instil a greater appreciation and value for rainforests themselves.

Reforestation

Reforestation of the rainforests has to be ambitious, but we must start somewhere. Plant two or three trees and the impact will seem imperceptible. However, if hundreds or thousands of people do the same thing, or if governments get involved, a huge difference can be made. Many schemes around the world offer the opportunity to pay for a tree to be planted, while others encourage volunteers to join in with the work.

Trees for Life in Scotland, for example, was started by one man, Alan Watson Featherstone.

Right: *Costa Rica, a pioneer of rainforest tourism, has built canopy bridges, such as this one in the Monteverde cloud forests.*
Inset: *Sop Chem Weaving Village, Laos.*

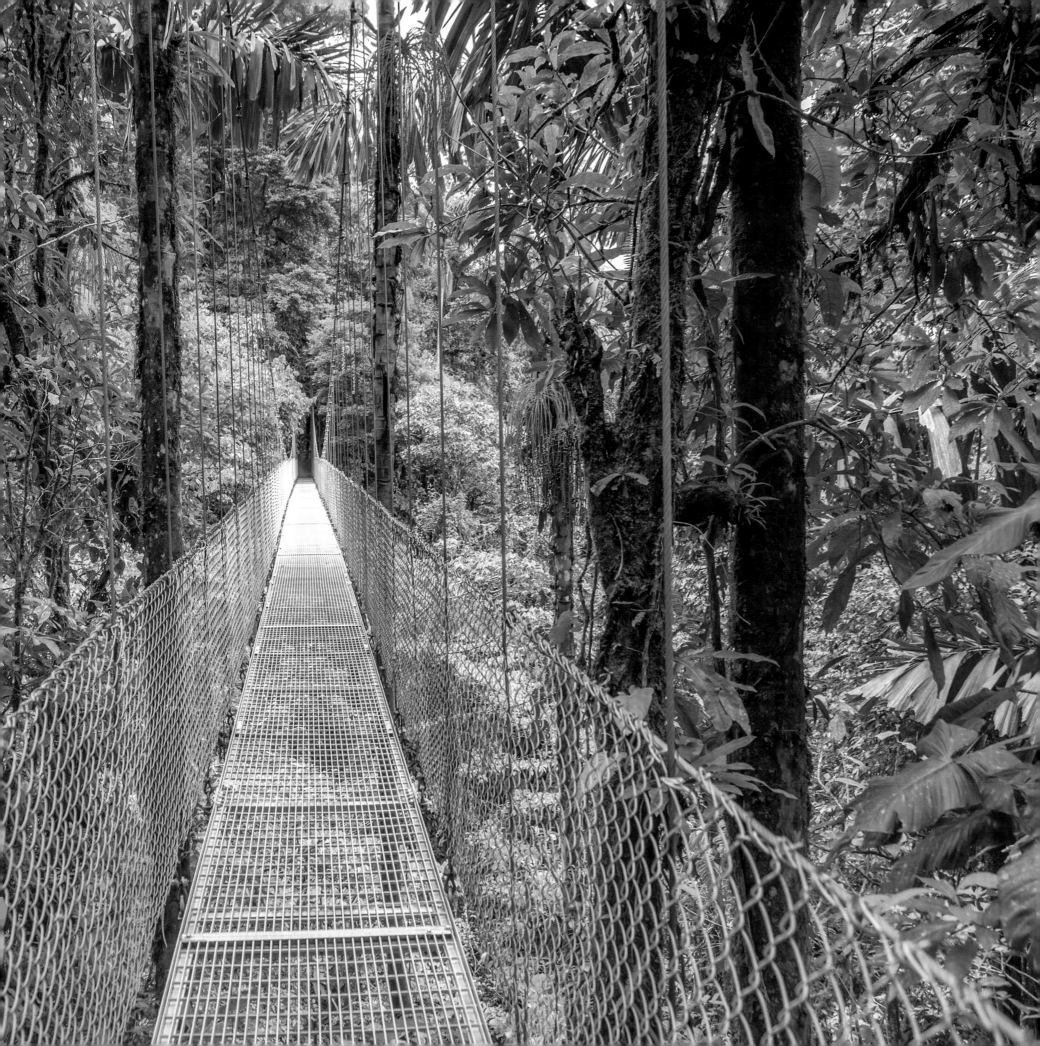

It has now become an award-winning charity that has, with the help of the public, planted millions of trees and is slowly restoring the Caledonian rainforest in Scotland (*see* p. 175). Similar projects exist all around the world. A simple internet search for 'rainforest tree planting' will provide a host of options to which any individual can donate their money or time.

What You Can Do

So, before you finish this book, perhaps you are wondering how you can help? There are numerous ways, both small and big; you do not necessarily need fundamentally to change your way of life. Many products you consume will have originated in the rainforest; one of the key ways to help is either to reduce your consumption of these products or find products grown in a sustainable way. The most powerful impact is to reduce your consumption of meat. Perhaps you could only eat meat once a week – or, if you wish, become vegetarian or vegan. This is undoubtedly the biggest single act you can make and many believe that it offers health benefits too.

Another small change is to try to source your morning coffee from farms that promote shade-grown coffee. This utilizes the natural structure of the forest without clearing it for more sun-thirsty varieties. Consider the products and foods that you buy, avoid those containing palm oil and try to find out where other raw materials come from. If possible, source more local alternatives, or choose to buy those grown in a less damaging manner.

Fundamentally, the pressure you place with your buying power is a key weapon in the war to save the forests. The other weapon is your voice: talk about the forests, pressure politicians to keep them in mind and pass on what you know by teaching others. The future of the rainforests is in our hands.

Left: *Tourists participating in a tree-planting programme to regenerate the rainforest at Samboja near Balikpapan, Indonesia.*

Index

Page numbers in *italics* indicate illustration captions.

Rainforest: Endangered

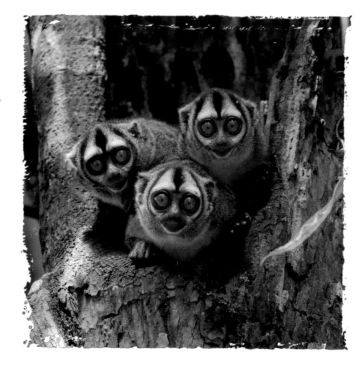

Three douroucoulis in a tree nest, Pacaya Samiria National Park, Amazon, Peru.

For further illustrated books on a wide range of subjects,
in various formats, please look at our website:
flametreepublishing.com